Japanese Art:
A Cultural Appreciation

Volume 30

THE HEIBONSHA SURVEY OF JAPANESE ART

For a list of the entire series see end of book

CONSULTING EDITORS

Katsuichiro Kamei, *art critic*
Seiichiro Takahashi, *Chairman, Japan Art Academy*
Ichimatsu Tanaka, *Chairman, Cultural Properties Protection Commission*

Japanese Art:
A Cultural
Appreciation

by SABURO IENAGA

translated by Richard L. Gage

New York · WEATHERHILL / HEIBONSHA · Tokyo

This book is a basically a translation of the author's *Nihon Bunka Shi* (Cultural History of Japan), published in 1959 by Iwanami Shoten, Tokyo, and especially revised and expanded by the author for this English version.

First English Edition, 1979

Published by John Weatherhill, Inc., of New York and Tokyo, with editorial offices at 7-6-13 Roppongi, Minato-ku, Tokyo 106. Copyright © 1978 by John Weatherhill, Inc.; all rights reserved. Printed in Japan.

Library of Congress Cataloging in Publication Data: Ienaga, Saburō, 1913– / Japanese art. / (The Heibonsha survey of Japanese art; v. 30) / Revised and expanded translation of the author's Nihon bunka shi. / 1. Japan-Civilization. I. Title. II. Series. / DS821.I3813 / 709'.52 / 78–2566 / ISBN 0–8348–1029–8

Contents

Japanese Art:
A Cultural Appreciation

CHAPTER ONE

Primitive Society

THE STONE AGE IN JAPAN The scholarly world today generally holds that human history can be said to begin from the time when people first made production tools and started to perform socially productive labor. Ordinarily, therefore, histories begin at the stage of the use of stone implements—that is, the Stone Age. Such tools were at once production tools and important cultural elements for the people who employed them. Japanese history, too, begins in the Stone Age, at a time when the social structure of the people was what may be called primitive.

Although until not many years ago the Japanese Stone Age was thought to consist solely of the period characterized by the kind of pottery known as Jomon, excavations in 1949 at Iwajuku, in Gumma Prefecture, produced stone implements unaccompanied by pottery of any kind, thus proving that a pre-pottery period had come before the Jomon age. Nothing in detail is known about that pre-Jomon period.

During the Stone Age, human beings did not engage in agriculture but obtained food by hunting, fishing, and gathering. They neither formed large groups for communal living nor accumulated excess material wealth. For these reasons, political authority, which is based on the power of wealth, did not emerge. In other words, the culture of the Stone Age differed basically from those of all other levels of primitive society in that there was no class opposition and society was not subjected to the authority of a national state.

JOMON POTTERY Since there is no written evidence, the length of the primitive stage of Japanese society is uncertain, and calculating absolute dates accurately in connection with it is beyond the powers of modern science. There is no doubt, however, that it was very long: the period known as that of the Jomon pottery alone lasted for thousands of years. It may be true that the distant ancestors of the Japanese people arrived in what is now Japan when the islands were still attached to the Asian continent, but the Japanese people of the Stone Age evolved their own culture within the Japanese archipelago, and for centuries that culture remained free of influence from the Asian mainland. It was beyond the power of these early people to rise above the low productivity level to which they were bound by the hunting-and-gathering way of life. Within the limits of that level, however, they developed techniques for producing stone and ceramic objects as sophisticated as any found in other Stone Age cultures. The numerous styles and abundant patterns of Jomon pottery (Fig. 1) bear witness to this sophistication.

An examination of the Jomon pottery found in the Kanto region reveals the extensive stylistic variation that took place throughout the long

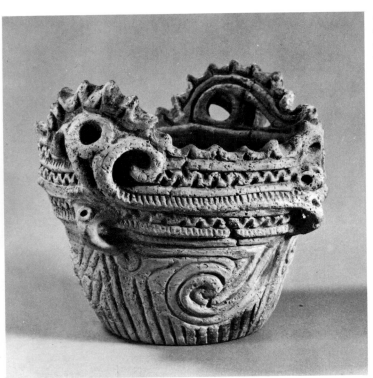

1. *Earthenware bowl. Middle Jomon period. Height, 17.3 cm. Kakimachi site, Nagaoka, Niigata Prefecture. Nagaoka Municipal Science Museum.*

2. Dogu *with snow-goggle eyes and elaborate* ▷ *costume. Terminal Jomon period. Height, 36 cm. Ebisudakakoi site, Tajiri, Miyagi Prefecture. Tohoku University, Sendai.*

history of this kind of ceramics. In this broad group it is possible to distinguish five major and twelve minor stylistic stages. In the earliest period the surfaces of the vessels were decorated with simple patterns made by rolling twisted strings over the clay. This style gradually gave way to more elaborate decorations called *jomon,* or cord patterns—a term that has given its name to the entire range of ceramics of this age. As time passed, the exteriors of the vessels became increasingly ornate. In what is called the middle period, sculptural decorations, piercing, and highly raised designs were used. In addition to the employment of more complex decorative patterns, the kinds of vessels were increasingly varied to include deep pots, shallow pots, footed pots, dish-shaped vessels, bottles, and vessels in forms resembling those of incense burners. Wares of

the later and terminal periods within the Jomon age were extraordinarily elaborate in their decoration. The rich variety of patterns used in Jomon ceramics and the development of stone-working techniques that enabled people to pierce hard pieces of jade suggest that, even at this early stage, the Japanese had already evolved the kind of craft skill that was to become a characteristic of their entire cultural history.

THE STAGNATION OF PRODUCTIVE POWER Nevertheless, skills in making pottery and working stone do not necessarily indicate progress in production technology. Generally speaking, in European history the peoples of the Paleolithic Age who produced simple tools by the unsophisticated means of chipping rock made no pottery and

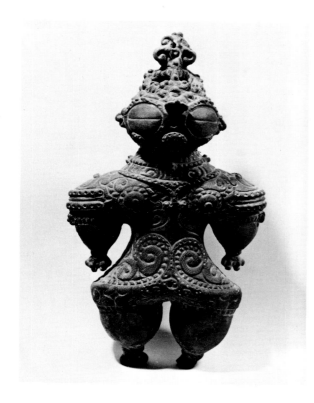

and-gathering economy and were in a state of production-power stagnation. The retardation shows that it was not easy for cultural waves to reach the Japanese islands from the Asian continent. Furthermore, the same difficulty created by geography was to become a characteristic that persisted throughout the history of Japanese culture.

In spite of their abilities in stone and ceramic work, the stagnation in productive power had a retarding effect on the spiritual level of the people of Japan in the Stone Age. Great skill in craft and insufficient self-awareness to allow them to evolve a higher social structure constituted the strange cultural imbalance of this primitive society.

A CONTROLLING BE- Although it is difficult
LIEF IN MAGIC to reconstruct the daily lives of the Japanese people of the Stone Age, surviving artifacts suggest that virtually everything they did was controlled by a belief in magic. Large stone rods, thought to represent phalli, and pottery female figures (*dogu*) with clearly indicated breasts (Figs. 2, 4) contribute to this impression, as do skulls in which the teeth have been cut to resemble a saw edge or in which some of the teeth have been deliberately extracted. These and other pieces of material evidence tell of the power that magic must have exerted in the daily lives of these people. As is almost universally true, magic was closely related to death and the ceremonies associated with it. It is unlikely that the bending of the limbs of corpses practiced in the Jomon period was only a measure to save labor in the digging of graves. It is much more probable that the limbs were bent as a way of preventing the spirits of the dead from coming back to haunt the living. Mounds of shells and bones left from the the Stone Age were once thought to be no more than refuse heaps. But in more recent times some scholars have advanced the theory that these mounds may have been places where religious ceremonies were held to conduct to heaven the spirits of animals used for food: an expression of

engaged in no agriculture. In the Neolithic Age, however, polished stone implements were produced. Europeans at this stage of development also made pottery and engaged in both agriculture and animal husbandry. The Japanese Jomon period differs sharply from this kind of culture. Though possessing the skills to make polished stone implements and elaborate ceramics, the Japanese of that age had not yet learned to farm or to raise animals.

The ancient Egyptian civilization already knew and worked metal around 5000 B.C. Bronze was used by the Chinese in the thirteenth century B.C. By the third century B.C. the Chinese Ch'in and Han dynasties already knew and used iron. In terms of absolute historical period, Japan was retarded in these respects, for in its Neolithic Age its people had not broken away from the hunting-

the hope that those animals would reappear on earth to enrich the human diet.

In many repects, connections between the culture of the Jomon period and that of the following Yayoi period (200 B.C. to A.D. 250) are unclear. The connection between primitive faith in magic and the later ethnic, or folk, religion is one of the unsolved problems. Nonetheless, in all probability the source of the ethnic faith is to be found in the old trust in magical powers.

SOCIAL STRUCTURE AND HOUSING

As is true of the daily lives of the people, the details of the social organization of Japan in the Stone Age remain largely unknown. Without doubt, however, the elder who excelled in magical practices controlled the group. Because of the fact that all the clay figures of magical connotation surviving from this period are female, it is likely that the social position of women was high. The failure of the male sex to completely subjugate the female in Japan until the end of the ancient period possibly resulted from the persistence of a trace of woman's high place in primitive society. In those distant times there was no wealth to provide a material basis for discrimination between the sexes. The blood tie between mother and child could well have been the axis around which to evolve a matriarchal family structure. Some scholars interpret a later Japanese marital system in which husband and wife lived apart as a vestige of an older matriarchy.

The dwellings of the people of the Jomon period belonged to what is called the *tateana* style. Buildings of this kind consisted of shallow pits, either rectangular or nearly rectangular oval in plan, in which posts were sunk. The thatch roof rested on the framework formed by the posts. Some of these houses had stones set in an otherwise earthen floor. The *tateana* house, which continued in use among the ordinary people well into what is called the ancient period, remained as an indication of the persisting powers of the primitive social structure.

THE JOMON AGE IN SUMMARY

Before moving on to the next period of Japanese history, I think it is important to recall the lack of government and class distinctions in primitive Japanese society. In other words, this society was one that modern man finds virtually impossible to understand. It had low productive power and was poor and underdeveloped in content. But its significance is great in the course of Japanese history because some of its elements persisted in the culture of later centuries. When new production techniques from the Asian continent entered Japan about the second century B.C., they completely altered the primitive society. The use of metals and the cultivation of wet rice fields mark the end of the Jomon culture and the beginning of a new culture characterized by the pottery type known as Yayoi. With the advent of this culture, the classless, governmentless society that had been in existence for thousands of years came to a close, and the society of class control and politics that has persisted throughout the rest of Japanese history came into being.

CHAPTER TWO

Early Ancient Society

THE ADVENT OF METAL CULTURE While the distant ancestors of the Japanese people remained at the primitive level of a Stone Age culture, the people of China were developing rapidly. By the Han dynasty (206 B.C. to A.D. 220) the Chinese had already entered their Iron Age. The spread of the Han people in all directions was most vigorous, and before long their influence reached Japan through the introduction of the use of metals and of agricultural technology. Although, when people evolve their own metal cultures independently, it is common for a Bronze Age to precede the Iron Age, Han influence enabled the Japanese to leap from a stone culture to an iron culture without passing through a distinct Bronze Age. Consequently, in the early stages of their metal culture, the Japanese employed articles made of both bronze and iron at the same time. This is one of the characteristics distinguishing Japanese cultural history from that of nations with steadily progressive civilizational growth.

The first Japanese metal-using culture is called the Yayoi culture because it is accompanied by ceramic vessels in the Yayoi style, so named after a type site in Tokyo. This kind of pottery (Fig. 3) does not represent a developmental continuation of the ceramics of the Jomon period. Whereas the Jomon pottery is elaborate and decorated to an almost distasteful extent, Yayoi pottery employs simple forms and rectilinear decorative patterns. It seems to mark a complete break in aesthetic taste. Indeed, some people argue that those who introduced the Yayoi culture came to the Japanese islands from elsewhere and conquered the people of the Jomon culture. If this explanation is correct, it would imply a break in the racial continuity of the people. But even those who support the theory of a new people bringing the Yayoi culture to Japan concede that the invaders must have been few in number. Their culture superseded that of the Jomon people to attain total prominence, but the people themselves were ethnically absorbed into the Stone Age populace of the islands. In short, though the Yayoi people brought a new ethnic element into Japan, they did not effect a complete racial replacement. Consequently, no matter who introduced it, the Yayoi culture as imported into Japan was no more than a series of borrowings and did not disrupt the continuity of Japanese cultural history.

THE EMERGENCE OF SOCIAL CLASSES AND POLITICAL CONTROLS The introduction of wet-field rice cultivation brought about far-reaching changes in the Japanese social system. Throughout the Stone Age, the coming together of too many people in one place created the danger of exhausting the food supply. For this reason, settlements could expand to only a limited degree.

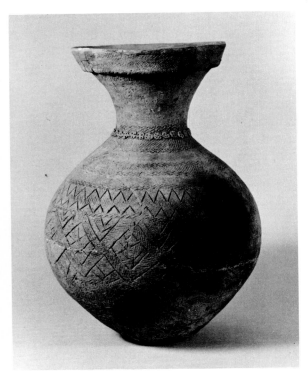

3. *Large earthenware jar with incised patterns and buttonlike ornaments on neck. Late Yayoi period. Height, 38 cm. Urashimayama site, Yokohama. Honcho Primary School, Yokohama.*

When the Yayoi people learned agricultural methods, however, labor forces became necessary for the cultivation of land and for irrigation. This need inspired a tendency toward aggregation in dense groups. The possibility of accumulating wealth in the form of surplus products meant that the size of the available labor force determined affluence. Those who commanded great wealth subjugated and sometimes even enslaved those whose wealth was slight, and thus a class-exploitation system came into being.

Material conditions of this kind are the foundation for class relations, and against this background relations of political control were born. In each region small political groups were formed. Among the known documents that take note of the Japanese land and people in early times is the Chinese *Hou Han Shu* (History of the Later Han), which dates from around A.D. 445. In this work a remark describing Japan in the first century B.C. says that the people of Wa (Japan) live on islands in the ocean and are divided into more than one hundred communities. It can be seen from this statement that even in such early times the people were grouped into numerous small subdivisions. These subdivisions were called *kuni*, or countries, in Japanese. Chinese historical writings that follow the Han history remark that these "countries" had kings.

From the dolmenlike stone tomb chambers, urn coffins, bronze mirrors, and other funeral articles found on the island of Kyushu, it is possible to see that a political ruling class had emerged by this time. But the lack of distinctive treatment to indicate rank among the funeral paraphernalia and the use of communal burial grounds suggest that what is represented by the grandiose Chinese word *wang*, or king, was in all likelihood no more than a village elder.

At a later stage the aristocrats of this society grouped themselves into clans to protect their pedigrees and used family names signifying their position as rulers. These names became hereditary. Because these two traits—the grouping of aristocrats into clans and the use of family names—characterize it, the society of this time is often called the clan-family-name (*ujikabane*) society to distinguish it from the legalistic (*ritsuryo*) society that followed it. In the next sections I shall discuss the culture of the time between the establishment of the Yayoi culture (during which the people were divided into many small communities) and the later culture of the Tumulus period, in which the clan and the hereditary name became characteristic.

ETHNIC RELIGION AND FESTIVALS As I have already noted, magic no doubt exercised a controlling influence over life in the most primitive Japanese society, but since there is a complete lack of documentary evidence, it is impossible to discover any de-

tails about the magical practices of those times. About the magical beliefs and religions of the Yayoi period, on the other hand, we have documentation providing concrete information. Furthermore, because the ancient agricultural ceremonies and magical religions have persisted into modern days—having of course undergone modifications—it is possible to use some religious observances preserved today in conjunction with documentary evidence in reconstructing the beliefs of the past.

Because of these possibilities, Kunio Yanagida* (1875–1962), a pioneer in the field of Japanese ethnological studies, succeeded in employing folk transmission as data in reconstructing a wide range of concrete information about Japanese ethnic religion. Since folk-transmitted data are the sole source of information, however, it is impossible to extract absolute dates or to make completely accurate statements. Especially in dealing with the ethnic religion of the very ancient past, it is safer to rely largely on whatever documentation is on hand and to employ present folk-transmitted data as indirect corroboration.

The first record that must be examined in connection with ancient Japanese folk religion is the description of the manners and mores of the people of Wa, as found in the Chinese work *Wei Chih* (History of the Kingdom of Wei), compiled around A.D. 297. In this account, the people of Wa—that is, the Japanese—are described as mourning for ten days whenever a person close to them died. During the mourning period, they refrained from eating meat and employed a head mourner to wail and lament. They gathered together to sing, to dance, and to drink liquor. When the period of mourning ended, the entire family took a bath of ritual purification. When the people of Wa made trips across the sea to China, they always took on board a man who lived much as a chief mourn-

er did. This man, called the *jisai,* did not comb his hair, allowed his clothing to become dirty, ate no meat, and approached no women. Should illness or other disaster befall the ship, the *jisai* was held responsible and was killed. Before undertaking a venture of any kind, the people of Wa divined the future by reading the cracks produced in bones by burning. They also employed tortoise shell in divination. Their queen, who was named Himiko, was versed in magic and bewitched the people.

This description is of immense value because it presents a probably accurate picture of the religious life of the people of Japan in the third century of the Christian Era. In Japanese records of the early eighth century—the *Kojiki* (Record of Ancient Matters), *Nihon Shoki* (Chronicles of Japan), the *fudoki* (provincial records), and other documentary sources thought to have been completed at about the same time—a number of stages of complicated materials overlap, making absolute dating difficult. Nonetheless, there can be no doubt that these Japanese works describe conditions in a period following the one delineated in the *History of the Kingdom of Wei.* Furthermore, although the Japanese documents describe religious forms that are newer than the ones in the Wei document, the material in the former sometimes coincides with that in the latter. This agreement leads to the reconstructive hypothesis that the Japanese documents offer a picture of Japanese religion at a comparatively early stage.

In the *Kojiki* occurs a story to the effect that when the god Ame no Wakahiko died, a house of mourning was constructed, and dancing and singing were carried on for eight days and eight nights. These acts conform closely to the descriptions of mourning found in the *History of the Kingdom of Wei.* Other equally close correlations can be made between the documents. For instance, the *Kojiki* says that when the god Izanagi returned from the land of death, to which he had followed his goddess Izanami, he purified himself— that is, he performed the *misogi,* or ritual purification, in a river. Furthermore, when the sun goddess Amaterasu became indignant at the

* The names of all modern (post-1868) Japanese in this book are given, as in this case, in Western style (surname last); those of all premodern Japanese are given in Japanese style (surname first).

behavior of a god and hid in the Heavenly Rock Cave, divinations were performed by reading the cracks in burned deer bones. Legend also has it that when the emperor Chuai conquered the people known as the Kumaso, the empress Jingu delivered oracles concerning the best policy to follow in the future. These three events from the Japanese documents correspond to the ritual bath in water at the end of the period of mourning, the divination by means of burnt bones, and the magical and bewitching powers of the queen Himiko as set forth in the Wei history. Such practices as ritual purification, divination by means of bones, and the use of mediums (*miko*) to communicate between man and disembodied spirits and other similar elements lived on for a long time in the religious customs of the people. Indeed, in these ancient things it is possible to see a primitive form of what later came to be the ethnic religion of Japan.

In the following centuries this ethnic religion was forced into the form of a philosophical system that goes by the name of Shinto and was devised in the hope that it could stand on a par with the systems of Buddhism and Confucianism, which the Japanese borrowed from the Asian mainland. The truth is, however, that the ethnic religion had no teachings or doctrines and certainly possessed nothing to compare with the classics or the sutras of the imported religions. The name Shinto means "way of the gods." And it was not until late in the Kamakura period (1185–1336), when believers in the magical powers of mediums organized a theoretical system copied from Buddhism, that anything deserving such a name came into being. Moreover, the theories employed by the people who devised the Shinto system were nonsense concocted from borrowings from Buddhism and Taoism. All of this was totally unrelated to the living religion of the people of Japan, for the true ethnic religion was originally, and has continued to be, nothing but magical ceremonies.

It seems likely that the religion described in the Wei history inherited much from the magical practices of the people of the still older hunting-and-gathering society. But after the opening of the Yayoi period and the introduction of plant cultivation, all religion became oriented toward ceremonies to insure that agriculture proceeded in an orderly and productive manner.

The festival (*matsuri*) is the most socially important of all magic-oriented acts in the Japanese ethnic religion. The agricultural nature of the major ancient festivals is immediately apparent. In the spring the Toshigoi no Matsuri was held to mark the beginning of planting and to offer prayers for an abundant harvest. In the fall the Niiname no Matsuri was held to give thanks for the harvest and, at the same time, to offer prayers for an abundant harvest in the following year. As time passed, the forms and contents of these festivals altered. Some elements that were only later accretions have come to be considered very ancient. In fact, however, the most ancient elements in the festivals often fall beyond the pale of what later people believed to be sensible and acceptable.

For instance, in later centuries the shrine—that is, a definite, permanent piece of architecture—came to be a prerequisite for festivals. In primitive times, however, the shrine was only a temporary structure destined to be dismantled once the festival of the moment had come to an end. In the early stages of the ethnic religion, there was no need for a permanent building. But as the same locality was used over and over for festivals and therefore acquired a special significance, a shrine building of a more durable nature would be erected there. Some shrines today continue to manifest this old philosophy. For example, at the Miwa Shrine, in Nara Prefecture, there is a worship hall but no main hall; the place of the latter is taken by Mount Miwa, to which the shrine is consecrated. At the Yudonoyama Shrine, in Yamagata Prefecture, a hot spring and the boulder from which it emerges are the holy part of the region, and there is no main building. Many similar shrines remain in various parts of Japan. In the famous eighth-century poetry anthology *Man'yoshu* there occurs an instance in which the Chinese characters for the word "shrine" (ordinarily read *jinja* in Jap-

anese) are given with a rubric indicating that they must be read *mori*, or "forest." As this suggests, the holy part of a Japanese shrine may be any natural object or phenomenon.

It seems likely that the permanent shrine building and the statue of a god that later became customary in Shinto shrines actually developed as a result of Buddhist influence. In Buddhist temples a statue of a Buddha is usually enshrined in the main hall. The Shinto approach, however, differs from the Buddhist one in this connection. According to Shinto thought, a tree, a mirror, a sword, or a piece of pottery is the place in which, if the festival succeeds in its aim, the spirit of the divinity will temporarily reside. The important point is the temporary nature of the residence, for which there is no need to construct a permanent building.

It is largely because of this aspect of the ethnic religion that Shinto gods have never been thought of as anthropomorphic. In a book called *Kojiki-den* the famous scholar Motoori Norinaga (1730–1801) discusses the nature of Shinto gods, or *kami*. He explains that Japanese *kami* may be worthy of the highest respect, though some of them are base. There are strong *kami* and weak *kami*, good *kami* and bad *kami*. Obviously what is meant by the word *kami* is entirely unlike the kinds of beings described as Buddhas, Bodhisattvas, or saints, all of which represent aspects of religion foreign to indigenous Japanese thought. Motoori's clearest statement of the nature of *kami* is that anything out of the ordinary, anything deserving reverence, is a *kami*. Human beings, animals, birds, mountains, rivers, grasses, and trees—all of these may be *kami*. Certain animals like the snake, deer, wolf, and monkey were closely related to the daily lives of the people of the past and were thought to be able to serve as mediators between men and divine spirits and thus to become *kami* themselves. Other things were believed to be endowed with the same powers: trees, boulders, mirrors, swords, jewels (*tama*), and so on.

It is true, as I shall explain later, that when the systematized legends of the age of the gods were compiled, it became the custom to devote shrines to the various gods and lords (*mikoto*) who appear in those legends. But in its pristine form the ethnic religion of the Japanese did not associate shrines with specific anthropomorphic gods. The Miwa Shrine, of which I have already spoken, is now considered sacred to the god O-omononushi no Kami but was once, according to the *Nihon Shoki*, dedicated to a snake. The Taga Shrine, dedicated to the god Izanagi no Mikoto, is supposed to have been originally devoted to a white monkey. Legends of such consecrations probably point back to a time that preceded early attempts to assign definitely named gods to each Shinto holy place. It must always be borne in mind that as long as its purpose was the ordering and prosperity of agricultural labor, the festival had no need of an object of worship. The important thing was the ritual act itself, and the shrine was no more than the holy place where such acts were performed. It did not derive its importance from being the permanent residence of a festival god.

Another significant aspect of the primitive festival was its nature as a ceremony performed by all members of the village community. The orderly progress of agricultural undertakings determined the well-being or misery of every member of society. Consequently, the magical festival, which was devoted to continued agricultural plenty, had to be performed by everyone. Indeed, this is still the case in rural Japanese villages today. In these festivals dedicated to local tutelary deities, occurring in spring and fall, there is no room for concern over the desires of the individual. Nor does Japanese ethnic religion permit latitude for such lofty spiritual ideas as salvation of the soul.

In later centuries it became customary to pray at Shinto shrines for wealth and protection from disaster, and the *Man'yoshu* contains poems in which prayers are offered to Shinto gods for safety on a voyage or aid in love affairs. As towns developed and grew, some of the old shrines came to occupy localities entirely cut off from agricultural pursuits. The people in charge of such institutions hit upon the idea of offering help in such things as business as a way of stimulating the citizenry to make contributions. But all these developments

recount the growth of a new kind of faith and constitute a change in the nature of the ethnic religion itself.

The nature of the festivals, however, remains largely unchanged. Even today they are group undertakings that ignore the wishes and feelings of the individual. Everyone is obliged to participate in them. Tales of celebrants who have forcibly carried the bulky palanquin (*mikoshi*) of the divinity into the very homes of people who refused to contribute to the ceremony suggest a continued belief in the obligatory nature of participation in festivals. Briefly, it is not the faith of the individual but the collective group spirit of the entire community that supports the Shinto festival.

In the ancient past, festivals remained the concern of the local villages. They were not national in nature. Nonetheless, the size of the annual harvest was a matter of major interest to the ruling class. Consequently, the lord or ruler found it necessary to conduct agricultural festivals on a wide scale. In time, two clans—the Nakatomi and the Imbe—came to be in charge of such extensive religious observances. These observances never extended beyond the limits of the ruling class and never played a part in the ethnic religion of the ordinary people. It was not until after the middle of the nineteenth century, when the emperor was at last restored to the central position in the national government, that a system was devised whereby the monarch was regarded as absolute and the people were required to make pilgrimages to Shinto shrines, all of which were associated with the imperial line as the ostensible descendants of the sun goddess Amaterasu.

In the sixth century, Buddhism was introduced into Japan. It developed rapidly in popularity, but it did not replace the ethnic religion. Unlike the Germanic tribes who had to abandon their old faiths upon accepting Christianity, the Japanese were able to maintain Buddhism and Shintoism side by side in harmony. The two religions existed and grew in parallel, and both have deep roots in the ways of living and thinking of the people.

The ethnic religion is obviously alive in the spring and autumn festivals, which even today are usually arranged and carried out by urban or village authorities. But the same religion is found in many places where it is less obvious. Although, on the surface, Japanese New Year's celebrations seem unrelated to the ethnic religion, actually several of the traditional ways of observing the occasion derive from ancient purely Japanese practices—for example, the use of pine branches to ornament gateways and of cakes of glutinous rice decorated with clean white paper, ferns, tangerines, and sometimes lobsters for placement in the tokonoma alcove and at various other points throughout the house.

In other holidays, too, the ethnic religion persists. The vernal and autumnal equinoxes and, still more important, the festival of Bon in the summer are not Buddhist, though Buddhist priests usually take charge of ceremonies performed to celebrate them. The Bon Festival, in which the spirits of the dead are thought to return for a brief time to be with the living, is clearly opposed to Buddhist teachings, which deny such immortality of the spirit. It is one example of an ethnic religious element that has been overspread with a thin veneer of Japanese Buddhism.

As the parallel development and harmonious coexistence of Shintoism and Buddhism indicate, Japanese culture is characterized by what might be called a layer structure in which new layers—either imported, as in the case of Buddhism, or developed at home—are imposed on old layers, which are by no means destroyed as a result but continue their own life. As I have said, the position of the Japanese archipelago, separated from the nearest mainland by stretches of sea, seriously limited the amount of foreign influence exerted on Japanese culture. Only on rare occasions have the Japanese deliberately and consciously rejected foreign cultural elements; on the contrary, they have, if anything, been too eager to import and to assimilate cultural products from other lands. Indeed, they have developed sophisticated skill at this process. Nonetheless, foreign culture has almost never taken root so deeply as to upset or seriously alter the traditional Japanese way of

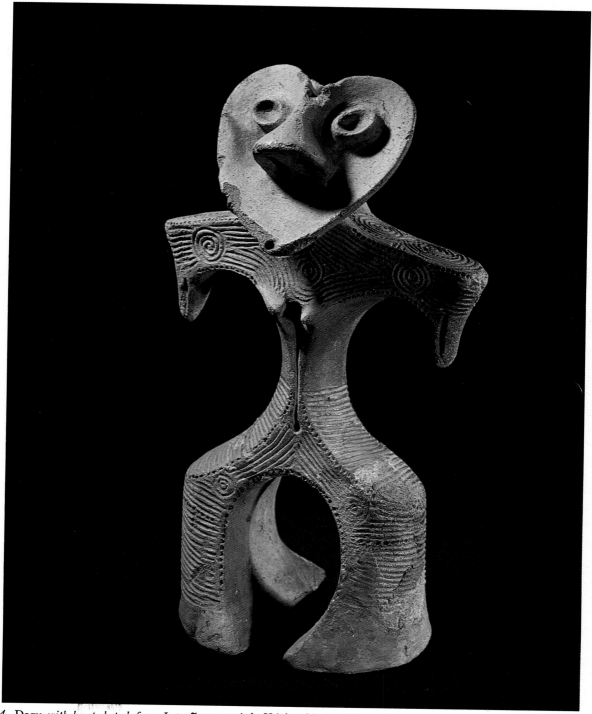

4. *Dogu with heart-shaped face. Late Jomon period. Height, 31 cm. Gohara site, Agatsuma, Gumma Prefecture. Collection of Kane Yamazaki.*

5. *Tomb known as Hashihaka. Early tumulus period, fourth century. Hashinaka, Sakurai City, Nara Prefecture.*

6. *Polychrome mural on west wall of Takamatsu-zuka tomb, showing court ladies. Late seventh or early eighth century. Asuka,* ▷
Nara Prefecture.

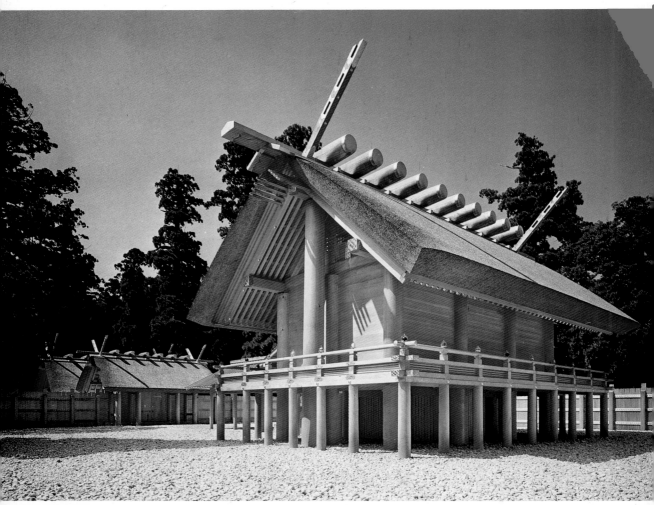

7. *Main sanctuary* (shoden) *of Inner Shrine (Naiku), Ise Jingu, Uji-Yamada, Mie Prefecture. Rebuilding of 1973.*

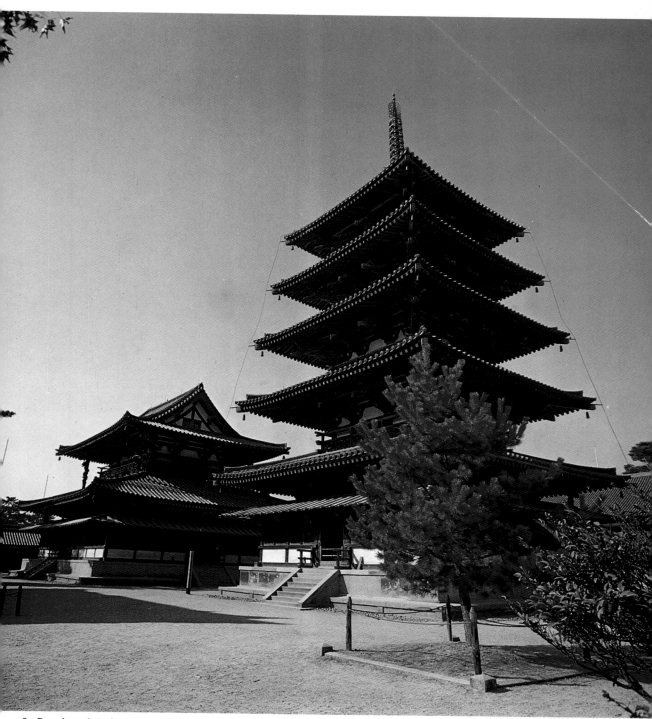

8. *Pagoda and, in background, Golden Hall, Horyu-ji. Late seventh century. Overall height of Pagoda, 32.56 m. Ikaru-ga, Nara Prefecture.*

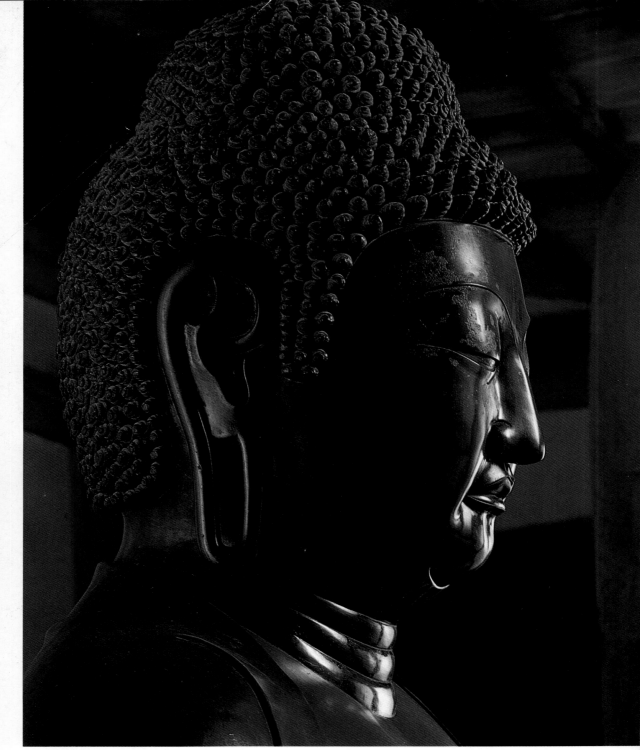

9. *Yakushi Nyorai. 688. Bronze; height of entire statue, 254.7 cm. Golden Hall, Yakushi-ji, Nara.*

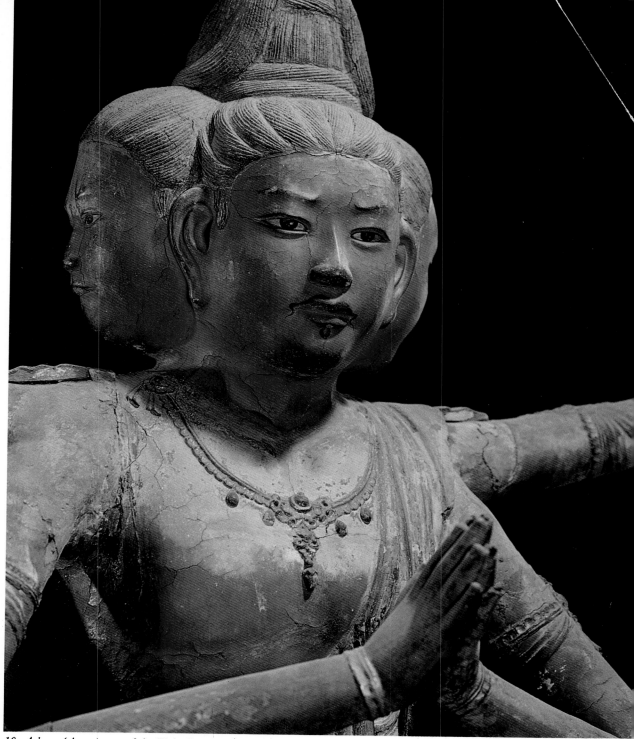

10. *Ashura (Asura), one of the Eight Supernatural Guardians of Sakyamuni. About 734. Colors on dry lacquer; height of entire statue, 152.8 cm. Kofuku-ji, Nara.*

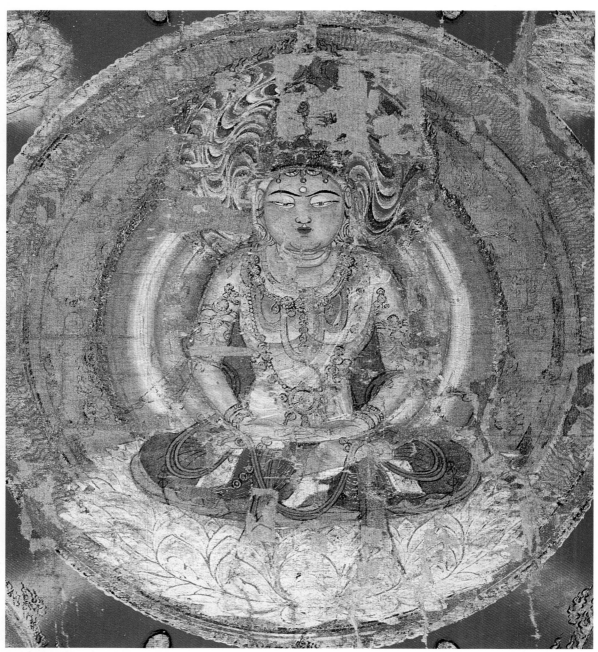

11. Dainichi Nyorai (Vairocana), the Great Sun Buddha: detail from Womb World section of Mandala of the Two Worlds. Late ninth century. Colors on silk; dimensions of entire mandala: height, 183.3 cm.; width, 154 cm. To-ji, Kyoto.

living and thinking. The old culture has persisted stubbornly in the everday world, and it is important to place proper stress on this persistence.

Wide-scale communications with other peoples have been hindered by geography. In the past, groups of people traveling back and forth between Japan and other lands effected the only contacts made with other cultural spheres. (It must be remembered that the situation before the development of rapid modern transportation was vastly different from the one we know today.) Furthermore, agriculture remained the major industry of the people for centuries. The people of Japan did not break away from the primitive agricultural patterns established in the Yayoi period until comparatively recently. As a result of these circumstances, no fundamental changes were made in the basic way of life, and this, in turn, provided a basis for the long-term continuation of traditional cultural elements.

The survival power of the traditional Japanese ethnic religion is proved by the continuation into modern rationalized society of many things that may be traced directly to it. In the past, of course, the all-pervading influence of the ethnic religion was more evident. It is likely that not a single facet of ancient society—including art, music, dance, economics, and politics—was unaffected by religion. I have already mentioned the way in which political power developed against a background of the magical powers of women acting as mediums between departed spirits and the living. The marketplace, the heart of commercial barter and exchange of surplus products in ancient times, was inseparably connected with festivals held at shrines. Markets were the places for communal singing and dancing (*utagaki* and *kagai*). Obviously incantations and spells for good luck were intimately related to the magical elements of the ethnic religion, but poetry and popular songs shared this relationship as well. Indeed, it is possible to say that many literary forms such as the poetry style called *waka*, the lengthy tales and romances (*monogatari*), the drama called Sarugaku Noh, the puppet drama, and others, which in later centuries reached high levels of artistic development, have their roots in the ethnic religion.

In legal trials of the past, it was sometimes the practice to require people to plunge their hands into boiling water to prove the veracity of their testimonies. Ritual purification (*harai*) was performed on criminals for its religious significance, though it was also a way of making a profit, since it entailed the criminal's forfeiting property for the sake of absolution. Motoori Norinaga sheds light on this point when he examines the nature of crime (*tsumi*) in its traditional Japanese interpretation. According to his explanation, the word *tsumi*—generally translated as crime or sin— pertains to more than evil action: it can mean sickness, misfortune, dirtiness, unsightliness, or any of the many things in the world that people hate or shun. This, like Motoori's definition of the word *kami,* is an example of the accuracy of his understanding of the characteristics of society in the distant past. I believe that, as he has pointed out, the people of ancient times regarded everything from actual crimes to natural disasters as *tsumi* and therefore something that required ritual purification. Because of the manifold nature of *tsumi,* many different kinds of ritual purification were required.

EARLY CHRONICLES: THE KOJIKI AND THE NIHON SHOKI The *Kojiki,* the *Nihon Shoki,* and several other works compiled in or about the eighth century are invaluable sources of information on the comparatively ancient form of the ethnic Japanese religion. These works are of the greatest importance in that they represent the Japanese people's first attempt to describe their history, society, and philosophy. But their nature is so complicated that the books are often misunderstood. To clarify their meanings, I should like to make a few remarks about them.

O no Yasumaro completed the *Kojiki* in 712 (the fifth year of the Wado reign period); Prince Toneri completed the *Nihon Shoki* in 720 (the fourth year of the Yoro reign period). These works, however, were not original creations. O

no Yasumaro and Prince Toneri merely organized into unified documents materials taken from other sources, adding their own comments to the resulting compilations. Although the newest material in the two books was written in the eighth century, the bulk of the contents is based on much older information, most of which derives from documents composed in about the first half of the sixth century. Aside from some seventh- and eighth-century coloration and additions, the older parts of the *Kojiki* and the *Nihon Shoki* may be regarded as products of popular thought. For example, the works contain material based on legends predating the fifth century. As this brief description suggests, both works are too multilayered and complex to allow the reader to consider them the simple products of a single historical period.

Both books are organized as chronological presentations of the lineages of the emperors, who trace their ancestors back to the gods. Although there are historically accurate parts, in many sections the material is either entirely fictitious or distorted from historical verity. It is therefore impossible to regard either book as historical in its entirety. Whereas the sections on the reigns of the emperor Temmu (673–86) and the empress Jito (690–97) may be accepted as historically valid, the parts on the age of the gods are entirely fiction. If these two classes of material are taken as the extreme poles, it is possible to identify a large range between them in which factual and fictional materials are intricately and subtly interwoven. Nor are the fictitious materials all of one piece of cloth. Some of them were made up at the compiler's desk; some were composed from legends of either the common people or the aristocracy. Moreover, the natures of the fictitious parts and their dates of composition vary. Probably the parts deriving from popular legends are the oldest.

After the middle of the nineteenth century, the Japanese government emphasized and made extensive use of the legend to the effect that the emperor was descended from the gods and that, consequently, Japan was a divine nation without peers. The old form of the legend is as follows: The god Takagi ordered the lord Ninigi no Mikoto to take the three sacred treasures—the curved jewel, the mirror, and the sword, which later became the imperial regalia—and to descend to rule the Land of the Reed Plains. (The story that the order originated with the sun goddess Amaterasu was a later variation that gained much credence.) The lord did as he was instructed and is said to have landed on a peak called Takachiho. The Koreans have a very similar myth in which a god is reported to have alighted on a mountain.

Still others of the myths in the *Kojiki* resemble stories of other peoples. For instance, the legend of the brothers Yamasachi and Umisachi, who are said to have exchanged a fishhook and a bow and arrow and then to have fought when one lost the fishhook, is similar to a tale found in the Celebes. Coordination of this kind suggests that Japanese culture partakes of elements from a wider cultural sphere extending throughout the Pacific. In spite of this characteristic and of the influence of the aristocratic compilers, many of the stories in these two books evolved from popular religion and pertain to gods whom the people of the eighth century actually worshiped. One interesting example of the way in which the breath of the common people invigorates the *Kojiki* and the *Nihon Shoki* is a song woven into the *Kojiki* tale of the emperor Temmu but said to have been sung by the members of the much earlier hunting-and-gathering society.

To point to the importance of the popular tradition in these books is not, however, to overlook the importance of the aristocratic element. Indeed, it is impossible to understand the *Kojiki* and the *Nihon Shoki* unless it is recognized that, while containing folk elements, both clearly intend to manifest the political will of the ruling class. The section dealing with the age of the gods that opens each book was written with this aim in mind. Since the Edo period (1603–1868) various interpretations have been made of these tales. Though some people have claimed that they are parables based on historical fact, today the scholarly world generally agrees that government

officials compiled these stories on the basis of actual conditions and popular legend to justify the supreme position of the imperial line. Of course, this could not be done until the imperial family had established firm control over the entire nation—perhaps in the early sixth century.

The main thread of the stories of the age of the gods concerns the way in which the progeny of the sun goddess Amaterasu, having overcome the progeny of Okuninushi no Kami of Izumo, descended from their heavenly abode at Takamagahara to rule Japan. All of the story is related to the manifestation of the authority and will of the sun goddess, the founder of the imperial family. The rule of Japan by the emperors is the axis along which the tale unfolds. Aside from a few characters, all of the divinities that appear in the story are personalized gods related either to the imperial family or to the ancestors of the aristocrats. Furthermore, the shrines and festivities later built and organized for these gods are only a reflection of political power and have no relation to actual, practical religious faith. It should also be noted that the apparently religious thought incorporated in the structure of the stories of the age of the gods is not always entirely mythological in nature. Sometimes it is political philosophy expressed in borrowed mythological forms.

Opinions vary about the parts of these books dealing with the times during and after the reign of the emperor Jimmu (a legendary figure who is said to have reigned in the seventh and sixth centuries B.C.), but many people agree that the earlier sections of these parts are of the same nature as the tales of the age of the gods and were composed for the same reasons. The later parts of the texts dealing with this legendary reign explain and justify the position of the ruling dynasty and describe the evolution of the aristocrats from the imperial line. The basic thought behind the *Nihon Shoki* and the *Kojiki* is reinforcement of the authority of the emperor and of the aristocratic families surrounding him. The absence of the ordinary people in the tales of the age of the gods accentuates the class-related nature of these parts of the two books.

SEX IN ANCIENT JAPANESE CULTURE

Although the basic structures of the *Nihon Shoki* and the *Kojiki* are in many respects similar, the methods of expression and the details of the two differ sharply. The *Nihon Shoki* is written in Chinese, and the aristocratic court official responsible for its compilation has altered stories dating from times earlier than his own and, by means of interpolation of political thought, has added a great deal of Chinese color to the work. Much of the *Kojiki*, on the other hand, speaks directly to the reader because it contains frank descriptions of the joys and sorrows of human beings unrelated to the will and intentions of the government. As Motoori Norinaga points out, the *Kojiki* description of the anger felt by Yamato Takeru no Mikoto against his father the emperor Keiko for ordering him to subdue the rebellious Emishi (Ainu aborigines) is a stunningly human evocation uncolored by Confucian morality, which was to become important in later periods of Japanese history. But this is not the only example of an emotional reaction about which the *Kojiki* takes an attitude unlike those that were to be common later. The lyrical relations between the god Izanagi and the goddess Izanami at the opening of the book and the description of the revealing dance performed in front of the Heavenly Rock Cave by Ame no Uzume in order to entice the sun goddess from her self-imposed retirement assume a distinctively ancient attitude toward sex and sex-related matters. Both the *Kojiki* and the *Nihon Shoki* suggest that the Japanese people of early times were very open about sex. Their frankness is further indicated by the use in ancient literary works of the commonplace word *au* (to meet) to mean sexual intercourse between male and female.

In the primitive period, sexual procreation was believed to symbolize magical powers. The sexual act and its magic were often represented by phallic stone monuments and by clay figures of unmistakably female sexual qualities. In the later periods, when agriculture had become firmly established, the magical aspect of intercourse and procreation continued to play an important

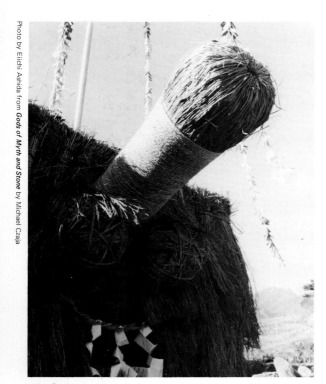

12. *Giant straw phallus made for the* Dosojin *festival. Makioka, Yamanashi Prefecture.*

part in the religious life of the people. (Fig. 12) Some of the sexual festivities performed at the time of planting of crops persist even today. For example, in Tochigi Prefecture, at the conclusion of the transplanting of the rice seedlings into the paddies, straw replicas of the male and female genitalia are made and are suspended from bamboo in such a way that, when the wind blows, the male organ penetrates the female. In Akita Prefecture, in the northernmost part of the island of Honshu, it was once customary, when the seedlings had been transplanted to the paddies, to have a hired man and woman perform the sex act. Both kinds of ceremony, symbolic and actual, represent an attempt to employ human sexual fertility to insure crop fertility.

Marital relations of the distant past are very revealing. In the most primitive society it is likely that a matriarchal system of domestic life based on the relation between mother and child prevailed. Later, the governing powers passed into the hands of men, and a patriarchal system was established. Nonetheless, it was still the rule for the husband and wife to live separately. Children lived with the mother, not with the father. The house was passed down from mother to daughter. All of this means that women occupied a position of considerable independence in relation to men and that there was practically no difference between the social standings of the sexes. Furthermore, the role of the woman in community productivity was high, since she was important in agriculture, the manufacture of edible salt, and the gathering of shellfish. Her status in this respect may have been left over from the more primitive age when labor was equally divided between the hunting men and the farming and gathering women.

Relations between man and woman began with sex and ended with the separation of mother and child from father. This situation made no clear distinction between romantic love and marriage; it left no room for platonic love divorced from physical relations; and it created circumstances in which relations between man and woman were inevitably both mental and physical. A marital arrangement of this kind reduced the possibility of creating hypocritical taboos about sexual matters. Nothing in later Japanese history resembles the kind of lack of family-oriented morality that must have characterized the situation in which father and mother lived apart and in which not only the man, but the woman as well, unless officially forbidden to do so, could enjoy as many sexual partners as were available.

The patriarchal system—inheritance in the male line—and inequality between the sexes took root first in the aristocracy. In this class a husband might have numerous wives. In the early period no grading of these wives according to seniority or rank was practiced, because it was felt senseless to do so as long as all of the wives lived in their own houses away from their husband. Since chil-

dren lived with their mother, it is unlikely that they developed strong family feelings for half brothers and half sisters by other wives of their fathers or that they could come to regard those other wives as relatives of any kind. No moral strictures existed against marriages between children of the same father by different mothers or between a man's child and any of his wives aside from the child's own mother. In the late nineteenth and early twentieth centuries the Japanese government preached a doctrine to the effect that only the system requiring the bride to live with the husband's family, over which the father exerted absolute control, was the true, pure, Japanese interpretation of marriage and family life. But the foregoing discussion of primitive and ancient Japanese marriage customs should have shown how this doctrine ran counter to the historical facts.

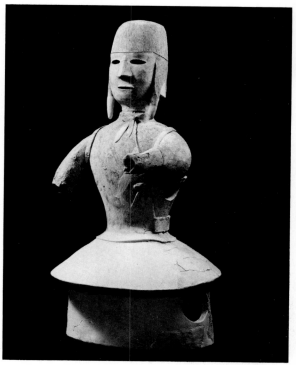

13. Haniwa man with cord for holding up sleeves. Fifth century. *Height, 54.5 cm. Osaka Prefectural Board of Education.*

DAILY LIFE IN THE ANCIENT AGE Obviously, during this period of ancient Japanese history, in contrast with the earlier primitive period of nondifferentiation, class distinctions existed in society. Huge burial mounds for the rich and powerful and humble graves for the poor and lowly were the afterlife consequences of a way of living that dictated raised-floor dwellings for the affluent and pit dwellings for the indigent. It is important to note, however, that the raised-floor building, originally used only for storehouses and for dwellings of the rich, gradually replaced the pit dwelling even for ordinary people.

Though nothing remains of the clothing of the people of the times when the great burial tumuli were raised, fortunately the clay figurines, called *haniwa*, which were set around the grave mounds of the rich, tell something about the appearance of men and women of at least the higher levels of society (Fig. 13). The *haniwa* show that both men and women wore a kind of robe on the upper part of the body. Women wore skirts and men baggy trousers that looked rather like a skirt. The common people may have worn a kind of poncho made of a single sheet of cloth with a central hole

for the head, but no details about this garment are available. The two-piece costume of both sexes as represented in the *haniwa* suggests that the one-piece kimono, which in time became a virtual trademark of the Japanese way of life, was a later historical product created by new and different social conditions.

TUMULUS ART The objects on which the ruling class of the Tumulus period lavished its resources and time were the great burial mounds from which the age takes its name (Figs. 5, 14). Today these mounds resemble hills, the sides of which are covered with grass and trees. But such was not their original appearance. When first raised, the mounds were faced with stone paving, and rings of cylindrical

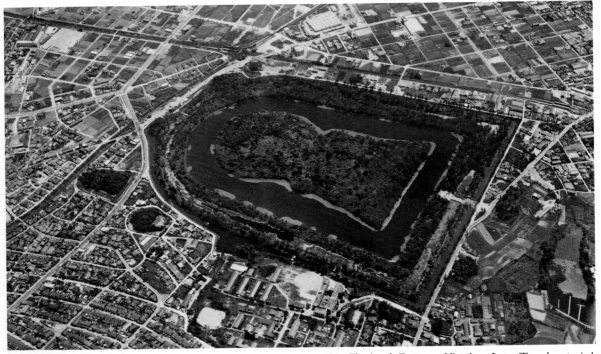

14. *Tomb of Emperor Nintoku. Late Tumulus period. Overall length of enclosure, 1000 m. Sakai, Osaka Prefecture.*

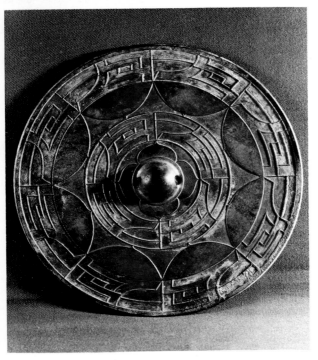

15. *Bronze mirror decorated with* chokkomon *pattern (intersecting curved and diagonal lines). Early Tumulus period. Diameter, 28 cm. Niiyama Tomb, Koryo, Nara Prefecture. Imperial Household Agency.*

clay figures, the famous *haniwa,* were lined up at about the middle level of the sides. To modern eyes the initial style of the mounds appears grotesque. Certainly there is no need to regard the mound in its entirety as a work of art.

The *haniwa* used on the sides of the tumuli, however, do have artistic merit. It seems that the more elaborate *haniwa* all evolved from simple baked-clay cylinders that were thrust into the sloping sides of the mounds to prevent soil slippage. Later, however, the cylinders were replaced by figures representing the funeral cortege or objects, people, and animals that had been important in the life of the deceased. Although in aesthetic terms the *haniwa* are less impressive than the wooden and metal sculpture later introduced from China, they have their own distinctive value. Their material is simple unglazed clay, but they have a rustic beauty—especially apparent in the eyes of some of the human and animal figures. They are a rich source of information about the ways of life of the people of the period during which they were produced.

It remains to mention some of the graphic evidence surviving from the Tumulus period. Relief carvings on the backs of bronze mirrors uncovered from the burial mounds (Fig. 15) show hunting and the houses of the times. Paintings and engravings on the stone antechamber walls of some of the tombs show groups of human beings and animals and probably represent the attempts of people of the late Tumulus period to offer magical protection to the dead. Tomb-picture subjects include circles, bracken forms, shields, quivers, arrows, horses, human beings, a bird on the prow of a boat, a man about to seize the mouth of a strange animal, toads, and so on. Some of the pictures may represent mythological subjects. These paintings and engravings, forerunners of a later branch of art to be imported together with Buddhist culture, decorate tomb chambers of a kind found mostly in Kyushu and are thought to be the result of influence from the Korean kingdom of Koryo, in sites associated with which similar decorated tombs are found. A few tombs of the same kind are located in eastern Japan as well.

Although there are no architectural remains from the Tumulus period, *haniwa* miniatures of houses, together with representations on the backs of bronze mirrors, offer some information about the shapes of dwellings and storehouses. The main halls of the Izumo, Sumiyoshi, and Ise shrines (Fig. 7) preserve the most refined and highly developed styles of raised-floor storehouse architecture.

CHAPTER THREE

The Age of the Penal and Administrative Codes

THE ESTABLISHMENT OF THE CODES Under the ancient system of rulership, such ambitious ventures as military expeditions to Korea resulted in a loose unification of various small groups subject to the political control of the Yamato clan. As time passed, the authority of the Yamato lord gradually expanded, and the number of districts directly under his control throughout the nation increased. The aristocrats subservient to him assumed the duties of government officials. In the sixth century some of the land under direct Yamato control was farmed by laborers belonging to a guild called *tabe,* and a census is thought to have been attempted. This set of circumstances suggests the formation of historical grounds for a later system by means of which the central government controlled land and distributed it as seemed suitable.

On the international scene the kingdom of Silla, which had a strong nationalistic awareness, resisted the Japanese presence on the Korean peninsula and completely destroyed the Japanese holdings there in 562. In China, in the sixth century, the Sui dynasty (589–618) healed the breach between the north and the south and established a powerful court. In the early seventh century the T'ang dynasty (618–907) further expanded the boundaries of the nation. China then became one of the most brilliant and powerful empires in the world.

Defeat in Korea and the unification and power of China strongly impressed on the Yamato court the need to put its domestic affairs in order by means of intensified centralization of authority. In the early seventh century, Prince Shotoku (574–622), who served as regent (*sessho*), took important steps toward such centralization. Although the biographies of this outstanding man are such complicated minglings of fact and fancy that it is difficult to know what is true and what is false in them, he undeniably founded a twelve-rank court system that contributed to a legalistic organization of officials in the Chinese fashion. As set up by the prince, this system was a radical departure from the system of hereditary clan posts employed earlier. Appointment to the twelve court ranks—each distinguished by the color of the cap its holder was permitted to wear—was based on the merits of the individual. Furthermore, although some people now claim that he had nothing to do with its authorship, Prince Shotoku is said to have issued in 604 what is called the Constitution of Seventeen Articles, a set of moral and political principles in which supreme authority was claimed for the Yamato lord, to whom all aristocrats were required to be obedient.

Traditionally it is believed that the title *tenno*, or heavenly emperor, for the ruler of Japan (a title derived from the Chinese notion of the ruler who possessed the mandate of heaven) and the name Nihon (or Nippon) for the Japanese nation were first employed either at the time when this constitution was promulgated or shortly thereafter.

Borrowings from continental culture had prepared the way for the establishment of the emperor system of government in Japan, and the case was very similar in regard to the centralization of authority. Stimulated directly by a unified Chinese court, the Japanese grew ever more eager to learn. For this reason, Prince Shotoku launched a campaign of cultural importations. In 607 he sent Ono no Imoko as envoy to the Sui court, and in the following year he dispatched a group of eager and diligent students and monks. Whereas in the past the Japanese had learned largely from gifts received in return for tribute to the Chinese court, from gifts presented by the Korean kingdom, or from Korean artisans sent as tribute to Japan, after Prince Shotoku began to send envoys to the continent the entire program of cultural borrowings became more vigorous and active. In 660 the kingdom of Kudara (Paekche), the only remaining point of support for Japanese power on the Korean peninsula, was overthrown by the combined efforts of Silla and the T'ang dynasty, but this did nothing to halt Japanese cultural importations. Nor did it sever communications among Japan, Silla, and T'ang China. Japanese envoys continued to travel to China until the end of the ninth century, shortly before the fall of the T'ang. Envoys to Silla continued from 727 until the tenth century, and connections were established between Japan and the state of P'o-hai in Manchuria. All of these relations contributed to an influx of continental culture into Japan.

In 645, the first year of the Chinese-style year period called Taika, Naka no Oe (an imperial prince who later reigned under the name Tenchi) and Nakatomo no Kamatari proclaimed the establishment of a governmental structure based on the legal codes of China. Later, after the succession war of 672, when the emperor Temmu ascended the throne, the power of the imperial government was further strengthened, and a number of legal codes—including the Kiyomihara Code, the Taiho Code, and the Yoro Code—were promulgated. The governmental structure of the nation was then firmly based on a system of penal (*ritsu*) and administrative (*ryo*) codes.

Briefly put, the aim of the penal and administrative codes—which, as has been said, were based on Chinese patterns—was to do away with the old system of private hereditary landholdings by aristocratic families and to replace it with a system under which all ruling power was concentrated in the hands of the central government. This meant that the positions of the old aristocrats were altered: they continued to control lands, but now in the capacity of government officials. In other words, the hereditary landholding privileges of this class were adapted to fit the framework of a legalistic central government. The class structure of the old system of rule by clans remained basically unreformed. Indeed, centralization of power may have increased the governing strength of the aristocracy.

The government, which theoretically owned all land, distributed it in parcels to the common people for agricultural cultivation. In return, the people were responsible for payment of taxes in produce, textiles, and other commodities as well as for corvée labor and military conscription. Of course, taxes were a great burden, but such physical-labor responsibilities as the corvée had the effect of converting even the so-called free and ordinary citizens into something like slaves.

As a leftover from the period of clan rule, in this period there existed a serflike class whose members could be bought and sold as chattels. This class accounted for a small percentage of the total population in the age of the penal and administrative codes, and its mere existence is insufficient to justify accusing the government of condoning slavery on a full scale. Still, the presence of such a class, in combination with the compulsory and heavy corvée burden on the ordinary citizenry, makes it possible to say that a kind of slavery characterized the policies of the

government. This slavery, of course, was a very different thing from the classical institution that existed in ancient Greece and Rome.

In order to understand fully the great heights reached by the culture of Japan in the age of the penal and administrative codes, it is essential to bear in mind the sources of both materials and labor. Without the massive labor force and wealth forcibly concentrated under conditions of servitude by a strong central government, the architectural and artistic brilliance of the age would have been impossible. Because of its reliance on concentrated wealth and labor, however, the culture of the period was unable to maintain its great heights in the face of weakening authority. Thus, in the following period, the culture and the governing system were to take unusual turns. This is true not only of Japan in the age of the penal and administrative codes but also of all other ancient civilizations that relied for strength and growth on the sacrifices of their people.

The power of the Japanese government in this age reached its zenith under the emperor Temmu (reigned 673–86) and the empress Jito (reigned 690–97). In the eighth century the people began to rebel against the heavy loads they had been forced to bear. The ruling classes found themselves facing serious insecurity and agitation. So far, however, no new class power had formed to threaten the old rulers, and the governing structure, under the penal and administrative codes, was in no danger. The great city-building and architectural achievements of the period bear witness to its still firm control.

In 710 the capital was moved from Fujiwara, the place that had served under the empress Jito, to a new city, Heijo (modern Nara), which was patterned after the T'ang capital Ch'ang-an. Temples and a splendid large-scale palace adorned the new city. Under the emperor Shomu, who was especially noted for his religious devotion, a series of provincial temples called *kokubunji* were built throughout the land. The immense monastery-temple called the Todai-ji was completed in the capital to serve as a kind of national religious headquarters. All of the architectural and en-

gineering tasks associated with these projects were costly and risky. None of them could have been accomplished if the government had failed to enjoy full control of the nation's resources. It is thus clear that much of the building done in the first half of the age of the legal codes was devoted to Buddhism. To understand why this is true it is important to examine Japanese attitudes toward Buddhism from the time of Prince Shotoku to that of the emperor Shomu.

THE IMPORTING OF CONTINENTAL SPIRITUAL CULTURE In much earlier times, Japanese imports from the Asian mainland had consisted primarily of production tools, weapons, and highly admired luxury craft items. Significant nonmaterial, cultural importations came later. For example, it was not until the fifth century that the Japanese, who formerly had no writing system at all, adopted the Chinese system of ideograms. The initial domestic application of this writing system consisted of no more than copying Chinese characters from imported bronze mirrors for use in inscriptions on locally produced mirrors. (Two such mirrors are the one excavated from the Higo Eta burial mound and dated 430 and another in the possession of the Kii Suda Hachiman Shrine, tentatively dated 443.) Still later, Chinese characters were used in actual writing, but for some time they were employed only by official recorders (*fuhitobe*, or *fubitobe*), who were generally natives of the Asian mainland. Knowledge of continental learning and religion had not yet penetrated even to the ruling class, let alone to the common people.

The arrival from Korea, in the sixth century, of doctors of the Confucian classics (*gokyo hakase*), together with later Korean gifts of Buddhist images to the Japanese court, marked the beginning of the import of spiritual elements of continental culture. But this aspect of Asian civilization was not to bear fruit in Japan until the seventh century and the achievements of Prince Shotoku.

As we have already noted, Prince Shotoku instituted a system of twelve court ranks. The names of the ranks derived from the Confucian virtues:

Greater Virtue, Lesser Virtue, Greater Benevolence, Lesser Benevolence, Greater Propriety, Lesser Propriety, Greater Sincerity, Lesser Sincerity, Greater Integrity, Lesser Integrity, Greater Wisdom, and Lesser Wisdom. The idea of distinguishing ranks by the colors of caps was based on the Chinese concept of five natural universal elements. In general, the whole plan of the court ranks would have been impossible without an understanding of Chinese philosophy. The Constitution of Seventeen Articles includes numerous quotations from the Confucian, Legalist, and Taoist classics. Even if these quotations were taken from secondary sources, they nonetheless bespeak Japanese erudition in Chinese learning.

Prince Shotoku was deeply interested in Buddhist teachings. He built many Buddhist temples and devoted much time to research in Buddhist studies. In contrast with most Japanese, who adopted Buddhism for its supposed magical powers in preventing misfortune and bringing good luck, Prince Shotoku, at least in his late years, had an accurate understanding of the true meaning of Buddhist teachings. In the nunnery Chugu-ji, attached to the temple Horyu-ji, outside the city of Nara, is preserved a piece of embroidery said to have been made at the command of the consort of Prince Shotoku. The inscription on the work is something that the prince is supposed to have told his wife: "The world is folly. Only the Buddha is true." Such rejection of the actual world is an idea completely foreign to earlier Japanese thought. Indeed, the knowledge of the emptiness of the world's search for a higher life is a notion introduced into Japan with Buddhism.

Prince Shotoku is said to have studied and annotated three Buddhist sutras: the *Vimalakirti Sutra*, the *Queen Srimala Sutra*, and the *Lotus Sutra*. An extant commentary on these three sutras is traditionally said to be the work of the prince, but today some people doubt the accuracy of this attribution. Nonetheless, even if the commentaries are not his work, the words that he left and those that have been preserved in the Chugu-ji embroidery are enough to show that Prince Shotoku was a revolutionary figure in the history of Japanese thought. Greek philosophy is said to have begun with Thales of Miletus; Chinese philosophy is said to have begun with Confucius; and Japanese philosophy may certainly be said to have begun with Prince Shotoku.

But in this he stood apart from his time. Although the Taika Reforms of 646 were a kind of fruition of his efforts in the field of politics, his Buddhist thought was unrelated to the general awareness of the Japanese people. In the realm of material achievements, the temple buildings undertaken by the prince were to have a formative influence on the immediate future of Japanese Buddhist development, but it would be centuries before his understanding of the teachings of Buddhism would be appreciated.

When first introduced into Japan, the Buddha was regarded by the people as a foreign *kami*, the word employed in the indigenous ethnic religion for any of the innumerable supposedly divine presences in the universe. The people of the sixth and seventh centuries regarded the new religion as a kind of magic, just as many Buddhists in Japan continue to regard it today. In this respect the popular attitude toward Buddhism did not differ from the popular attitude toward the indigenous religion. In both cases the people were eager to take advantage of supernatural powers for the sake of curing illness, averting disaster, and procuring blessings and the good things of this life. Thus, in the light of their approach to religion, it was only natural for them to pray for such blessings simultaneously at Shinto shrines and Buddhist temples. Records surviving from the seventh and eighth centuries show a large number of instances of such double invocations. For the people, Buddhism did not differ from the older ethnic religion; both were considered magical rituals for insuring good and avoiding ill.

In the earliest years of its Japanese application, Buddhism was largely a private religion for such aristocratic families as the Soga. Somewhat later, as the time of the Taika Reforms approached, it spread to reach a wider audience. The emperor Jomei and his court constructed a temple known as the Kudara Dai-ji (Great Temple of Paekche).

The emperor Temmu relocated this temple and built what was called the Daikan Dai-ji (Great Official Temple) and the Yakushi-ji, the temple of the Healing Buddha, Yakushi (Bhaisajyaguru). In general, the government expended prodigious energy to assure the flourishing of the Buddhist faith, and Temmu, in addition to his temple-building projects, ordered public readings of the *Sutra of the Golden Light*.

Efforts in the name of Buddhism reached a pinnacle in the reign of Emperor Shomu (724–49). In 741 this diligent and devout man ordered the building of the previously noted *kokubunji*. These provincial temples were devoted to the protection of the nation as promised in the *Sutra of the Golden Light*. It was also Shomu who sponsored the building of the vast monastery-temple Todai-ji in Nara and the enshrining in its main hall of a colossal gilt-bronze statue of the Buddha Vairocana (in Japanese, Birushana). So ardent was Shomu in the Buddhist faith that he prostrated himself before the great statue of the Buddha, whose slave he declared himself to be. Protection of the nation through magical means was clearly the major motive in all this fervent attention, and the *Sutra of the Golden Light* was therefore a great favorite with the emperor and his supporters, for it promises that the Four Celestial Guardians will protect the monarch who rules properly.

Although prayers for personal help were conducted, they were secondary in importance to the desire for protection of the nation as a whole. This desire led the court to an almost unnatural fervor for the magical properties of Buddhism. But no consideration was taken of the fundamental aim of Buddhism: the search for the way to enlightenment concerning the true nature of the universe. In later centuries, religious groups accustomed to taking a servile attitude toward central authority have argued that emphasis on the protection of the nation in Japanese Buddhism was praiseworthy. It must be remembered, however, that this approach was totally unrelated to the fundamental Buddhist aim of cultivating the individual human being with the ultimate goal of the attainment of Buddhahood. It was,

instead, no more than servility in the face of power. Since the nation could be equated with the emperor, who was the central holder of power, and with his government, protection of the nation was in a sense equivalent to magical protection of the system based on the penal and administrative codes. These codes, as we have seen, gave rise in Japan to a kind of slavery. In other words, a religion devoted to the protection of the codes countenanced class distinctions, and such a religion ran counter to the fundamental Buddhist teaching of equality arising from the Buddha nature in all human beings.

In the period under discussion, Buddhist priests were not free to teach the Buddhist way as they saw fit. Socially, they were on a par with government officials, and the clerical network in control of Buddhist affairs throughout the country was composed of government-appointed officers. Without government permission, people were forbidden to enter the priesthood. Priests were not subject to conscription, but all of their actions were strictly prescribed by legislation.

In both the Taiho and the Yoro legal codes are sections called *soni ryo*—that is, regulations dealing with monks and nuns. They are filled with prohibitions, the most noteworthy of which is the forbidding of monks and nuns to hold religious ceremonies outside of officially recognized temples or to cause people to congregate for religious purposes. Obviously, the legalist government expected only a single benefit from Buddhism: protection of the governing organization. Moreover, the people in power realized that the spread of Buddhism could generate an antiestablishment movement. The pressure applied to the famous priest Gyogi (668–749) when he took it upon himself to go about preaching Buddhism to the people gives an indication of religious conditions under the government based on the penal and administrative codes.

Given its social role and its importance to the protection of the governmental establishment, it is not surprising that the Japanese Buddhism of this age produced nothing noteworthy in the line of philosophical thought. As a consequence of

contacts with the continent in general and with T'ang China in particular, almost all of the Buddhist scriptures were imported into Japan at this time. Many sutras and treatises were copied, and the reading aloud of sutras, treatises, laws, and other Buddhist documents was considered a way of obtaining merit through virtue. Such readings, as well as other Buddhist ceremonies, were often conducted at court, but all performances of the kind were only magical acts for the sake of temporal blessings. None of them dealt with the meanings of the scriptures for their own sake.

It is true that priests of the six Nara sects—Sanron, Hosso, Kusha, Jojitsu, Ritsu, and Kegon—as well as those of the Nirvana sect, perused and studied the scriptures. The results of their scholarly labors, however, never went beyond the walls of their studies. Their knowledge was entirely literary and bore no relation to any popular faith.

In later centuries Buddhist sects were to split apart into sometimes sharply opposed, isolated entities. But in the age of the penal and administrative codes there were no factions, and many different sects might be served by a single temple.

BUDDHIST ART OF THE ASUKA, HAKUHO, AND TEMPYO PERIODS

Because it functioned largely as a means of protecting the authority of the state, Buddhism during the age of the legal codes produced very little significant religious philosophy. For exactly the same reason, however, it was able to sponsor the creation of a brilliant material culture that accounts for its importance in Japanese history.

To the people of these times, Buddhism, like the indigenous ethnic religion, was magical, but the demands imposed by the ceremonies of the two were very different. Buddhism was much the more demanding. From the outset, the ruling class of Japan imported Buddhism as one part of continental culture. The members of this class regarded the production of vast and impressive monasteries and temples, exquisite Buddhist sculpture, and other appurtenances of worship as expressions of religious faith. The movement to sponsor the prosperity of Buddhism in Japan automatically meant progress in the transplantation and cultivation of Buddhist art on a large scale.

In later history Buddhism was to lose all social roles in Japanese life except those related to funerals and masses for the dead. When this happened, temples became gloomy, somber places. But such was not the case in the age of the codes. In the Hakuho (646–710) and Tempyo (710–94) periods the powerful people of the nation devoted great labor and wealth to making Buddhist temples centers of imported culture. The moral philosopher Tetsuro Watsuji (1889–1960) has made a number of interesting observations about the impact that Buddhist temples must have had on the people of these times. He speculates on the feelings the great monasteries must have inspired in the hearts of Japanese who had long been accustomed to mountains and fields and small, humble buildings. He writes of the upward-reaching structures, the melodic lines of the roofs of the temples seemingly suspended between heaven and earth, and the brilliant contrast between red-painted wooden structural members and white plastered walls. As he points out, the people must have been awed to enter great main halls and to find in the shadowy interior spaces, under roofs supported by massive pillars, Buddhist statues with gently curving and swelling arms and shoulders, flowing garments, and serene, merciful countenances. Watsuji goes on to say that the statues must have seemed to be realizations of the eternal Buddha and that the aesthetic appeal of such works for the people of the time is easy to understand. Finally, he remarks that the artistic appeal was certainly one of the inspiring forces behind the drive for the prosperity of Buddhism in Japan and that it is impossible to understand the art and culture of those times without taking into consideration the importance of such aesthetic appeal. Although his approach is that of a poetic imagination that fails to take into account the social foundations on which the culture and art of the times rested, Watsuji nonetheless accurately states the cultural significance of temples to Japan in the seventh and eighth centuries.

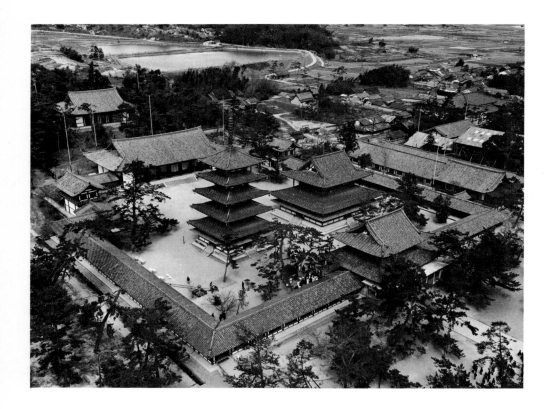

Japanese Buddhist temples were concentrations of continental cultural elements: architecture with its soaring tile roofs, red-painted posts, and complicated bracketing systems under the eaves; refined and elegant sculpture in bronze and dry lacquer; brilliantly colored paintings; elaborately wrought ritual objects; and beautiful craft articles of many kinds. On festival days, temple compounds became the scenes of musical and dancing performances, the strange instruments and grotesque masks of which must have seemed the height of the exotic. Though a privileged right of the ruling class only, Buddhism nonetheless inspired the ordinary people, who formerly had known nothing but simple Yayoi-style ceramics, *haniwa* figures, and colored paintings in tomb chambers, to learn the venerable sculptural and painting techniques of the Asian continent.

The first full-scale Japanese Buddhist temple

was the Hoko-ji, or Asuka-dera, as it is more popularly known. This institution, sponsored by the Soga family, was built by tilemakers, architects, and artists from the Korean kingdom of Paekche and completed in the early years of the seventh century. The sculptor Kuratsukuri no Tori, who was of an immigrant family, created a large bronze statue of Sakyamuni (in Japanese, Shaka), the historical Buddha, for this temple. Although it has been very badly damaged, the statue survives today in Asuka, Nara Prefecture. Recent excavations and investigations in the vicinity of the Asuka-dera site have shown that the temple had three golden halls (*kondo*) arranged around a pagoda. Definite knowledge of the founding date of the Asuka-dera makes it possible to call this temple a representative achievement of Japanese Buddhist culture in the first half of the seventh century. Unfortunately, however, the

◁ 16. *Aerial view of Horyu-ji. Late seventh century. Ikaruga, Nara Prefecture.*

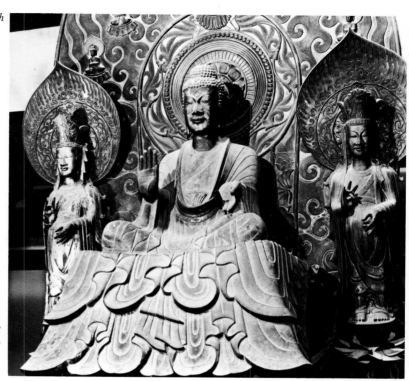

17. *Shaka Triad, by Tori. 623. Bronze; height of Shaka Buddha, 86.3 cm.; height of attendants, approximately 91 cm. Golden Hall, Horyu-ji, Ikaruga, Nara Prefecture.*

only piece of material evidence remaining from the temple is the battered and often repaired statue of Sakyamuni.

The most important surviving examples of Asuka-period art are to be found at the temple Horyu-ji, located near the city of Nara (Figs. 8, 16). The Golden Hall, Pagoda, Middle Gate (Chumon), and part of the corridor surrounding the western compound of the temple preserve such significant stylistic traits as marked entasis in the posts, modified gammadion patterns on the balustrade rails, and so-called cloud brackets. These stylistic traits are not be be found in the architecture of the succeeding Hakuho period and would seem to prove that the Horyu-ji is an Asuka-period temple. For a long time, however, dispute has raged over the actual building date. Documentary evidence claims that the temple was founded by Prince Shotoku, but the *Nihon Shoki*

claims that it burned completely in 670. In recent years, it has been shown that an older temple compound existed at a place slightly removed from the present Horyu-ji. It now seems indisputable that this older site (that of a temple called the Wakakusa-dera) was the location of the temple actually founded by Prince Shotoku and that the present Horyu-ji is a reconstruction made after the fire of 670. Furthermore, it seems that the general architectural style of the Horyu-ji is considerably later than that of the Asuka period.

The bronze sculptural group of Sakyamuni and two attendants in the Golden Hall of the Horyu-ji (Fig. 17) is said to have been made in supplication for the repose of the soul of Prince Shotoku in 623. The archaic smiles, antique solemnity, stylized robes, and unrealistic appearance of the figures are characteristics inherited by Asuka-period Japanese sculpture from the sculpture of the

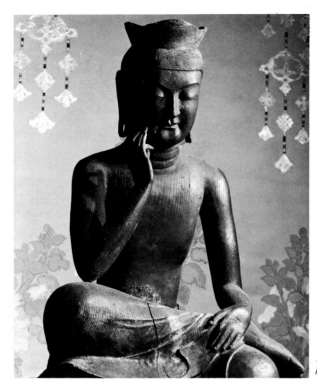

18. Miroku Bosatsu. First half of seventh century. Wood; height, 123.5 cm. Koryu-ji, Kyoto.

Chinese Northern Wei (386–534). The same traits are to be found in the so-called Kudara Kannon, now housed in the museum adjacent to the west compound of the Horyu-ji, and in the Yumedono (Dream Hall) Kannon in the east compound of the same temple. Two famous statues said to represent the Bodhisattva Maitreya (in Japanese, Miroku), both seated in the position called "royal ease" (one foot lifted to the knee of the other leg), show the transition from the style of the Asuka period to that of the following Hakuho period. In these works the severity and stiffness of the older style are lacking. One of the two statues is at the Koryu-ji, in Kyoto (Fig. 18). The other—the more famous—is in the nunnery Chugu-ji at the Horyu-ji. The only examples of pictorial art surviving from the Asuka period are the illustrations of the Sacrifice for a Stanza episode in the life of the Buddha Sakyamuni and

the embroidered tapestry commissioned by Prince Shotoku's consort after his death. The painted illustrations are executed in a technique known as *mitsuda-e*, which employed oxide of lead suspended in oil. They decorate the wooden panels of a small interior shrine called the Tamamushi-zushi. The embroidered tapestry is a fanciful representation of life in the Buddhist paradise.

The art period following the Asuka is called the Hakuho. Although there is no imperial-reign period designated by this title, it has become customary to refer to the style completed between the late seventh and the early eighth centuries as Hakuho.

The most outstanding surviving examples of the art of the Hakuho period are the three-storied East Pagoda and the Buddhist sculpture of the temple Yakushi-ji. Since the Yakushi-ji was originally built at Asuka and was moved to

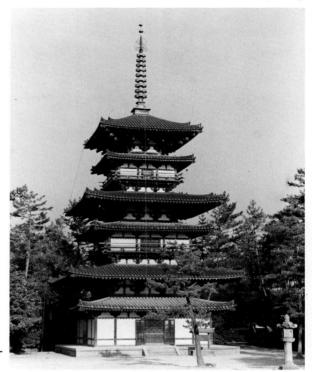

19. *East Pagoda of Yakushi-ji. 730. Height, 34.14 m.; dimensions of first story, 10.52 m. by 10.52 m. Nara.*

its present location when the capital was transferred to Heijo (Nara), scholars are divided on the dating of its architecture and sculpture. Some argue that the works were made for the original temple and moved to the present site later. Others insist that they were produced for the Yakushi-ji after it was moved to its present location.

No matter which interpretation is correct, the works of art at the Yakushi-ji may be regarded as representing the phase of transition between the style of the Asuka period and that of the later Tempyo period. In both the architecture and the sculpture one may see a moving away from the models of China when it was under the rule of northern and southern dynasties (317–589) and a tendency to learn from the works of the early T'ang dynasty. The famous three-storied East Pagoda of the Yakushi-ji (Fig. 19) appears to have six stories because of the addition of sub-

sidiary roofs and projecting sections. (The roof and the projection are called *mokoshi* in Japanese.) The alternation of projecting and receding lines in this beautiful building produces a sense of rhythmic grace that justifies the use of the famous phrase ''frozen music'' in connection with it.

In the Golden Hall of the temple is the Yakushi Triad, a bronze sculptural group comprising the Buddha Yakushi (Bhaisajyaguru) and attendants known as the Moonlight and Sunlight Bodhisattvas (Figs. 9, 20). In the Toindo, or East Precinct Hall, is a bronze statue known as the Sho Kannon (Sacred Kannon). Although it is possible, in these works, to see traces of the older styles in the treatment of the garments, generally the bodies and faces are realistically rendered, and the flesh is more richly modeled and more fully apparent under the clinging draperies. These statues clearly reveal the influence of Gupta Indian art as

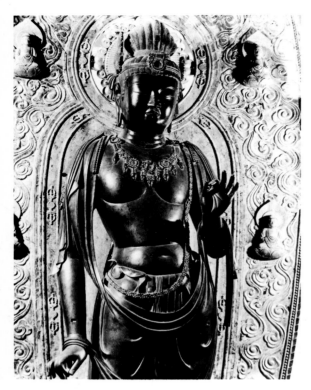 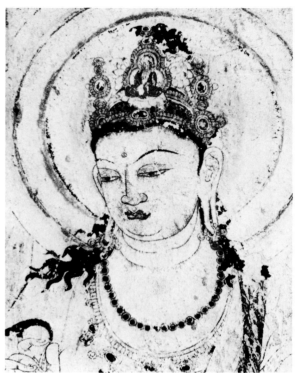

transmitted through the kind of T'ang style seen in works remaining in the temple Hokei-ji.

The oldest surviving Japanese Buddhist paintings and some of the great monuments of world art were the murals that once adorned the walls of the Golden Hall of the Horyu-ji (Fig. 21). Usually assigned to the Hakuho period, these pictures had firm outlines (the so-called iron line) and colors that linked them with the murals of the cave temples of Ajanta. Unfortunately, the Horyu-ji murals were extensively damaged by fire in 1949.

Because it had reached a pinnacle of power and affluence at this time, the ruling class of the Hakuho period was able to sponsor the production of works of art that are more vigorous and wholesome than those of the succeeding age. The Buddha head (originally a part of the main image at a temple called the Yamada-dera) now

in the museum of the temple Kofuku-ji in Nara is a beautiful childlike representation that symbolizes the excellence of works of Hakuho art (Fig. 22).

A colored mural painting of four ladies of high court rank was discovered in 1972 at the Takamatsu burial mound in Nara Prefecture (Fig. 6). It is the first survivor of a long series of Japanese secular paintings. The now sadly damaged murals of the Horyu-ji Golden Hall occupy a position in relation to Japanese Buddhist painting comparable to that of the four ladies in relation to nonreligious painting.

The majority of the outstanding works of art of the Tempyo period were produced during the reign of the emperor Shomu (724–49). Since very few pieces of truly first-rate quality survive, it is difficult to make a fair judgment of the art of this age. The main hall (Great Buddha Hall) of the

20. (opposite page, left). Gakko Bosatsu (Moonlight Bodhisattva) of Yakushi Triad, Golden Hall, Yakushi-ji. Second half of seventh century. Bronze; height, 315.3 cm. Nara.

21. (opposite page, right). Kannon Bosatsu: detail from mural depicting the Paradise of Amida on west wall (Panel 6) of Golden Hall, Horyu-ji. Around 700; destroyed by fire in 1949. Overall dimensions of mural: height, 260 cm.; width, 313 cm. Ikaruga, Nara Prefecture.

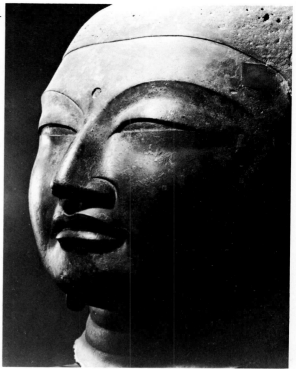

22. Head of Yakushi Nyorai (originally principal image of the Yamada-dera). 685. Bronze; height, 97.3 cm. Kofuku-ji, Nara.

temple Todai-ji and its colossal statue of the Buddha Vairocana ought to be major achievements of Shomu's reign, but they have been damaged and repaired so often that little remains of their original forms. Two fine examples of Tempyo architecture survive: the Golden Hall of the Nara temple Toshodai-ji, where the great Chinese priest who is best known by his Japanese name, Ganjin, resided, and the Hokkedo (also known as the Sangatsudo) at the Todai-ji. The Toshodai-ji Golden Hall (Fig. 23) has an open-front colonnade that recalls the appearance of classical Greek temples. Among the sculptural masterpieces of the age are the following: the Shukongojin (or Shikkongo Shin; Fig. 24) and the Sunlight and Moonlight Bodhisattvas in the Hokkedo of the Todai-ji, the Four Celestial Guardians in the Kaidan-in (Ordination Hall) of the Todai-ji, the Twelve Godly Generals at the Shin Yakushi-ji,

and the statues of the Eight Supernatural Guardians (Fig. 10) and the Ten Great Disciples at the Kofuku-ji. All of these pieces represent the realistic style of the mature T'ang.

The realism of the Tempyo period is not startling; it is a successful combination of realistic detail with spiritual content. In contrast with the boldness and wholesome vigor of the work of the Hakuho period, however, sculpture of the Tempyo shows a nervous concern with detail. It is almost as if it were reflecting the intensifying contradictions inherent in the penal and administrative codes of the governmental system on which the society of the time was based.

Two extraordinarily notable surviving examples of the cultural achievements of the Tempyo period are the Lecture Hall of the Toshodai-ji and the collection of personal belongings of the emperor Shomu housed in the Shoso-in repository of the

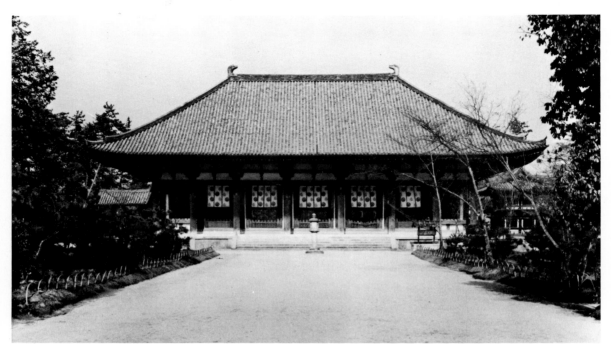

23. *Portico of Golden Hall, Toshodai-ji. Second half of eighth century. Frontage of Golden Hall, 28 m. Nara.*

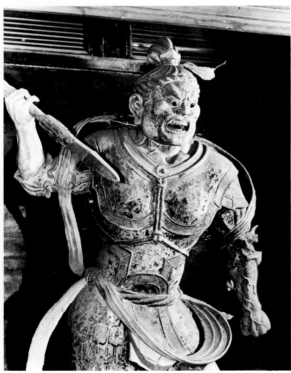

24. *Shikkongo Shin. About 733. Painted clay; height, 167.5 cm. Sangatsudo (Hokkedo), Todai-ji, Nara.*

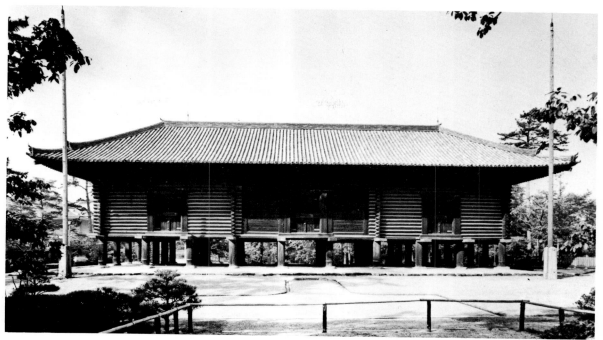

25. Shoso-in. About 756. Height, 14.24 m.; length, 33 m. Todai-ji, Nara.

26. Box with hexagonal pattern and gold- and silver-leaf flowers: container for go board. Eighth century. Wood; height, 15.6 cm.; length, 53 cm.; width 53.5 cm. Shoso-in, Todai-ji, Nara.

Todai-ji (Fig. 25) The Toshodai-ji Lecture Hall is especially interesting as a piece of secular architecture. Originally it stood in a palace in the capital city of Heijo. The collection of personal objects of the emperor Shomu represents art and craft trends from many parts of the world in the seventh and eighth centuries (Fig. 26).

It is important to recall that the Buddhist culture of this time—a culture whose Japanese manifestations have been sketchily described in the preceding pages—had virtually the whole known world for a background. Influences from many lands are to be found not only in large works but also in the smallest details as well. For instance, the scroll pattern called *rindo karakusa,* found in many Asuka-period craft items, is seen not only in the Yunkang cave temples in China but also in the honeysuckle pattern found in Turkestan, Gandhara, Sassanian Persia, the Saracen world, and as far afield as the Eastern Roman Empire. This pattern, which originated in Egypt and Assyria and passed to Greece, is one example of worldwide diffusion of a given decorative element.

During the Tempyo period, imported dances and music were performed together with traditional Japanese dances at palace entertainments and during temple ceremonials. Although there is some doubt as to whether music and dances designated as music from Paekche, music from P'o-hai, or music from Silla were in fact recreations of authentic performances from these places, it is beyond question that this aspect of Japanese culture in the seventh and eighth centuries drew on much of the known world for materials (Fig. 53). As further evidence of the breadth of this cultural background, I might mention the musical instrument called a *kugo* in Japanese and a *k'ung-hou* in Chinese, an example of which is included in the collection of the Shoso-in. The same instrument is to be seen on ancient Assyrian stone reliefs.

T'ang China was one of the great cultural teachers of Japan. The T'ang period was one in which the Chinese engaged in relations with other peoples to a greater extent than at any previous time in their history. China was vast, and people from many lands visited there, bringing with them all kinds of exotic things. It is not surprising that the Japanese envoys traveling to T'ang China to learn should have come into contact with various cultures and should thus have served as the means of indirect transmission of elements from these cultures to Japan. Since people from China, Silla, India, and Persia visited the court of Japan, the Japanese ruling class probably lived in an atmosphere of cosmopolitanism rare in the history of the nation. Only in the comparatively short period when traders and missionaries from Spain and Portugal visited Japan in the sixteenth and seventeenth centuries and then, in the modern period after the Meiji Restoration of 1868, were the Japanese to experience such extensive foreign contacts. An incidental, though interesting, hint that even Christian legend may have been part of the general cultural flux taking place in the seventh and eighth centuries is to be found in a traditional legend about Prince Shotoku himself. Shotoku, or Holy Virtue, is a title bestowed posthumously on the prince. In life he was known as Prince Umayado, or Prince Horse Stable. Indeed, it is related that he was born in front of a stable. Some people think that this may reflect the Christian tradition that Christ was born in a stable. It is known that Nestorian Christians were in the T'ang capital, and it is conceivable that this piece of Christian mythology was transmitted to Japan by way of visitors from China.

Unflagging hunger for cultural exchange was doubtless one of the reasons for the development in the seventh and eighth centuries of a continental culture that remains amazing even today. But even more important is the fact that Buddhist art of that time was more than mere art. Though it may have lacked lofty philosophy, this art was the product of religious enthusiasm. If power and money alone are all that is needed to inspire great art, why were the might and wealth of the seventeenth-century Tokugawa family able to produce nothing better than the mausoleums at Nikko? Undeniably, religious faith was the source of the high-quality art of the Asuka, Hakuho, and Tempyo periods. The emperor

Shomu himself revealed the extent to which such faith could go when, though a Shinto divinity himself, he prostrated himself as a slave before the Three Treasures of Buddhism. Exactly how the aristocrats were able to sponsor the production of magnificent art by using groups of craftsmen who apparently did not merit so much dignity as the title of artist remains an unsolved mystery. But I suspect that the inner aspects of this art, especially in connection with religious faith, may provide a clue.

NEW DEVELOPMENTS IN TRADITIONAL ARTS

It was not merely Buddhist content that accounted for the charm of continental culture. The Japanese ruling class was eager to copy the system that had enabled the Sui and T'ang dynasties to create mighty national states. The compilation of the 1,500-article penal and administrative codes in Japan, a nation previously lacking even customary laws, is an illustration of the force of this desire. Still another illustration is found in the building of a permanent capital on the pattern of Ch'ang-an, the western capital of the T'ang dynasty. In the new capital, Heijo, the Japanese built palaces with continental-style tile roofs and red-painted posts. The officials of the court wore continental-style costumes, and daily life was permeated by objects and influences from China and other parts of the world. The extent to which such things gained prominence can be judged from the immense collection of imported mirrors, swords, gaming boards, screens, and other articles among the personal property of the emperor Shomu stored in the Shoso-in. Even the articles in the Shoso-in collection that are not actually imports from abroad are faithful copies of continental originals. Still, though it was possible to import material things from China, it was impossible to import the social basis for their creation. Consequently, continental influences extended only to such matters as exterior ornamentation for temples and palaces and to the fields of luxurious living and amusement. They failed to generate a profound change in the ways of thinking and living of even the ruling classes.

For example, the buildings for public ceremonies in the palace of the emperor were constructed on continental models. But, judging from the inner quarters (dairi) of the palace in Kyoto (the present building is a scholarly reconstruction built in the nineteenth century), the living area for the emperor had cedar-bark, not tile, roofs and unfinished wooden structural members. That is to say, the living quarters were in a pure, traditional Japanese style. Chinese eating habits never found acceptance in Japan in early times. Furthermore, although government officials were supposed, in principle, to study the Confucian classics and pass examinations to hold office, as was the case in China, many offices held by high-ranking families became hereditary, and only a small number of clerical officials actually mastered Confucian learning. Even these people read the classics more with an eye to literary values than to moral training. Aristocrats and members of the imperial family wrote Chinese-style verse of the kind found in the anthology known as the *Kaifuso*, but in terms of quantity and quality this verse was never on a par with *waka*, or Japanese-style poetry.

If this was all true of the ruling classes, the connections between the population in general and the leisurely and luxurious culture of the continent were still more tenuous. Priests like Gyogi traveled about among the people teaching Buddhism in spite of established governmental objections. It even became customary to form religious organizations to collect meager contributions from the people in order to build temples. Owing to the general poverty of the people, building projects of this kind would have been impossible without such organizations. In these ways the Buddhist faith began to be disseminated among the ordinary people, and, as the ninth-century Yakushi-ji priest Keikai writes in the *Nihon Ryoiki*, the common people came to believe that the Buddha would answer their prayers. This trend was much later to result in popular faith in Buddhism. In the heyday of the govern-

ment of the legal codes, however, cultural aspects of Buddhism played a small part in the religious activities of the masses.

The Japanese borrowed Chinese-style family morals and the paternalistic system, according to which a man could put his wife aside for failure to have children or merely for making him jealous. The Chinese belief that the father, as the head of the house, could punish his children for failures in filial piety was also taken over by the Japanese. But the system could not be fully enforced as long as the marital arrangement in which the husband and wife lived separately persisted. As had been true in earlier periods, relations between men and women remained extremely open. Both parties had to be agreeable for the formation of a marital union. All attempts to forbid what might be described in modern terms as common-law marriages under circumstances of this kind were doomed to failure. The refusal of the Japanese of ancient periods to bend to hypocritical codes of sexual morality indicates their wholesome attitude toward such matters. It was in poetry that they gave most vivid expression to their feelings on love and sex. The famous eighth-century poetry anthology called the *Man'yoshu* is filled with love songs, and Motoori Norinaga considered it a matter of pride that, in comparison with the relative paucity of such poetry in Chinese literature, Japanese poetry is especially rich in love verse. The *Man'yoshu* contains 4,400 poems composed by aristocrats and nameless commoners as well. The very existence of such a large collection of Japanese-style verse proves that in the culture of Japan of the seventh and eighth centuries the old tradition not only managed to survive the influx of continental importation but also was sufficiently strong and deep-rooted to make forward strides. The truth is that Japanese literary and artistic talents surpassed differences between the imported and the indigenous to develop and mature on their own. Meaningful comparisons can be drawn between some of the poems in the *Man'yoshu* and other works of art of the period. The grandeur of the poetry of Kakinomoto no Hitomaro is comparable with the dignified beauty of the Yakushi Triad at the Yakushi-ji. The delicate maturity of the poems of Yamabe no Akahito and Otomo no Yakamochi suggest the same traits as found in the statues of the Four Celestial Guardians in the Kaidan-in of the Todai-ji and the figures of the Eight Supernatural Guardians at the Kofuku-ji.

Some people claim that the historical driving power that made great artistic maturity possible can be traced to the unification of the nation and the ascending social movement of the ancient period. But it seems more likely that the true source is the balance between the opposing forces of tradition and the desire to import new foreign cultural elements on a large scale. The Japanese succeeded in responding to cultural stimuli from abroad while inspiring vital development of their native traditions. The mural paintings that once adorned the walls of the Golden Hall of the Horyu-ji illustrate my meaning. Though these murals employed techniques and styles similar to those seen in the murals in the cave temples of Ajanta, purity and clarity in the Japanese pictures take the place of instinctive richness and abundance in their Indian counterparts. Undeniably, the Japanese-style poetry in the *Man'yoshu* is an example of traditional, indigenous literary art, although even these verses are not without Chinese influence. Obvious Chinese literary elements—the Festival of the Stars and the Taoist hermit—are of relatively little importance, but the form of the poems is a matter of considerable interest. The poems sound irregular when they are heard, but in written form they are immediately seen to be formed of five- and seven-syllable structures, which are patently related to the five- and seven-character structures used in Chinese poetry. The Chinese characters with which the poems are written are irrefutable instances of continental cultural influence.

I have already mentioned the use of Chinese characters in writings by immigrants from the continent in early times. The wide-scale use of the Chinese writing system at a later date was an epoch-making development. When the Japanese adopted the ideograms of the Chinese language,

they followed two borrowing systems. Sometimes they applied Chinese characters to the writing of Japanese words, the meanings of which were utterly unlike those of the characters in their native usage. Sometimes they took the meaning of the character only and pronounced it as if it were a Japanese word. For example, using the Chinese character for the word "mountain," they would pronounce it *yama*, which is the Japanese word for mountain. Even in its Japanese approximation, the Chinese-style pronunciation of the character for mountain is *san*, something quite unlike *yama*. But neither of these borrowing methods was used consistently because of the vast differences between the natures of the Japanese and Chinese languages. Japanese is an agglutinative inflected language with polysyllabic words, whereas Chinese is uninflected and is composed, in the main, of monosyllabic words. The Chinese therefore can, and do, use one character to represent one word, but the Japanese cannot very well do this when they are forced to supply something with which to give written expression to such grammatical equipment as verbal and adjectival endings. It soon became apparent, therefore, that a system of writing employing signs with no fixed meanings but with phonetic values was essential. This was gradually produced in the form of the *kana* syllabaries. Derived from the physical forms of the Chinese ideograms, these systems are used in conjunction with characters. One of the *kana* systems (no longer used) is employed in the *Man'yoshu*. It is called the *man'yo-gana*, and it enabled the Japanese poets to give written expression to literary thoughts. Like Columbus's egg, the *kana* systems seem a simple matter when seen with the advantage of historical hindsight. But they are in fact a classical example of the way the Japanese people have modified things they have incorporated from other cultures.

EARLY HEIAN CULTURE Until the dispatch of emissaries to T'ang-dynasty China was terminated in 894, formal efforts to import continental culture were pursued as before, and governmental functions continued to conform to the general legal structure established earlier. The first part of the Heian period—from the time in 794 when the capital of the nation was transferred to Heian (modern Kyoto) until the late ninth century—can be viewed as part of the age during which society was governed on the basis of the penal and administrative codes, but new tendencies in both government and culture were gaining impetus. One of the most notable changes that occurred at this time had to do with the ownership of land.

Under the system of government based on Chinese-style legal codes, all land belonged to the crown. Ordinary people were allotted plots (*kubunden*) for cultivation, and aristocrats, great religious institutions, and other people and organizations of authority were granted tax-free lands. Gradually such holdings developed into the *shoen*, or manors, which were to become a salient feature of the Japanese system of land tenure. The manors were further augmented by the holdings of peasants who found the tax burden on their land too heavy to bear and who therefore fled, allowing their plots to be swallowed up in the holdings of the wealthy. This kind of passive resistance on the part of the peasantry inevitably led to the dissolution of the Chinese-style system of government by legal codes. In the outlying districts and in the central government, the officials lost power as the Fujiwara clan consolidated its position of authority. This mighty family became hereditary holders of the vitally important position of regents (*sessho*) and first imperial counselors (*kampaku*). The Fujiwara suppressed all who might have been able to give them competition and thus ushered in a period of dictatorial rule on an economic basis supported by the huge incomes from vast manors all over the country. As might be expected, this development in politics and economy led to culture of an increasingly aristocratic coloration.

Two of the most outstanding figures of this period of Japanese history are the monks Saicho (also called Dengyo Daishi, or Dengyo the Great Teacher) and Kukai (also called Kobo Daishi, or Kobo the Great Teacher). Both of these men traveled to China to study Buddhism under the

T'ang dynasty and, upon returning to Japan, established temples and monasteries. Saicho, who studied T'ien-t'ai Buddhism in China, founded the monastery Enryaku-ji on Mount Hiei, near Kyoto. There he and his followers developed Tendai Buddhism, which is the Japanese counterpart of the Chinese T'ien-t'ai. Kukai studied Esoteric Buddhism in China and, upon his return to Japan, established the Shingon sect, which had its main temple first at the Kyo-o-gokoku-ji (popularly the To-ji) in Kyoto and later at the monastery called the Kongobu-ji on Mount Koya in Wakayama Prefecture. Kukai died at the Kongobu-ji. Although both Tendai and Shingon remained at least nominally part of the network of temples devoted to the application of Buddhism for the magical protection of the nation, in two respects they differed vastly from the Buddhism practiced earlier. First, religious faith was the central element around which Shingon and Tendai were organized. Second, in spiritual and economic terms, these two faiths maintained a high degree of independence. Nonetheless, since the time had not yet come when the common people could be brought together in mass religious organizations, both Tendai and Shingon ineluctably sought the protection and regular support of aristocrats. It follows that the major tasks of these religious bodies during the Heian period involved magical means of satisfying the temporal desires of the nobility. Tendai, originally based on the *Lotus Sutra* (Hoke-kyo), came to include a number of Esoteric elements. Tendai and Shingon enjoyed great popularity with the aristocrats, who called on their priests to perform ceremonies of a magical nature supposed to insure that the person sponsoring them would achieve the court promotion he desired or would otherwise profit.

Because of the influences of these two religious sects, Esoteric styles played an important part in the art of the period (in art histories, this period is known as the Jogan age). Representative statues of the age include those of the chief Esoteric Buddha, Dainichi Nyorai (Vairocana), a deity

also notably portrayed in painting (Fig. 11); of the Nyoirin Kannon (Cintamanicakra); of the Five Great Kings of Light (Go Dai Myo-o), with Fudo Myo-o (Acala) at their center; and of the Five Mighty Bodhisattvas (Go Dairiki). Some of these, like Fudo Myo-o and the other Great Kings of Light, are vigorously wrathful in appearance. Perhaps two of the greatest masterpieces of the Esoteric style are the statue of the Nyoirin Kannon at the Kanshin-ji, in Osaka, and the painting of the Yellow Fudo at the Onjo-ji, in Shiga Prefecture. In general, the sculpture of this period is characterized by a more violent psychological force than that of the Tempyo period. Instead of the bronze and dry lacquer used earlier, wood is predominant. Recent research suggests that perhaps statues carved by devout, humble priests for poor chapels and temples were the basis on which refinements were worked to produce the mainstream of sculptural art of the early Heian period. At any rate, statues of the period most often were not produced in official workshops as in the preceding age.

Owing to the lack of large anthologies, few Japanese-style poems of the early Heian period survive. But because of the extent to which Chinese was studied by the official class, Chinese-style prose and poetry were produced in considerable quantity. Collections like the *Ryounshu*, the *Bunka Shureishu*, and the *Keikokushu* can be ranked with the *Kaifuso* of the Nara period. Among the poets of the time were the great priest Kukai himself, Ono no Takamura, and Miyako no Yoshika. In addition to Chinese characters, *kana* syllabaries were beginning to be used in literary works. Indeed, by this time the foundation was already completed for the great literature in *kana* that was to come in the succeeding age.

Recent excavations at the site of the ancient palace at Fujiwara have uncovered a number of plaques bearing inscriptions. Among the writings are some using symbols like those in the *kana* syllabaries. Since Fujiwara was a palace in the Asuka period, the *kana* systems may be much older than has heretofore been supposed.

CHAPTER FOUR

Aristocratic Society

THE CHARACTER OF ARISTOCRATIC SOCIETY

Government by means of legal codes gradually changed into a system of aristocratic rule, and the high-ranking officials of the earlier society became the aristocracy. Indeed, the emergent noble families can be traced back to the clan leaders (*ujikabane*) of much earlier times. For instance, the Fujiwara family was descended from the Nakatomi (Nakatomi no Kamatari was granted the name Fujiwara in 645). The Nakatomi were an ancient clan who later became officials in charge of certain religious functions. Although there were ascents and descents in the fates of individuals involved in the historical changes that occurred in the forms of government, continuity can be seen in the ruling classes of Japan from the time of the unification of the nation and the formation of a government centered on the emperor. In the wide view, then, Japan was under governing systems that shared much in common from the fourth to the twelfth century. But rule by regents and the aristocratic society, which characterizes the Heian period (794–1185), differs from the system prevailing when the legal codes were in full operating force.

Under the old social system the aristocrats acted as officials and were conscious of their important role in politics. Indeed, through politics they maintained contact with the common people. The ways of living of both the peasantry and the nobility shared many common elements from as early as the Yayoi period. The abundance of poems relating the feelings and attitudes of the common people in the *Man'yoshu* amply testifies to the amount of shared experience that existed between the two classes. In the aristocratic society of the Heian period, on the other hand, the top-ranking members of the nobility resigned their political and official duties to underling officials and gave themselves wholly to the celebration of ceremonies and to various cultivated amusements. Lack of any work worthy of the name broke the practical bonds between the court nobles and the common people. Furthermore, although their estates and lands were the economic basis of their existence, the aristocrats lost direct contact with them and with the peasants working them. Residing entirely in the capital, the aristocratic absentee landlords entrusted the management of their properties to stewards and did no more than act as holders of authority to whom it was necessary to send the income from the estates. Middle- and lower-grade noblemen remained on their lands in the provinces and accepted actual responsibility for management. But the higher classes of the aristocracy lived in the capital, where they indulged in luxuries, enjoyed the spring flowers and the autumn moon, and concerned themselves with promotions in court rank and with love affairs. Inevitably, the society of the aristocrats came to consume without producing and enter-

tained very limited views of the other social classes. Until a later time, when peasant culture rose to some prominence, aristocratic life tended to exclude everything associated with farming and labor.

Obviously, since their very livelihood depended on their lands and the cultivation of these lands, the aristocrats could not totally ignore the peasants. Sometimes they turned to farming scenes in their poetry or in the paintings they admired, but they lacked understanding of the joys and sorrows of peasant labor. The farmers and farm images occurring in their art are no more than seasonal decorative pieces on a par with the flowers, the moon, the deer, the geese, and other elements often employed in such work. For the Heian nobility, Kyoto, the rivers, lakes, and mountains around it, and the tightly enclosed aristocratic class were the entire world. Anything beyond those limits was outlandish, even otherworldish. Nor were domestic circumstances the only influences that limited the scope of this society.

In 907, shortly after the dispatch of Japanese envoys to China was terminated, the great T'ang dynasty fell. Soon the Korean kingdom of Silla and the Manchurian state of P'o-hai also collapsed. In other words, all of the Far Eastern cultures with which Japan had engaged in foreign relations vanished. Japan never established formal relations with any of the Five Dynasties (907–59) that followed the T'ang or with the Sung dynasty (960–1279). The virtual isolation of the country further narrowed the vision of the aristocracy at the capital and had an obvious effect on the nature of its culture.

Shut off from much of the world and unburdened by political responsibilities, the aristocrats were free to live in luxury and to follow tasteful pursuits. They fostered cultural skills and accumulated knowledge and refinements that enabled them to develop highly sensitive and delicate perceptions. Their circumstances may have caused them to have a biased social view, but these same circumstances enabled them to produce a culture that peoples of later ages have found difficult to emulate.

By the time of the Heian aristocratic society, the mass importation of styles and information from the continent had already ceased. This means that, unlike the great continental Buddhist culture of the age of the penal and administrative codes, the aristocratic society developed in a characteristically and distinctively Japanese way. The issue is clouded by much doubt, but freedom from continental influence and the attainment of great artistic excellence are undeniably noteworthy characteristics of Japanese cultural history.

If one is to understand why the class-conscious, isolated aristocratic society could create art and literature that are universal in appeal and have continued to captivate people over the centuries, one must take into consideration the continued custom of separation between man and wife. The system of separate domiciles for married people—the common social attribute of all classes of Japanese society from primitive times—was not abolished in the Heian period. The independence of the female that was insured by this family arrangement was still maintained. Woman was not yet subservient to man. Inherited property was divided among all of the children, including the daughters, and it was not unusual for women to become holders of landed estates. The Fujiwara family consolidated their position as hereditary regents and counselors to the emperors by repeatedly marrying Fujiwara girls to imperial princes. The presence of Fujiwara women among the consorts and relatives of the emperors was of the greatest importance. As might be suspected, there were many such women in the court, and several of them proved to have considerable talent in cultural endeavors.

Although the social position of the Fujiwara ladies and their counterparts throughout the structure of aristocratic society was high, the women were productively less important than their distant ancestors in primitive society who had shared agricultural labor with the men. In Heian society, women had very little reason for existence apart from being objects of male amours. Furthermore, the freedom with which a man could separate from one woman and take a new and

more pleasing one implanted deep anxieties in the minds of wives who must have often lived in fear of losing the affections of their lords. Suffering of this kind imparted a subtle gloom to the Heian-period female psychology, and this gloom, in its turn, enabled the women to plumb great depths of introspection when they undertook literary work. It is this kind of profundity that compensates for the lack of external breadth in the culture of this period.

Female frailty in the face of psychological insecurity was not the only weakness marking the age, for the entire aristocratic class was not invariably powerful. Because, as absentee landlords, the aristocrats were isolated from land, they constantly faced the danger that the common people, who derived great vitality from rural society, would topple them from their high places. The provincial Tengyo disturbances of 939 and the vandalism that frequently threatened the public peace of the capital itself gave ample grounds for forebodings about future disaster. The gathering strength of the provincial lords and the sudden rise of the warrior classes with their feudal-style relationships were developments that inevitably led to the destruction of the old social order from within.

It is astonishing that the aristocracy failed to sense this historical process intuitively. But if the aristocrats were in one sense arrogant and disdainful, in another they were cowardly and powerless. Deeply superstitious, they placed faith in taboos and in such methods of avoiding baleful influences and possible calamity as *monoimi* (which means, roughly, abstention from all kinds of things) and *katatagae,* or changing directions to avoid harm. Overdevelopment of artistic tastes and a sad lack of rational and scientific knowledge, as well as a deepening trust in magic inherited from primitive society, partly account for Heian-period superstition. But to understand it more fully one must realize that the elements that I have been discussing caused intense social uneasiness.

The insecurity experienced by the ruling class suggested that their position of material blessedness was by no means eternally guaranteed. This, in turn, prompted the aristocrats to seek spiritual salvation beyond the world of actuality. Although the culture of this class during the Heian period was deficient in universal humanity, it was inseparably connected with a prevalent sense of humility inspired by insecurity.

THE LITERARY ART
OF THE TALES

The literature of the sagas and tales (*monogatari*) is one of the outstanding and most typically Japanese aspects of the culture of the Heian period. The development of a system of writing with which to represent the Japanese language more accurately than had been possible with Chinese characters alone made this literary genre possible.

Throughout the period when the syllabary known as the *man'yo-gana* was used, individual symbols were gradually simplified until new ones, quite different in form from the Chinese characters from which they originated, came into being. This process followed two courses. In one instance, a part of a Chinese character was used to represent the sound by which the character was at the time pronounced. For example, the left-hand part of the character 阿, pronounced like the *a* in "father," was isolated and modified to look like this: ア. It was then used to represent the *a* sound wherever it occurred. The right-hand part of the character 礼 (*rei*) was isolated and altered to form the symbol レ and was then used to represent the syllable *re*. It is thought that this system of abbreviations originated from the habits of students and priests of making notations and comments on Buddhist classics in what was a kind of shorthand. The symbols used in making these notes were gradually standardized and put into general use. This was the origin of the syllabary known as *katakana*. The *kata* part of the designation indicates that the symbol is incomplete or an abbreviation of a full character.

The second course by means of which a new syllabary came into being involved the three styles in which it is possible to write Chinese characters. In Japanese, these styles are called *shin, gyo,* and *so.* The *shin* style is the most formal

and the clearest. The *gyo* style is somewhat more cursive and free, and the *so* style is highly cursive. So untrammeled is the *so* way of writing that sometimes the shape of the character is radically altered. From the *so* writing style, certain characters were adopted for a cursive syllabary called *hiragana* (the name is of much later coinage and was not used when the system was first employed). In *hiragana* the syllable *a* (as in "father") is represented by the symbol あ, which originated from the cursive script for the character 安. Similarly, the cursive version of the character 礼 produced the *hiragana* symbol れ for the syllable *re*.

The processes by which the Chinese ideograms were abbreviated and modified to form syllabaries for the needs of the Japanese language were the outcome of centuries of use by many people. The legends that a person named Kibi no Makibi (or Mabi) invented *katakana* and that Kukai invented *hiragana* are not to be credited. Furthermore, until movable type standardized them, the forms of the symbols for the syllabaries were not universally the same. The fixed use of one symbol shape for one sound is a relatively recent development.

Although the Japanese never created their own original writing system, they modified Chinese ideograms in both form and function in order to be able to use them phonetically to satisfy the requirements of their language. The difference between possessing only an ideographic or a hieroglyphic writing system and possessing a phonetic script has an immeasurable influence on the development of culture. Consequently, the importance of the creation of *hiragana* and *katakana* to Japanese history was extraordinary.

The literary art of the Heian-period aristocratic culture would have been unthinkable without the syllabaries. Since the eighth century, the time of the *Man'yoshu*, no large collection of Japanese-style poetry had been compiled, but the emperor Daigo (reigned 897–930) commissioned one. In 905 the poets Ki no Tsurayuki, Oshikochi no Mitsune, and Mibu no Tadamine compiled the *Kokinshu*, or *Kokin Wakashu* (Anthology of Old and Modern Japanese Poems). In this collection the abbreviated syllabary forms, which formerly had been no more than a convenience for the private writer, appeared in public letters. After this, many literary works composed in the syllabaries appeared.

A total of eight poetry anthologies commissioned by emperors were to be compiled throughout the Heian period and into the early Kamakura period (1185–1336). Since, from the standpoint of the writers, the *waka*, or Japanese poem, was the only true literary form aside from Chinese-style poetry and literature, inclusion in one of the imperial anthologies was regarded as a paramount honor. Still, it is difficult to rank the *waka* of this period highly in terms of aesthetic merit. The earlier collections are especially devoid of interest.

In contrast with the *Man'yoshu*, which often expresses the feeling of the common people and is powerfully charged with emotion, the poems in the Heian-period imperial collections derive entirely from the aristocratic class, express stereotyped ideas, and involve a great deal of wordplay. They lack the depth of feeling to appeal to readers of later times. The passionate love poetry of the woman poet Izumi Shikibu (late tenth to early eleventh century) is an exception to the general vapidity.

Monogatari, or tales, which were originally considered only a recreation and second-rate literature, were the form in which Heian-period letters reached the pinnacle of excellence. The tales are not much like modern novels. They derive from old stories and popular legends that had formerly been transmitted by word of mouth. Though the writers of the *monogatari* employed the Chinese learning and Buddhist thought that were part of their educational background, the tales themselves represent a distinctly and originally Japanese creation.

Earlier Japanese writings had sometimes been distinct in tone from the literary works of the continent. For example, the *Kojiki*, though a historical work, differs from Chinese histories in being a kind of tale. It is basically unlike the *monogatari*, however, because it is not the result

of the creative efforts of a single individual, as the Heian-period tales are. The popular stories passed on by word of mouth among the people of the nation could not take fixed literary form as long as writing depended on Chinese characters or the cumbersome *man'yo-gana*. But with the perfection of the simpler *katakana* syllabary, the literary skills of the intellectual class were put to use in reworking traditional materials.

The famous *Genji Monogatari* (The Tale of Genji) mentions another tale as the ancestor of the entire genre. This older story is the *Taketori Monogatari* (The Tale of the Bamboo Cutter). Its framework is a popular story about a child of divine parentage who comes into the world of men from a stalk of bamboo, has many experiences with mortals, and then returns to the realm of the gods. In the *Taketori Monogatari*, the child of the gods becomes a beautiful woman for whose sake many men are eager to perform services. The tale contains abundant narrative elements and is clearly a literary and creative reworking of folklore. The employment of a bamboo cutter, a laborer of the mountains and forests, as a leading figure in the tale shows that the *Taketori Monogatari* represents a transitional phase in which not all of the material of the tales has been transformed into things of the aristocratic world. In a later tale called the *Ochikubo Monogatari,* great effort was exerted to remove all folk-tradition elements and to depict the life of the aristocracy in realistic terms. The attempt was not entirely successful, since the main theme of the tale is the mistreatment of a step-child, a frequent motif in folk literature. Even the *Genji Monogatari,* in which creative writing on the part of the author, the court lady Murasaki Shikibu, is predominant, contains a number of folk elements like the story of Tamakazura, who travels far and wide, experiencing hardships and trouble before departing for the other world.

Waka are found in abundance throughout such tales as the *Utsubo Monogatari* and the *Genji Monogatari,* in both of which they play important parts in unfolding the plot. This suggests that poetic sagas form one of the sources from which the Heian-period *monogatari* developed. Some of the earlier tales—for instance, the *Taketori Monogatari,* the *Ise Monogatari,* and the *Yamato Monogatari*—are in fact story-form versions of materials found in *waka* poems. It seems likely that the Heian-period *monogatari* evolved as a consequence of the combined influences of verbally transmitted folk tales and poetic stories.

Undeniably, the *Genji Monogatari* has structural weaknesses: it is no more than a stringing together of a number of short tales. But all of them center on the figure of Genji, the shining prince, and on the people of the generation following his. The great merits of the book are the subtlety and intricacy with which it depicts the characters of the prince and his male and female associates and the delicacy with which it delineates the romantic intrigues of the aristocrats of its day. In terms of skillful revelations of interior motives, the *Genji Monogatari* can hold its own with the finest modern novels. Indeed, it reached the pinnacle of success in completely developing the possibilities of the *monogatari* form. Its forerunners had been bound to the folk tales on which they were based. They had presented to the reader only the external characteristics of the personages appearing in them. The *Genji Monogatari* is patently different in that it reveals the inner psychological workings of its cast of characters. I suspect that what enabled the author to make this advance in literary art was the tradition of keeping diaries, especially popular among court ladies.

In earlier times, diaries had been regarded as more or less public records of political affairs. But as the aristocrats who kept them moved further away from politics and concerned themselves solely with ceremonies and amusement, individuals frequently kept private diaries relating such things as customs and precedents. Still, these were official documents written entirely in Chinese characters and in a language that was neither Chinese nor Japanese but a hybrid mixture of the two. With the composition of the travel diary known as the *Tosa Nikki,* by Ki no Tsurayuki (c. 866–945), however, the literary genre of the diary began a course of development in which

women were to play a prominent part. The *Tosa Nikki* contains a considerable amount of text in *kana,* which was ordinarily considered suitable only for female writers; men of cultivation customarily employed only Chinese characters and the hybrid Sino-Japanese style. Some of the works of the female diarists were outstanding. As an example, I might cite the *Kagero Nikki,* by the mother (c. 935–95) of Fujiwara Michitsuna.

Though no other name is known for her, this lady provides an interesting picture of the kind of life led by women who occupied themselves with the writing of diaries. In addition to being the mother of Fujiwara Michitsuna, she was the wife of the *kampaku,* or chief imperial counselor, Fujiwara Kaneie and the daughter of a low-ranking aristocrat. But since her husband not only had other legitimate wives but was also a lofty courtier of a debauched character, it is likely that the lady spent many sad nights alone. It was the tragic interplay between loneliness imposed by the prevailing marital system and the preservation of woman's spiritual independence that made women diarists capable of penetrating deeply into their own psychologies and of giving literary expression to their predicaments. Murasaki Shikibu, in the *Genji Monogatari,* although she treats her subject less fully than does the author of the *Kagero Nikki,* pointedly depicts the feelings of an intellectual woman who has lost her husband at an early age and who comes to serve in the residence of the imperial consorts. It may be that Murasaki refined the psychological description given in the *Kagero Nikki* for use in her own realistic depictions in the *Genji Monogatari.*

Unlike the tales and popular traditions that were in a sense its forerunners, the *Genji Monogatari* contains almost nothing of the supernatural or the miraculous. It is a subtly written, realistic portrayal of the lives of the members of the aristocratic class of its time. The ladies and gentlemen of the court, the people for whom the book was written, could see themselves and their own lives in the lives of the characters, with whom they could probably identify completely. At the time of its composition, this book, which has come to

be regarded as one of the supreme masterpieces of Japanese literature, was considered second-rate writing with which women and children would while away the tedious hours. (It must be remembered that, apart from Chinese-style writing, only the *waka* poem was considered truly first rate. But it lacked the power to attract the minds of women and children as the tales did, primarily because it demanded elaborate and troublesome technical skills and specialized powers of appreciating its merits.) It is the realistic nature of the *monogatari,* especially of the *Genji Monogatari,* that brings the world of the Heian-period imperial court to life for readers of all succeeding times.

But realism is not the only thing that makes the *Genji Monogatari* great literature. In a smooth narrative it includes the author's great store of objective knowledge about relations between men and women, ways of living, poetry, music, painting, and many other intellectual and artistic matters. Again, and even more important, it is pervaded by a philosophical view of life that, although nowhere flatly stated, is apparent throughout the book. Genji, the shining prince, almost supernaturally blessed with good looks, aristocratic background, and talent, is powerless before the fate that overrides all human planning. Viewing her world with a keenly analytical look, Murasaki Shikibu intuitively senses that the aristocratic society she depicts will be swept away in the tide of historical development.

The famous *Makura no Soshi* (Pillow Book), by Sei Shonagon, another woman writer of the times, is difficult to rank on the same level of excellence as the *Genji Monogatari.* Nevertheless, the wit and perception with which the writer observes many facts of her society are astonishing.

The *Genji Monogatari* is believed to have been written at the beginning of the eleventh century. This was the time when the great Fujiwara family was at the peak of its power. One of its most outstanding members, Fujiwara Michinaga, was then in full glory, and it is sometimes said that he was the original on which Murasaki modeled the character of Genji.

After the time when these great works were

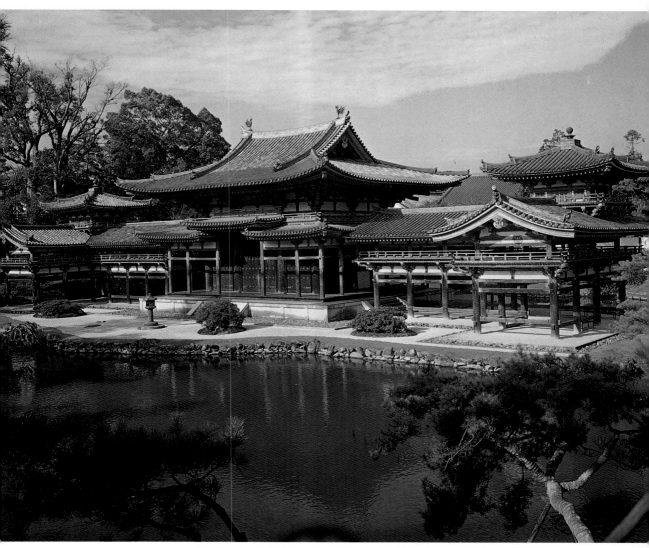

27. Phoenix Hall (Ho-o-do) of Byodo-in. 1053. Length, 48.78 m. Uji, Kyoto Prefecture.

28. *Section from* Suzumushi *(Bell Cricket) scroll of* Genji Monogatari Emaki. *Early twelfth century. Colors on paper; height, 21.8 cm. Goto Art Museum, Tokyo.*

29. *Mounted section from* Ise-shu *division of Nishi Hongan-ji manuscript of* Sanjurokunin-shu *(Thirth-six Poets' Anthology).* ▷
First half of twelfth century. Ink and colors over paper collage; height, 20.2 cm.; width, 31.8 cm. Collection of Hikotaro Umezawa, Tokyo.

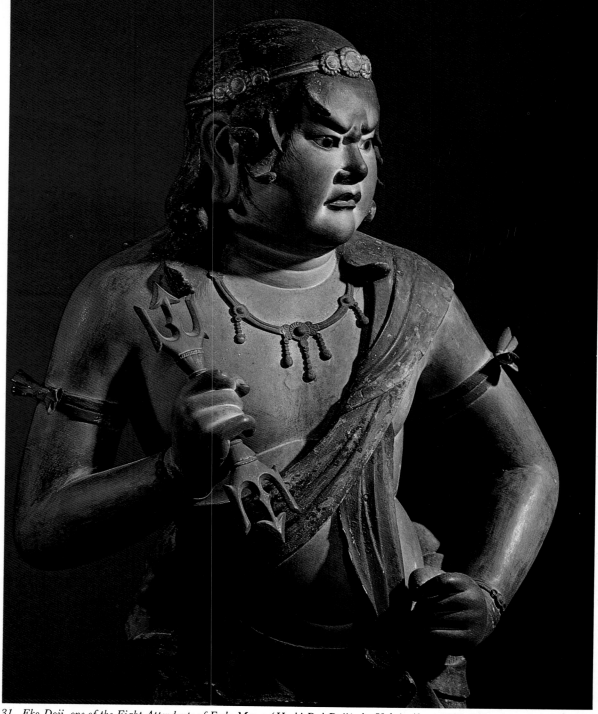

31. *Eko Doji, one of the Eight Attendants of Fudo Myo-o (Hachi Dai Doji), by Unkei. About 1198. Painted wood; height, 96.3 cm. Kongobu-ji, Wakayama Prefecture.*

◁ 30. *Portrait of Minamoto Yoritomo, attributed to Fujiwara Takanobu. Late twelfth to early thirteenth century. Colors on silk; height, 139.4 cm.; width, 111.8 cm. Jingo-ji, Kyoto.*

32. Section of Fukuoka *division of the picture scroll* Ippen Hijiri Emaki *(Pictorial Biography of Saint Ippen) by En'i. Dated 1299. Colors on silk; height 38.2 cm. Kankiko-ji, Kyoto.*

33. Detail from Rakuchu Rakugai Zu *(Scenes In and Around Kyoto) by Kano Eitoku, showing festival scene with floats and portable shrines. About 1570. Pair of sixfold screens; colors and gold on paper; each screen: height, 159.5 cm.; width, 364 cm. Uesugi Collection, Yamagata Prefecture.*

34. *Detail of dry-landscape garden, Daisen-in, Kyoto.*

produced, the aristocratic society began to wane, and, as this happened, the literary genre of the *monogatari* lost energy. Although the *monogatari* form continued to be used to relate lives of members of the upper classes throughout the Heian and into the Kamakura period, none of its successors equaled the *Genji Monogatari* in merit, lasting interest, or powerful influence on readers and writers. The effect of this great book is an example of the formative ability of the national tradition, the power of which can transcend historical ages and social classes. This was the case when the Buddhist art of the Nara period became the energy behind a revival in Japanese art that took place in the late nineteenth and early twentieth centuries.

But the *Genji Monogatari* was not the only product of Heian-period art to manifest such power. Yamato painting (*yamato-e*) and the picture scrolls, which are the subject of the following discussion, also exerted great and important influence.

THE DEVELOPMENT OF THE PICTURE SCROLLS

We have already observed that pictorial art appeared very early in Japan, as is shown by the cave paintings of the Tumulus period. But painting with ink or colors on paper or silk or other cloth did not emerge until the introduction of suitable techniques from the Asian continent. The history of Japanese painting in this sense begins with the introduction of Buddhist graphic art.

The subject matter of Buddhist paintings was limited to Buddhas, Bodhisattvas, other divine beings, and the backgrounds against which they were set. Formalized patterns for the representation of these subjects were established in India and China. In producing Buddhist pictures, Japanese artists found little leeway for their own imagination.

Secular Chinese paintings of emperors, palaces, and landscapes were admired in Japan from early times. It is recorded that the emperor Shomu owned a screen decorated with such pictures. Furthermore, it is said that during the ninth century, when the study of Chinese literature was especially popular, Japanese painters engaged vigorously in the production of Chinese-style secular pictures. It seems likely, however, that works produced in this fashion were copies of Chinese originals.

The tenth century saw the growth of a truly Japanese style of painting represented by what is known as *yamato-e* (Yamato painting). In the beginning, this designation did not pertain to style but to subject matter alone. Whereas *kara-e* (Chinese painting) meant paintings of Chinese subjects, *yamato-e* meant paintings of exclusively Japanese subjects in Japanese style. Gradually, however, characteristic *yamato-e* traits began to evolve, and the style was used even in representing Buddhist subject matter. The Amida Hall of the Byodo-in (the building now often called the Ho-o-do, or Phoenix Hall), located at Uji, near Kyoto, was completed in 1053 (Fig. 27). It enshrines a gilded wooden statue of the Buddha Amida (Amitabha). This image (Fig. 35), the work of the sculptor Jocho, is an example of the way in which all art of this time was being treated in distinctively Japanese fashion. The door panels of the hall were decorated with pictures of Amida descending from paradise to greet his faithful followers. The subject matter of the paintings was Buddhist, but it is said that the backgrounds against which the Buddhist figures appeared represented scenery near Uji. As this example suggests, Japanese painting was about to transcend the boundaries between the secular and the sacred.

Paintings in the Yamato style were most often used to decorate sliding partitions (made of paper over a wooden framework) and folding screens: articles of furnishing intimately connected with the residential architecture and way of life of the aristocrats. The homes of the nobility of the time were built in what is called the *shinden* style: a central main building, various outbuildings, and small pavilions, all connected by means of open, roofed corridors and placed in spacious gardens decorated with ponds. In later ages, it became customary to floor Japanese houses with tatami, but in the Heian period floors were

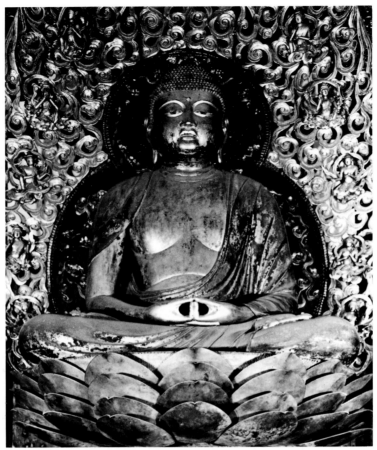

35. *Amida Nyorai, by Jocho. 1053. Gold leaf and lacquer on wood; height of image, 295 cm. Phoenix Hall (Ho-o-do), Byodo-in, Uji, Kyoto Prefecture.*

usually wooden, and mats of woven grass were placed only where people sat. Rooms were frequently very spacious. They were divided by means of folding screens (*byobu*), sliding partitions (*fusuma*), or a kind of framework with draperies called a *kicho*. Because of their functional importance, folding screens and sliding partitions were greatly in demand. Many of the aristocrats were persons of great artistic refinement and employed the finest painters to decorate the

sliding panels and folding screens of their homes. Such people, whose wealth and extravagance made lavish interior decoration possible, regarded art as an integral part of daily life. They filled their homes with art objects of the kind that people today must visit museums to see, and they read great works of literature like the *Genji Monogatari* for pleasure.

The major thematic material of the *yamato-e* that appeared on screens and sliding partitions

involved familiar human activities—such yearly ceremonies and events as *komahiki* (presentation of horses as tribute to the emperor) and *tsuina* (exorcism)—set in the frame of the changing seasons. Cherry blossoms, the moon, snow, and other aspects of nature at varying times of the year were frequently employed. A distinctively Japanese genre, the *yamato-e* fits into none of the traditional Chinese painting categories: portraits, pictures of flowers and birds, and landscapes. The subtle interweaving of the world of nature and the activities of mankind is reflected in the *Genji Monogatari* and other literary works as well as in these pictures. But the creations of *yamato-e* furnish one of the most vivid examples of the fusion of nature and man that characterizes all phases of Japanese art.

Although none of the screen and sliding-partition paintings of the Heian period survive, abundant documentary evidence and the so-called *Senzui Screen,* owned by the temple Jingo-ji and painted in the Kamakura period, make possible a conjectural reconstruction of what they must have been like.

The few *yamato-e* works that survive from the Heian period are in the form of *emaki,* or scroll paintings. It was not unusual to include illustrations in the texts of the scrolls that were the predominant form for books of the time. Hints for this kind of treatment may have derived from China, but the deliberate exploitation of the long, narrow form of the scroll in something like motion-picture fashion to tell a story is a distinctively Japanese idea. The picture scrolls combined paintings in Yamato style with works of literature to form a total artistic creation of a kind impossible with the techniques of other genres.

The scroll was not the only example of a combination of text and illustrative matter. Some *yamato-e* screen paintings were accompanied by verses suited to the pictorial theme. The verses were written on separate pieces of paper and attached to the surface of the screen to contribute to the lyrical mood. But the combination of text and pictures in the scrolls was different. In this case, narrative was the result of the combined effect of pictures and text. It is significant in this connection that most of the scroll paintings are used in conjunction with tales, or *monogatari.*

In some scrolls, blocks of text alternate with pictorial depictions of related scenes. The extant versions of the *Genji Monogatari* scrolls are in this form, which is eminently suitable to a work in which artistic effect derives less from a unified plot line than from descriptions of individual scenes (Fig. 28). The *Genji Monogatari* scrolls are outstanding works whose great appeal is the result of four distinct elements: the story itself, the richly colored pictures of the gorgeous apparel and luxurious way of life of the aristocracy, the elegance of the cursive script with which the text is written, and the craft-art beauty of the handsome colored papers on which the text appears. Both the *Genji Monogatari* scrolls and the Nishi Hongan-ji version of the *Sanjuroku-nin Shu* (Thirty-six Poets' Anthology) scrolls (Fig. 29) are works of great merit, revealing the artistic tastes of the Heian-period nobility.

But the alternation of illustrations with blocks of text failed to take full advantage of the possibilities of the scroll. Gradually there evolved a kind of scroll painting that made use of no written text at all and relied on a continuous horizontal strip of pictures to unfold the story in a chronological sequence of events. The evolution of this kind of picture scroll resulted in a unique graphic form. Two of the masterpieces of this type surviving today are the *Shigi-san Engi* (Legends of Shigi-san Temple) and the *Ban Dainagon* (Story of the Courtier Ban Dainagon) scrolls. Both sets contain fascinating pictures of crowd actions. One of the scrolls of the *Shigi-san Engi* tells the story of a magic flying rice bowl that transports a rice warehouse from the home of a rich man to the mountain retreat of a hermit. The consternation of the amazed crowd of spectators at this unheard-of occurrence is expertly portrayed (Fig. 36). The distress of a group of courtly officials is depicted with equal vividness in the scene in the *Ban Dainagon* scroll showing a fire at a gate of the imperial palace (Fig. 37). Both examples deserve special notice for the creative way in which they

36. *The flying bowl and the airborne granary: scene from the picture scroll* Shigi-san Engi *(Legends of Shigi-san Temple). Second half of twelfth century. Colors on paper; height, 31.5 cm. Chogosonshi-ji, Nara.*

transcend ordinary spatial limitations of paintings and portray action in progress. As suits the nature of the subject, the style of the drawings is vigorous and realistic. In this they contrast with the pictures in the *Genji Monogatari Emaki,* where heavily applied colors and decorativeness establish the predominant mood. The style and material of the *Shigi-san Engi* and *Ban Dainagon* scrolls represent an unhesitating use of elements from the full-blooded life of the ordinary people, and this inclusion of abundant folk elements in art accounts for one major transformation taking place in the culture of the eleventh and twelfth centuries, when aristocratic society reached the twilight of its glory.

As I have already had occasion to mention, the ruling class of this period was composed almost entirely of absentee landlords dwelling in the capital. It lacked the ability to understand the rural areas and their people. Gradually, however, the power of the provincial landholders and the warriors in remote areas began to increase, and, as this happened, major governmental authority shifted from the hands of the Fujiwara regents and counselors into those of retired, or cloistered, emperors (*in* or *ho-o*). Often imperial rulers decided to step down from the throne in order to escape the burdensome round of ceremonials associated with their title and thus to free themselves to engage in whatever might catch their fancy. In several cases it was politics that captured their interest. On the surface of things this shift in power seemed to be no more than a change within the central imperial government. In fact, however,

37. *Detail from fire scene of* Ban Dainagon Emaki *(Picture Scroll of the Courtier Ban Dainagon). Second half of twelfth century. Colors on paper; height, 31.5 cm. Sakai Collection, Tokyo.*

government by cloistered emperors found its major support in the provincial landholding class, the members of which had been steadily growing more wealthy. The supremacy of this group in the provinces came to be reflected in the central government when the cloistered emperors assumed greater power. The rise of the Taira and Minamoto warrior clans, which were to be of immense importance in later historical developments, was made possible because cloistered emperors relied on warriors of this kind for support. Such reliance introduced new policies and had an influence on the culture of the times.

Under the rule of the cloistered emperors, society could no longer be succinctly described as merely aristocratic, since it now included ideas and cultural elements derived from the common people. In the field of literature, the *monogatari* reached the end of its development. Historical tales and romances like the *Eiga Monogatari* (Tales of Glory), describing the times of Fujiwara Michinaga, and the *Okagami* (Great Mirror), dealing with the same period, were still being written. But other works, like the *Konjaku Monogatari Shu* (Anthology of Old and Modern Tales), were relating the pure, unvarnished facts of the simple lives of ordinary people.

A similar change was taking place in the performing arts. Whereas, in the earlier years of aristocratic society, court entertainments had consisted largely of ceremonial music and dance of the kinds borrowed from China and Korea in the eighth century, during the time of government

38. Detail from Choju Jimbutsu Giga *(Scroll of Frolicking Animals and People), attributed to Toba Sojo. First half of twelfth century. Ink on paper; height, 31.8 cm. Kozan-ji, Kyoto.*

by cloistered emperors more popular folk entertainments also came to the stage for aristocratic audiences. Among these were comic songs and dances and mimicry, called Sarugaku, and the rural songs and dances called Dengaku (Fig. 48), which helped lighten the farmers' labors during such arduous tasks as the springtime transplanting of rice seedlings into the flooded paddies. The songs of humble prostitutes and female puppeteers found favor with aristocratic circles, and the retired emperor Goshirakawa compiled an anthology of them called the *Ryojin Hisho.*

No matter how refined, the aristocracy of the Heian period was a narrow, degenerate society of people who consumed without producing. Inevitably, this society came to a stalemate when it reached the limits of its development. In-

vigoration for the national culture was at hand, however, in the form of infusions of the less refined but more robust and wholesome culture of the ordinary people. The introduction of such elements provided the strength that aristocratic culture lacked. But the sharp contrast between the aristocratic and the folk elements of the newly developing culture must not be overlooked.

In the *Konjaku Monogatari Shu* occurs a tale concerning a provincial official in Omi Province who built a Buddha hall in which he conducted services and who once he invited a learned priest from Mount Hiei, near Kyoto, to visit him. The priest from the capital, surprised to hear rural Dengaku music being played, made a sneering remark about his provincial host's lack of musical understanding. The story shows that a gulf

39. *Frontispiece to* Gonno-bon *chapter of* Heike Nokyo *(Sutras Dedicated by the Taira Clan). Dated 1164. Colors on paper; height, 27.3 cm. Itsukushima Shrine, Hiroshima Prefecture.*

already separated folk and aristocratic ideas on music. But by 1096 the Dengaku style of music had become popular with everyone from the ordinary townspeople to the loftiest aristocrats, some of whom are said to have purchased Dengaku hats and to have scandalized the more conservative members of their class by sporting this headgear through the streets of the capital. The intrusion of the culture of the common people symbolizes the advance of a popular power that can never be suppressed. The *Shigi-san Engi Emaki* and the *Ban Dainagon Emaki* are products of the same historical and cultural force.

During the concluding years of the Heian period, the scroll genre developed further in works of great interest. Among these are the *Kokawa-dera Engi* (Legends of Kokawa-dera),

the satirical *Choju Jimbutsu Giga* (Frolicking Animals and People; Fig. 38), and the scrolls illustrating the *rokudo,* or six realms of existence, in Buddhist thought. In the last set, the portrayals of hungry ghosts, hell, and illnesses are vividly and disturbingly graphic in showing some of the cruel aspects of human life.

THE EXTENSION OF ARISTOCRATIC CULTURE

The culture of the aristocrats reached a level of great excellence in the Heian capital and extended to provincial regions as well. This is not to suggest that there had been no earlier cultural activity in parts of the nation other than the capital. In the eighth century, as we have noted, the central government commanded the

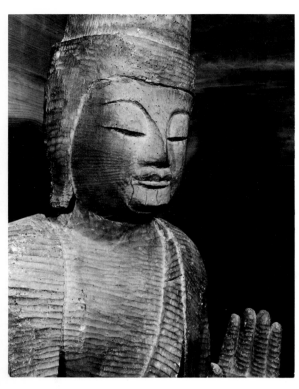

40. *Natabori (ax-carved) Gakko Bosatsu (Moonlight Bodhisattva), by an unknown artist. Tenth century. Wood; height of entire statue, 122.7 cm. Hojobo, Hinata, Isehara City, Kanagawa Prefecture.*

41. *Altar of Konjikido (Gilded Hall), Chuson-ji. 1124. Hiraizumi, Iwate Prefecture.* ▷

establishment of regional temples (*kokubunji*) in many parts of the country. Cultural activities, as well as Buddhist services, took place in these temples, but everything connected with them was the result of governmental action and did not reflect the initiative of the local people. No works surviving from the provincial temples of the time can be compared favorably with the art treasures of the Todai-ji and the Kofuku-ji in Nara. During the ninth and tenth centuries, however, Buddhist culture had taken root in the provinces. In the eastern (Kanto) part of the main island of Honshu, a distinctive style of sculpture called *natabori* (ax-carved) developed for the production of Buddhist figures (Fig. 40). These rough statues, bearing the marks of the tools with which they were produced, deserve attention as

independent manifestations of regional culture. For all their interest in this respect, however, aesthetically they must have looked very crude to the sophisticated city aristocrats.

Still, as the economic and military might of provincial nobles began to increase, the quality of their artistic undertakings also improved until they were able to command works as good as anything made by the artists and artisans of Kyoto. The outstanding examples of the high level of cultural development in the provinces in these times are the surviving temple structures at Hiraizumi, in the home territory of the northern branch of the Fujiwara family. The Konjikido (Gilded Hall) of the temple Chuson-ji (Fig. 41) and the remains of the Muryoko-in attest to the majesty and brilliance attained by the aristocrats

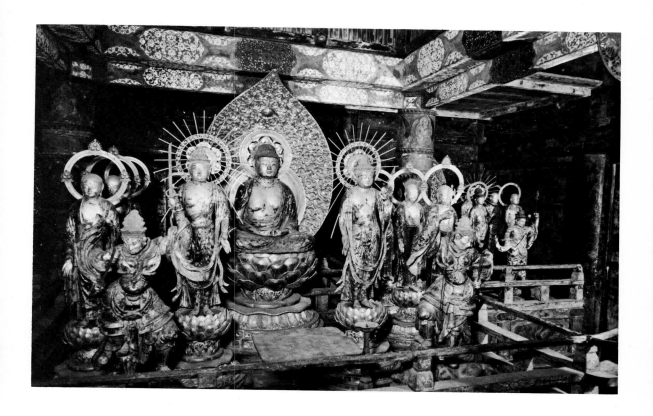

of areas removed from the capital. The gardens of the Muryoko-in were patterned on those of the famous Byodo-in at Uji. Though smaller in scale than the two just mentioned, other temples and halls—for instance, the Amida Hall at Shiramizu and the similar halls at the temples Kozo-ji and Fuki-dera—testify to the glories of the rich families of the provinces. Indeed, by the end of the Heian period, the strength of such people equaled that of the nobility of the capital. They laid the foundation for the military aristocracy of the following historical period. It is not surprising, then, that the base of operations of this military aristocracy was to be the eastern part of the country and not the older, more sophisticated zone around the capital.

An interesting sidelight on the cultural expan-sion radiating from the capital to the provinces in this period is the overseas development that came about because of the great fondness for decorated Japanese fans in Sung-dynasty China. In a book called *Huang-chao Lui-yüan*, the eleventh-century Chinese writer Hung Hsiao-yü noted that decorated Japanese fans sold at the temple Hsiang-kuo-ssu were expensive because of their artistic merit, which he claimed was probably beyond what Chinese artists could achieve. The praise is all the more telling because it was written by a Chinese and cannot be discounted as boasting. At about this time Japan began to take pride in its own distinctive culture. Recognition must have been especially gratifying because it came after a long period of feeling shamefully retarded and urgently in need of borrowing as much of

42. Section of Byobu Dodai *(draft for inscription on folding screen)*, by Ono no Michikaze *(Tofu)*. 928. Paper scroll; height, 22.7 cm. Imperial Household Collection.

continental culture as possible in the shortest possible time.

Examples of excellent Japanese calligraphy, as well, were sent to Chinese Buddhist temples. For instance, in 926 the priest Kanken took an example of the cursive calligraphy of Ono no Tofu (or Michikaze; Fig. 42) to China, and in 988 the priest Chonen took a similar example written by Fujiwara Sukemasa for presentation to the Chinese emperor. The people who examined the calligraphy are supposed to have said that there were probably few calligraphers in China who could do as well. Another example of calligraphy sent by Chogen to the Sung T'ien-t'ai temple Kuo-ch'ing-ssu is said to have caused the priests and laymen there to rejoice.

Of course, the achievements of Japanese culture as presented in China on occasions like these did not inspire the Chinese to undertake developments in new directions. But that the proud Chinese should—even on a one-time basis—praise the maturity of Japanese cultural efforts was an epoch-making turn of events.

WAYS OF LIFE IN TOWN AND COUNTRY

In spite of its material splendor and aesthetic refinement, the culture of the Heian-period aristocrats was sadly deficient in rational intelligence about society and nature. There was a deep gap between the aristocratic way of life and the very low standard of living among the common people. The *Konjaku Monogatari Shu* presents so harsh and miserable a picture of the lives of the

lower classes that one is tempted to doubt the veracity of the elegant courtly life depicted in the *Genji Monogatari*. Gradually, however, the gap separating the upper and lower classes and the city and country dwellers was closed by cultural energy moving upward from below. This was the popular strength that was to become the basis and the initiative for the cultural movement during the long period in which Japanese feudal society developed.

Styles of clothing provide clear indication of the changes that were taking place in the period of transition from the aristocratic to the feudal society. The ladies and gentlemen of the court, who had only ceremonials and elegant amusements with which to occupy themselves, wore beautiful but physically inconvenient and limiting garments, like the *juni-hitoe*, or twelve-layered garment, of women. It is true that the aristocratic man was permitted to wear somewhat less formal and binding clothes for relaxation and sports, but even this apparel was not as free or comfortable as the clothes of the low-ranking court officials and the upper levels of the common people. Naturally, it was the members of the working classes who wore the simplest and most practical dress, since their work demanded freedom of action. In the following Kamakura period, the warrior class, which had attained the position of maximum political power, wore the garments of the common people for everyday use and the clothing of the low-ranking Heian aristocracy for formal, ceremonial occasions. In other words, in the realm of costume, the way of life of the common people became a norm for all classes of Japanese society. The trend in clothing indicates the general direction in which culture was moving—that is, new creative strength was rising to topple the overly formalized and debilitated society of the aristocrats.

CHAPTER FIVE

The Growth of Feudal Society

THE RISE AND HISTORICAL SIGNIFICANCE OF THE WARRIOR CLASS

Historical development assumes its clearest form when it manifests itself in decisive alterations of political power. The general order of events by which this process takes place is for strength to accumulate gradually in the lowest levels of society and to rise slowly until it causes a revolution in political power. It is now historical common sense to regard the laboring class as the basic historical driving force, since it controls the power of production. The transition from the Chinese-style system of social control by means of penal and administrative codes to one of hereditary aristocracy was not so much the outcome of the efforts of the Fujiwara family and other nobles as the product of the passive resistance of the peasantry, who fled from and abandoned lands allotted to them for cultivation and thus contributed to the collapse of the land-allotment system and to the creation of great landed manors. Similarly, it was the growth of the peasantry that later led to the dissolution of the manors, the destruction of the remnants of the ancient social system, and the establishment of a feudal society.

The conflict between warriors and aristocrats was not a struggle between two factions of the ruling stratum of society. The warriors arose from the groups of nobles who did not live in the capital as absentee landlords but who remained on their lands in the provincial areas. In a sense, the rise of the warriors was a resurgence of power from the peasant masses. The process of emergence amounted to an attempt to replace, by revolutionary means, the class that had traditionally held power in the nation since the Yayoi period. The clan leaders of the ancient period, the nobility of the age of the penal and administrative codes, and the later aristocracy had all maintained controlling positions because of their relations with the imperial house. In contrast, the warriors, as landholders who actually lived on their land, stood firm on a practical agricultural economy. In the early stages of their rise to power, advancement without connection with the imperial-household system was impossible. The warrior class in general, therefore, was forced to undergo a period of subjugation to the aristocracy. Its members served as constables (*tsuibushi*) and police commissioners (*oryoshi*) under the Fujiwara. It is true that they were for a while forced to recognize the supremacy of warrior clans that derived from the aristocracy—like the Minamoto clan (Genji) and the Taira clan (Heike)—but their relations with the lower classes provided support for their rise to power. Indeed, it can be said that the successful destruction of the ancient system and the building of a feudal society depended on the lower classes for driving power. But the change was not accomplished at once. It was necessary for the warriors to compromise with the aristocrats time and again, and centuries

were required before a society completely organized on feudal principles could be built.

The Hogen Insurrection of 1156 and the Heiji Insurrection of 1159–60 brought the Taira clan to the summit of power in the government in the capital, but this did not mean a replacement of the aristocratic society with a society dominated by the military. It only gave the Taira important places within the existing governmental structure. Later the Taira were defeated by the Minamoto clan, and in 1185 Minamoto Yoritomo established a military government (*bakufu*) in the city of Kamakura, far from Kyoto. Even this important development, however, did not accomplish the transition to a truly feudal society, for Yoritomo actually did no more than establish an independent power organization to supervise warriors and their landholdings. He did not deprive the imperial government of its authority. In other words, the establishment of the Kamakura *bakufu* amounted to the creation of a double system of control split between the military leaders and the aristocrats.

Throughout the period of the Kamakura *bakufu* (1185–1336), the same process continued. The Jokyu Insurrection of 1221, however, prompted the Kamakura government to insist that both constables (*shugo*) and land stewards (*jito*) henceforth be appointed from the ranks of its own warriors. In this way the warrior class accelerated the development and consolidation of its own controlling power by working to destroy the ancient system of manors. Although the action failed to accomplish completely the transition from the dual ruling system of court and *bakufu* to one controlled entirely by the dominant warrior class, it contributed to the achievement of that goal.

Political events were reflected in the culture of the times. As the warrior class began to gain in strength, it produced a new culture embracing popular elements of a kind not seen in the purely aristocratic culture. But just as the political authority of the court nobles was not destroyed all at once, so their authority in the field of art and letters remained high for a long time. Unable to produce anything comparable on their own, the members of the warrior class found themselves forced to bow to court culture and to learn as much as possible from it. For a while, culture, like politics, manifested a dual warrior-aristocratic structure. Gradually, however, the warrior element grew stronger as the aristocratic element declined, and this process is one of the most significant cultural aspects of the period.

THE EVOLUTION OF THE WARRIOR AESTHETIC TRADITION

The older Japanese social order attempted to employ direct control for the mustering of the people as a labor force, even, if necessary, under conditions that approached those of slavery. The social order of the feudal period attempted to use dispersed local rulers in order to acquire the producing power of the people attached to the lands controlled by those rulers. In short, control of land was the central aim of the feudal government. The device by means of which the warrior class achieved this aim was the system based on bonds between a lord and his vassals. The agreement concluded between the two parties entailed responsibilities. The lord promised to recognize the rights of his underlings to lands, or, in some cases, he granted lands. In return for these concessions the underlings ageed to support the lord financially and militarily in times of peace and war. Such agreements greatly strengthened the position of the overlords in terms of both money and arms. At the same time they made for great social solidarity because, from the bottom to the top of the social structure, many different bonds of fealty were concluded and, again, because superior-subordinate relations of the same type characterized family relations throughout a system of hereditary vassalage. Nothing comparable to the bond between lord and vassal was ever seen in the society of the court aristocrats. Perhaps the authority afforded by lord-vassal relations gave the warriors a great advantage over the nobility.

Psychologically, this kind of relationship was unintelligible to the court aristocracy. In time of battle, master and man alike must share great

hardships, perhaps even death. Bonds between men who must fight together for their lives are much more solemn than contracts concluded for the sake of material gain.

On the other hand, what the feudal relationship gained in psychological depth it lost in terms of nationwide scope. The governmental system during the age of the penal and administrative codes had been concerned with the whole nation. The feudal bonds limited the views of lord and retainer to their own welfare and aggrandizement. Throughout the age of the Fujiwara regents and the court nobility, plots and intrigues were rife, but human life was rarely taken. The feudal warrior compares ill with the aristocrat on this score. The warrior felt no compunction about resorting to massacre and to acts of revolting cruelty. In fact, he had very little respect for life at all. It would be an error to concentrate on the good aspects of feudal society and to overrate its views of human relations. Nonetheless, it must be said that the warriors did introduce a fresh moral strength into an aristocratic culture that had fallen into decadence.

The *bushi*, or warriors, that appear throughout much of Japanese history varied in characteristics from age to age. They ranged from the warriors of the Kamakura period, whose economic basis was rural and agricultural, to the famous samurai of the Edo period (1603–1868), who were largely unproductive consumers dwelling in the capital or in castle towns. Obviously, the morality of the warrior differed with the time in which he lived. *Bushido*, or the way of the warrior, glorified into a kind of universal moral code by ethics philosophers of the late nineteenth and early twentieth centuries and famous in Europe and America, was an Edo-period product and was naturally strongly flavored with the attitudes of that age. The morality of the feudal warriors of earlier times was a very different thing.

In general, mutual responsibilities between lord and vassal were unequal, since the lord was in a position to force his vassals to perform the duties stipulated in the contract between them. In some early Japanese feudal agreements, how-

ever, the wording indicates a noncontractual, almost familial, unity. In this sense, Japanese feudalism differed sharply from classical European feudalism, which was based on the idea of a bilateral contract between lord and vassal. Japanese feudalism prescribed relations between ruler and ruled that differed greatly from relations prevailing between similar groups at the time when Japan was governed by the penal and administrative codes. In more ancient times the ruling classes exercised unilateral control over the people, whom they were able to treat as slaves. Feudalism, on the other hand, rested on the obligation (*go-on*) of the lord for the well-being of the vassal and on the requirement that the vassal render service (*hoko*) to the lord.

In the Edo period all of this was to change when the power of the ruler became so great that his vassals were separated from their land and reduced to something like the status of the modern salaried worker (of course, they were paid in stipends of rice instead of in money). Under such circumstances, the independence of the vassal disappeared. During the evolutionary period of the feudal system, when the central government was still relatively weak, vassals were agricultural managers with their own lands to look after, and they were blessed with considerable independence. Aside from the lowest grades—warriors without landholdings of their own—they were by no means constrained to adopt a servile attitude toward their overlords or to perform any and all services without comment.

At this time the morality of the warrior did not impose total, unquestioning devotion, as has sometimes been argued. Warriors fought bravely in battle but did not forget to ask for rewards for their services, as the numerous extant written requests for such compensation eloquently testify. Furthermore, although hereditary relationships strengthened the power of endurance of the bond between lord and vassal, the number of vassals who became alienated from their lords as prevailing situations changed was not small. For example, Hatakeyama Shigenobu, who later became famous as one of the staunchest supporters

of Minamoto Yoritomo, originally served the Taira clan in its efforts to suppress Yoritomo.

The development of a standard of morality based on relations between lord and vassal was a natural consequence of the dissolution of the formal unity of the old national state and the subsequent formation of scattered regional societies. In this sense it marks a great historical dividing line.

In terms of the psychology of the Japanese people, it marks an equally important development. Under the older ruling systems, the Japanese had known nothing but absolute servility in relation to their rulers. Although the contractual relations evolved in the growing phase of the feudal period were not perfect, they did involve bilateral agreements, and in this sense they represented an epoch-making advance.

The bilateral relationship inspired a literary genre not found among court aristocrats—a genre exemplified by the military romance called the *Heike Monogatari* (Tales of the Heike). A number of earlier works had dealt with the exploits of valiant soldiers, but such stories did not occupy an important place in the history of Heian-period literature. It was not until the Kamakura period that military tales (*gunki*) came to full flower in some of the most outstanding literary creations of the age. Representative works of this kind appearing from the thirteenth century to the beginning of the fourteenth century include the *Jokyuki*, the *Hogen Monogatari* (a three-volume tale dealing with the adventures of Minamoto Tametomo and the Hogen Insurrection of 1156), the *Heiji Monogatari* (a three-volume account of the Heiji Insurrection of 1159–60), and the *Heike Monogatari* (the twelve-volume epic narrative of the rise and fall of the house of Taira). In terms of length, interest, and literary merit, the last in the list is far superior to the others.

Although scholars do not agree about the way in which the *Heike Monogatari* came into being, clearly it is basically different from the *monogatari* written by the aristocrats. The *Heike Monogatari* was originally sung by minstrels to the accompaniment of the Japanese lute (*biwa*) and was not a work composed by a single person writing calmly at a desk for the pleasure of a reading audience.

The uniformity—or its lack—in the versions of the two kinds of tales illustrates another of the important differences between them. It is true that some copies of the *Genji Monogatari* differ from others, but the discrepancies are minor and textual. In no case is it possible to point to major rearrangements or to omissions of parts of the story. The case is quite different with the *Heike Monogatari*, of which numbers and arrangements of episodes differ radically from version to version. The very length of the tale is inconstant. The popular version consists of twelve volumes, but the *Gempei Seisuiki* (Record of the Rise and Fall of the Minamoto and the Taira), which is recognized as a version of the same tale, consists of forty-eight volumes. Minstrels often altered the arrangement and content of the material to meet the needs of their audiences. The *Heike Monogatari* must be regarded as the product of long years of performance by minstrels for many different groups of people, some of whom had a small part in the actual composition of various versions. In contrast with the Heian-period tales, which were written by known authors for limited audiences, the *Heike Monogatari* has a popular, if not strictly an ethnic, nature.

In the military tales, for the first time, the warrior makes his appearance as the leading character in a Japanese literary genre. It is true that the major version (*ichigatabon*) of the *Heike Monogatari* employs a framework reflecting the philosophy of the Jodo Buddhist sect, but it seems likely that this framework was not originally a part of the tale, the main interest of which is the warrior class and its role as the leading element in the new age. The same thing can be said of the *Hogen Monogatari* and the *Heiji Monogatari*.

In none of these works are the agricultural and managerial roles of the warriors discussed. The tales concentrate on feats of arms in battle. The *Obusuma Saburo Emaki* (fourteenth century) is interesting precisely because it reveals something of the daily lives of warriors (Fig. 43). Relating the adventures of two warrior brothers, it deals

in detailed fashion with such themes as loyalty, sense of duty on the part of the lord, relations between parents and children, and fearlessness in the face of death. In addition, it presents an unvarnished picture of the individual warrior's pursuit of fame and profit for his own personal advantage. The work enables the reader to understand the true nature of military ways of living and thinking without the kind of hypocritical beautification and Confucian decorations that characterize the so-called way of the warrior of the Edo period.

The *Heike Monogatari* involves literary exaggeration. For instance, it paints Taira Shigemori in altogether good terms and shows nothing but bad aspects of the character of his father, Taira Kiyomori. Nonetheless, it is filled with a coherent realism and a firm understanding of truth that are its major attractions.

Concentrating entirely on the daily lives of the aristocrats, the *Genji Monogatari* subtly suggests the tragedy of life, while limiting direct depictions of tragic events. Many of the military tales contain no information on daily life but deal solely with the activities of the battlefield. The *Heike Monogatari*, however, owes its enduring popularity to totally different characteristics. First, it is tragic throughout. Second, since it is organized as a relentless flow of action leading to the ultimate destruction of the Taira clan, it is filled with rich dramatic effects. It is wider in scope than anything found in the literature of the court aristocrats and has great appeal for ordinary people.

In the late fourteenth century, the *Taiheiki*, the last of the military romances of any literary merit, was completed. It relates in vivid detail a series of stories connected with the vicious military conflict that took place during the years between 1318 and 1358, but it lacks the thematic unity of the *Heike Monogatari* and produces a much less powerful total impression. It deals with the period when Japan was divided between the so-called Northern and Southern courts, and it therefore presents important material about a time when basic changes were destroying the social system under which the country had been ruled for cen-

44. Section from Moko Shurai Emaki *(Mongol Invasion Picture Scroll)*. Dated 1293. Colors on paper; height, 39.4 cm. Imperial Household Collection.

◁ 43. Section from Obusuma Saburo Emaki *(Picture Scroll of the Samurai Obusuma Saburo)*. Late thirteenth century. Colors on paper; height, 29.1 cm. Asano Collection, Kanagawa Prefecture.

turies. Furthermore, since it is free of the romantic veil that colors and glamorizes the lives and activities of the characters in the *Heike Monogatari,* it offers a historically interesting picture of warrior leaders. The other tales of military men and their destinies produced during the Muromachi period (1336–1568) are of little interest as literature.

War stories, the forerunners of the military romances, were popular in the Heian period. During that age, scroll paintings based on such stories were produced, but the earliest surviving scrolls of this type, the *Moko Shurai Emaki* (Mongol Invasion Scroll) and the *Heiji Monogatari Emaki* (Tale of the Heiji Rebellion Scroll), date from the late thirteenth and the early fourteenth centuries, respectively—that is, after the beginning of the Kamakura period. Although, in terms of skill, both are works of a decadent age and are of only secondary importance, the *Mongol Invasion Scroll* (Fig. 44) is of interest because of the way in which it came to be produced. Takesaki Suenaga, who participated in the anti-Mongol campaigns of 1274 and 1281, commissioned it to be painted as

a record of his own battle experiences. When it was completed, he offered it to his clan god. It is interesting to note that the needs of the warrior class could stimulate the production of a work of art.

THE REALIZATION OF A NEW BUDDHISM

The upsurge of popular power, at the head of which stood the warrior class, created art genres unlike anything in the culture of the court aristocrats. This same movement gave birth to a kind of Buddhism alien to the Buddhism of the Heian nobility. Intuitively aware that the splendors and glories of this world are transient, the court aristocrats gradually came to seek salvation in a world to come. Buddhism met the religious needs of these people by offering them the teachings of the Pure Land sect, according to which man can be born again in the Western Paradise merely by calling on the name of the Buddha Amida. An influential work setting forth this teaching is the *Ojo Yoshu* (Essentials of Rebirth), completed by the priest

Genshin in 985. The aristocrats of Kyoto built gorgeous halls to enshrine statues of the Buddha Amida and allowed themselves to enjoy the illusion that being in such halls was a foretaste of the paradisiacal life to come. The teachings of the *Ojo Yoshu* were especially well suited to the mental states of people indulging in such fancies. But this work offered little to the ordinary people, constantly harried by the labors and trials of everyday life. For them, a more straightforward salvation was needed. Humble novices and sages, leading lives out of keeping with strict Buddhist regulations and relying entirely on recitations of the Amida salvation formula (called the *nembutsu*) and readings from the *Lotus Sutra*, created a faith closer to the hearts of the ordinary people. The teachings of the two important men I shall discuss next—Honen and Shinran—and the simple recitations and religious performances they advocated gave doctrinal background to popular religious practices in existence since the Heian period.

Beginning during the time when the government was conducted by cloistered and retired emperors, crises of increasing severity plagued the court aristocrats, who gradually recognized in their deteriorating world the fulfillment of an ancient Buddhist prophecy. It had long been said that two millenniums after the death of Sakyamuni, the historical Buddha, his teachings and all enlightenment would disappear from the world, and a period known as the Last Law would set in. Naturally this caused great anxiety in the court of the Heian period, and concern deepened because of the numerous disturbances that converted the capital city into a virtual arena for conflict and pillage. Under such circumstances, people of all classes longed for good tidings of salvation from destruction. In response to this longing the priest Honen (1133–1212; posthumous name Genku) raised a call for a new religion.

Honen taught that the one way to salvation was the simple invocation of the name of the Buddha Amida. In setting forth this doctrine he was, of course, trying to help all people find salvation. There are no class distinctions in the Buddhism of Honen. But he was especially eager to open a way to salvation for the poor and destitute and for the uneducated, who lacked the ability or the leisure to reach enlightenment through study. In this sense he raised the banner of popular religion and, in doing so, produced a revolutionary change from the Buddhism of the court nobles. Honen's teachings found followers in all classes, from the imperial family and the loftiest aristocrats and warrior leaders to chiefs of robber bands and low-class prostitutes. One of his most famous disciples, the priest Shinran (1173–1262), lived in various agricultural villages in the Kanto district, where he was able to take the teachings of Honen even further into the heart of the people by making direct contacts with peasants and warriors of the lowest orders. In his principal works Shinran set forth the doctrine that man is intrinsically evil and that he must not rely on his own powers but must entrust himself completely to an absolute power to find salvation. He further insisted that the name of Amida must not be invoked with a feeling of personal volition but that salvation must be considered as resulting solely from the grace of Amida. In this way Shinran deepened the meaning of the Pure Land sect and eliminated the traces of magical ritual that had clung to the invocation of Amida as taught by Honen.

Buddhism is fundamentally a universal religion devoted to the salvation of all mankind. Prince Siddhartha Gautama, the Buddha, indicated this when he left the home of his chieftain father and devoted himself to the course of meditation that ultimately led to enlightenment and to his teaching mission. In the early centuries of its introduction into Japan, however, Buddhism had been used for two purposes fundamentally inimical to its true nature. First, it had been employed as a semimagical method of protecting Japan as a nation. In this way it was partly converted to the level of traditional ancient magical religions dedicated solely to the achievement of worldly aims. Second, Buddhism had been used as material for scholarly pursuits by priests whose lives and thoughts were isolated from the ordinary world. In this sense, Japanese Buddhism became a form of lip service to Chinese models.

One of the major significances of the new Buddhist movements of Honen and Shinran lies in the alteration they made in this situation. Owing to their efforts, Buddhism in Japan obtained a new philosophical basis. For the first time in the seven centuries since it was introduced, Buddhism became a truly Japanese religion answering the present needs of the people. Honen and Shinran cut the bonds between Buddhism and both national interest and the interests of the aristocracy and devoted themselves to the salvation of the common people. The Pure Land sect and the True Pure Land sect, founded by these men, for the first time in Japanese history made the important claim that faith must be free and independent of the concerns of state. Their declaration invited criticism, even oppression, from the older, more established Buddhist sects, whose well-being and prosperity were closely tied to those of national authority. But neither of these men bowed in the face of such oppression. Shinran even resisted the imperial court when it attempted to apply pressure against his faith.

The Amidist schools of Buddhism caused great disturbance throughout the Japanese religious world. Although, on the surface, they sharply condemned these new movements, even the older sects did not remain unaffected by them. High priests of sects like the Nara Kegon and Hosso devised invocations that they claimed would enable their followers to attain Buddhahood. Ironically, borrowing Honen's method, they persisted in attacking Honen.

The farthest-reaching alterations worked in an old Buddhist sect during this period are those seen in the Hokke-shu, or Lotus sect, founded by Nichiren (1222–82). This vigorous priest argued that in the world of the Last Law the *Lotus Sutra* was the only way to salvation, which he said could be achieved by simply chanting, "Hail to the Sutra of the Lotus of the Wonderful Law (Namu Myoho Renge-kyo)." Clearly this formula derived from the invocation of the Buddha Amida taught by the Pure Land sects.

There are many traces in the Nichiren sect of elements derived from older Buddhist sects. For instance, Nichiren attempted to force the Kamakura shogunate to see that only the adoption of faith in the *Lotus Sutra* could save the nation from calamity. This insistence resembles the older belief in Buddhism as a protector of the state. There is an important difference, however: whereas, in earlier times, Buddhism had served the authority of the national state, according to Nichiren the national state must serve the *Lotus Sutra*. Nichiren put his religion on a plane much higher than everything else and went so far as to inform the government that both the shogunate and the imperial court were subordinate to the Buddha. If they did not adopt the true faith, Japan would face destruction. Like Honen and Shinran, Nichiren refused to give in, even when compelled to withstand oppression.

I have shown how the development of the faith in Amida stimulated other alterations in Japanese Buddhism. These changes were generated from within, but Zen Buddhism proved to be an important influence generated from without. Zen, derived from Indian meditation and known in Chinese as Ch'an, was introduced into Japan by priests returning from study trips to Sung China. Relations between Sung China and Japan had been established as early as the time of Taira Kiyomori, who endeavored to expand trade between the two nations. After this, Japanese merchants and priests traveled to China with some frequency. In 1191 the priest Eisai (1141–1215) brought to Japan the teachings of the Rinzai (Lin-chi) sect, which was to become the major current of Japanese Zen. Since Eisai himself was involved in the Esoteric teachings of Tendai Buddhism, he cannot be called a purely Zen priest. But in 1227 the priest Dogen (1200–1253) returned to Japan, bringing with him the doctrines of the Soto (Ts'ao-tung) Zen sect and advocating that only by abandoning all other things and devoting oneself to seated meditation (*zazen*) could enlightenment be achieved.

It is interesting to note similarities between the strict religious style of Dogen and the Jodo and Nichiren sects. The contribution to the Japanization of philosophical and doctrinal terminology

of all three of these groups is of the greatest importance. Maintaining perfect faith in the practices he learned in Chinese Zen temples, Dogen wrote his most important doctrinal work in Japanese, not in Chinese or in a Japanese version of Chinese. Honen, Shinran, and Nichiren also wrote their important religious works in vernacular Japanese. The expression of abstract philosophical speculations in the Japanese language cannot be unrelated to the development of independent Japanese philosophical thought. Possibly because Dogen avoided making comfortable ties with the national authorities, Soto Zen did not immediately meet with great popularity. In contrast, Rinzai was at once enthusiastically welcomed by. the aristocrats and the warrior classes alike. The regent Hojo Tokiyori (1227–63) invited the Chinese priest Lan-ch'i (in Japanese, Rankei) to be the first abbot of the Rinzai temple Kencho-ji. Hojo Tokimune (1215–84) invited another Chinese priest, Tsu-yüan (Sogen), to be the first abbot of the temple Engaku-ji. Both of these temples were established in Kamakura, and it was not long before many followers of the great leaders of the Kamakura shogunate began to study Zen.

The new Buddhism of the Kamakura period emphasized spiritual elements and paid little attention to the building of temples and the production of religious sculpture. Consequently, it exerted little influence on the arts. Still, some examples of Zen art of the time have importance: the scroll painting (Fig. 32) relating the life of the priest Ippen (1239–89), who founded the Ji branch of the Pure Land sect, and the portraits of Zen priests (the pictures are usually referred to as *chinzo*).

The new Buddhism taught the importance of looking steadily and sternly at the facts of life and of attempting to overcome the contradictions of human existence by taking positive measures. The attitude that actuality must be examined as actuality found application in the graphic and plastic arts (Fig. 31). Painted portraits that accurately represented the individual personality became frequent (Fig. 30). In sculpture, as well, realistic

45. Ni-o, or Kongo Rikishi, known as Naraen Kongo (Kongo with Closed Mouth), by Unkei and Kaikei. Dated 1203. Painted wood; height of entire statue, 848 cm. South Main Gate, Todai-ji, Nara.

representation was the keynote of a number of great works, among them the Kongo Rikishi (Ni-o) by Unkei and Kaikei, in the South Main Gate of the Todai-ji (Fig. 45), and, at the Kofuku-ji, the statues of the Indian Buddhist patriarchs Mujaku and Seshin by Unkei and those of the Demon Shouldering a Lantern (Tentoki) and the Demon Carrying a Lantern on His Head (Ryutoki) by Koben.

The art works and architecture in the Todai-ji and the Kofuku-ji are of special interest because they represent a wedding of two traditions. During the war between the Minamoto and the Taira, the city of Nara was burned. But in the Kamakura period attempts were made to restore some of its great monuments, among them the Todai-ji and

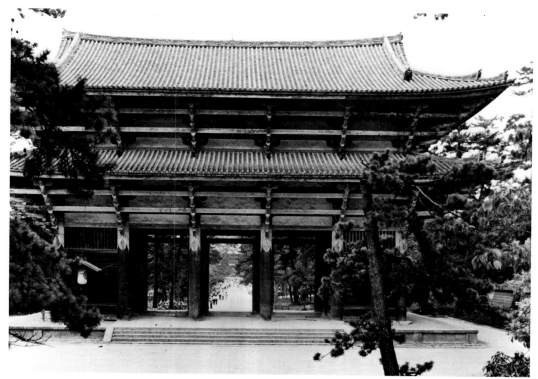

46. South Main Gate, Todai-ji, Nara. Reconstructed in 1199. Frontage, 28.8 m.

the Kofuku-ji. In the rebuilding project, artisans of the Kamakura period tried to capture the stylistic moods of art of the Tempyo period, when the buildings were originally constructed. The result is an arresting combination of interpretations of old traditions and the aesthetic requirements of a newer age.

The priest Chogen was the great moving force behind the rebuilding of the Nara temples. For the sake of the project, he imported from China the so-called Tenjiku-yo (Indian style) of architecture, which made possible the erection of large buildings with relatively simple methods of construction and assembly. The South Main Gate (Nandaimon) of the Todai-ji (Fig. 46) is the most outstanding among surviving examples of this style, which was otherwise never widely used in Japan.

With the increasing power of the Zen sect, the architectural style employed in the building of Zen temples was to prove much more popular. This, too, was a new style imported from the continent and was called the Kara-yo, or Chinese style. It must be borne in mind, however, that both of these styles, despite the use of the name Indian style for the first of them, were Chinese in origin. Characteristics of the Kara-yo included unpainted wood, absence of decoration, and earthen floors. The Shariden (Reliquary) of the Engaku-ji (Fig. 47), in Kamakura, is highly valuable as a true medieval example of these architectural characteristics.

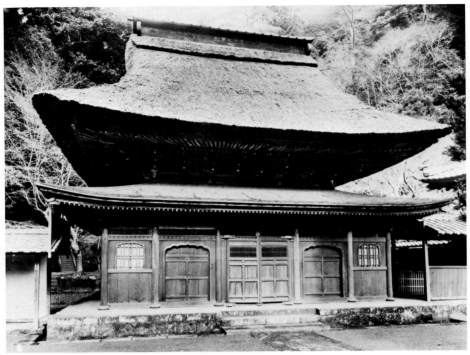

47. *Reliquary (Shariden), Engaku-ji, Kamakura. Zen-sect style, late fourteenth to early fifteenth century.*

THE EMERGENCE OF THEORETICAL PHILOSOPHY

The Japanese philosopher Chomin Nakae (1847–1901) maintained that from ancient times Japan lacked anything definable as true philosophy. Whether this can be accepted as truth is a moot point, but there is no denying the poverty of Japanese output in the field of theoretical speculation as compared with the excellence of Japanese achievements in the fields of literature and art. Nevertheless, the new Buddhism of the Kamakura period ranks with the highest and most valuable products of mankind in the spiritual realm and is rare in the culture of the Japanese people, who have never proved very astute in abstract thought. The development of ability in abstract thinking, however, must not be considered as a sudden mutation occurring only in the field of the new Buddhism, for at about the same time attempts at theoretical speculation began to be made in other realms as well.

Poetry illustrates this point. Several noteworthy written works on the nature and theory of poetry remain from the preceding historical age, but the *Korai Futaisho* (Notes on Poetic Style Through the Ages) of Fujiwara Shunzei (or Toshinari; 1114–1204) and the *Maigetsusho* (Monthly Notes) of Fujiwara Teika (or Sadaie; 1162–1241) are of immensely greater importance. How much significance can be placed on the aesthetic theories of these books is a matter open to doubt, but they unquestionably performed the historical role of developing the theory of *yugen*, or mysterious, subtle symbolism, which was to become the source of much that is typical of Japanese aesthetic thought.

Earlier written histories had been content to record facts without making comments on them.

(It is true that the *Okagami*, a historical tale of events that occurred between 850 and 1025, reveals a slight awareness of historical judgment.) But in the Kamakura period a thoroughly philosophical and critical attitude toward history appeared for the first time in Japan. For instance, in 1220 the aristocratic Tendai abbot Jien produced a book called *Gukansho* (Jottings of a Fool), in which he attempted to explain the historical inevitability of the emergence of government by the warrior class and, in doing so, made use of a certain amount of Buddhist philosophy. The *Jinno Shotoki* (Record of the Legitimate Succession of the Divine Emperors), brought out by Kitabatake Chikafusa in 1339, represents a still further step toward historical philosophy and away from writing history as no more than an assemblage of facts. (In this work, Chikafusa sets out to prove that the ruler who controlled the Southern court during the period between 1336 and 1392, when two imperial courts vied for power, was the legitimate emperor.) Neither of these works has the profound philosophical background sometimes attributed to them. Both conform the facts of history to the political bias of the writer. Nonetheless, they are attempts to apply theoretical and analytical methods to the writing of history.

Similar attempts were being made in the field of the ethnic religion. As I have already noted, this religion consisted of no more than magical rites and had no teachings or written classics. The first documentary teaching for the ethnic religion was a book entitled *Shinto Gobusho* (The Five Classics of Shinto), which was a set of forgeries by the priests of the Outer Shrine at Ise. It was the basis on which what is called Ise Shinto developed. In the late fifteenth century, Yoshida Kanetomo (1435–1511) instituted what is called Yuiitsu (Primal) Shinto, or Yoshida Shinto, which was related to the Confucian Shinto evolved by scholars in the Edo period.

All of these teachings were unrelated to the actual Shinto faith of the people and were indeed no more than manipulations of concepts performed with the aim of increasing the authority of the professional Shinto priest. Since they were attempts to give a set of doctrinal teachings to something that basically lacked them, Shinto writings of this kind were very little more than absurd pastiches of Buddhist and Taoist ideas with distorted additions borrowed from the *Kojiki* and the *Nihon Shoki*. Nonetheless, even such works reveal the prevailing dissatisfaction with the mere recording of facts.

From the standpoint of literary heritage and output, the most important manifestation of the new interest in speculative thought was the work of writers of philosophical miscellanies. The two most outstanding examples of the genre are the *Hojoki* (Record of a Ten-Foot-Square Hut), produced in 1212 by the retired courtier Kamo Chomei (1151–1213), and the *Tsurezuregusa* (Grasses of Idleness), written by another retired courtier, Yoshida Kenko (1283–1350). Although such miscellaneous jottings carry on the diary tradition and are part of the general class that includes the *Makura no Soshi*, they are both permeated with contemplative thought about humanity and the world and are more than records of sensitive impressions. The *Hojoki* expresses the negative attitude of a man who retired to a hermitage on Mount Hino, where he reflected on the earth-shattering changes that he saw in the collapse of aristocratic society and where he sought spiritual and mental repose. The approach of the *Tsurezuregusa* is more positive. Its author looks steadily at the contradictory aspects of man and the world and seems to find in them a new beauty and stability. Furthermore, he does not reject the support found in the accumulation of wealth. The two works are separated in time by nearly one hundred and twenty years, and the tone of the second no doubt bears traces of the growth of the newly rising feudal society. Although neither is based on a consistent philosophy, neither is guilty of the kind of borrowing that is the basis of the so-called Shinto classics. Both manifest a growing ability to develop opinions and conceptions about the world and about humanity, and these opinions and conceptions have a meaning that differs from that of the new Buddhism of the times.

For the Japanese ruling class, from the time

when the nation was governed under penal and administrative codes, Confucianism was the very essence of scholarship, but Confucian studies were limited to the kind of commentaries and textual interpretations in the field of the classics that were the major scholarly tradition of China in the Han (206 B.C. to A.D. 220) and T'ang (618–907) periods. Such studies were understandably less than popular, and it appears that more artistic classics like the *Shih Chi* (Historical Records) and the literary anthologies were much more widely appreciated. In the Sung period (960–1279), however, great development in philosophical theories took place against a background of Buddhist thought. These theories found formulation in Neo-Confucianism, which was introduced into Japan around the fourteenth century. At that time Rinzai Zen, which had achieved popularity, taught that Zen culture consisted of a blend of the teachings of Confucianism, Buddhism, and Taoism. It is not surprising that Zen priests were the first to study Neo-Confucianism. For a long time its doctrines did not penetrate Japanese society as a whole, and it thus failed to offer the people a new morality. Nonetheless, it deserves special mention because it was later to become the source from which Confucianism grew to be the controlling morality in the period of mature feudalism.

THE PERSISTENCE OF THE ARISTOCRATIC TRADITION

The authority of the Kyoto imperial court persisted even after the establishment of the Kamakura shogunate in 1185 and the ascent of the warrior class to political leadership. The aristocratic cultural tradition also remained unbroken. For instance, during the time of troubles that ensued after 1177, aristocratic poets like Fujiwara Teika fled from the strife of the actual world to seek a fantasy world of beauty where they could forget suffering and anxiety. Their attitude was different from that of other notable men of roughly the same epoch. Kamo Chomei found peace in a mountain retreat but kept his eye constantly on the changing situation of the practical world. Honen and Shinran threw themselves unflinchingly into the world of human suffering and sought a paradoxical kind of salvation in the very act. The aristocratic poets, like Teika, did not flee from the dirty, decaying capital city, though they retired from participation in the affairs of public life. They clung to the fading authority of their class and, as a result of their complicated approach, were able to develop the important aesthetic theory of mystery and subtlety (*yugen*) represented in the poetry anthology known as the *Shin Kokinshu*, or *Shin Kokin Wakashu* (New Anthology of Old and Modern Japanese Poems), compiled during the early Kamakura period and completed in 1205.

The natural descriptions found in the poems in this anthology are not realistic. Instead they rise on the wings of rhetoric and fantasy to become artificially produced concepts without counterparts in actual phenomena. They vividly reveal the mental state of a declining upper class that, while losing contact with reality, cannot forget the glories of the past and continues to boast in a way that is somehow sad. Though less vigorous in tone than the *Man'yoshu,* the *Shin Kokinshu* is technically and stylistically much better than such other anthologies as the *Kokinshu*. Together with the *Man'yoshu,* it is one of the two high points in the history of Japanese *waka*-style poetry.

In spite of such achievements as this, however, it was difficult for a failing social class to pursue a course of wholesome cultural development. After the *Shin Kokinshu,* aristocratic poetry lost creative power. It came to be excessively involved with meaningless secret compositional tricks. Disputes among various schools of poetry and other unproductive activities proved symptomatic of an art approaching the termination of its vigor. Gradually other forms—the *renga* (a variation of the *waka*) and the offshoot of the *renga* known as the *haikai*—came to occupy positions of preeminence in poetry. Still, the *waka* tradition never entirely died out but persisted into later periods in the works of such poets as Okuma Kotomichi (1798–1868) and the group of poets published in the early-twentieth-century magazine *Myojo*. Persistence of this kind

indicates the deep-rooted nature that, for better or for worse, characterizes Japanese cultural traditions.

Although the warrior class of the Kamakura period succeeded in gaining political ascendancy over the aristocrats, in terms of cultural achievement they remained subordinate. This is indicated by the fervor with which they were eager to learn from their cultural betters and to emulate them. For instance, the remote Northern branch of the Fujiwara family copied the aristocratic culture of the capital by building, in distant Hiraizumi, the richly decorated temples Chuson-ji and Muryoko-in. The Kamakura shoguns and regents, after the time of Minamoto Yoritomo, founder of the shogunate, invited poets, painters, and Buddhist sculptors (notably Unkei) from the capital to bring to their city the culture of the aristocracy. An example of the influence of the court on the warrior political leaders can be seen in one aspect of the life of Minamoto Sanetomo (1192–1219), the third shogun, who is said to have become a poet in the tradition of the *Man'yoshu* after he received a copy of this work from Fujiwara Teika. Other examples of the same kind could be cited.

In short, it is a mistake to overlook the aspirations of the warriors toward aristocratic culture and to see them as no more than people who emphasized the martial life and the warrior's moral code to the exclusion of all else. The admiration they held for the culture of the capital is clearly proved by the fact that at least fifty members of the Hojo clan, from which emerged the warriors who became regents of the shogunate, had poems published in the imperial anthologies. (Fifty is only the number recorded as having contributed; the actual number may have been larger.) Hojo Sanetoki (1224–76) founded the famous Kanazawa Library in Kanazawa (now part of Yokohama) for the collection of copies of the classics. Today books thought to have been part of this ancient collection are still to be seen in the Shomyo-ji, in Kanazawa. It would seem that the warriors acted as guardians of an aristocratic cultural tradition that stood on the verge of annihilation. This role of the military rulers in Kamakura times suggests that a social class can inherit and carry on a cultural tradition that bears the stamp of creators from a distinctly different social class.

THE DISSOLUTION OF THE MANOR SYSTEM AND THE DECLINE OF ANCIENT POWER

Year by year the constables (*shugo*) and stewards (*jito*) of the ruling warrior class made increasing inroads on the political power and the landed manorial holdings of the aristocrats, who were struggling to retain their position in the capital. But still other forces were at work for the downfall of the Kamakura shogunal government. From 1219 to 1221 the retired emperor Gotoba was involved in an uprising against the shogunate. This event, known as the Jokyo Insurrection, after the era name, resulted in an easy victory for the shogunate and in defeat and subsequent banishment for the retired emperor. In 1334, however, different circumstances permitted the emperor Godaigo to overthrow the Kamakura government and to install himself as actual ruler of the nation. The brief period in which he ruled is called the Kemmu Restoration. But Godaigo's efforts were doomed to failure from the outset, since it was impossible to turn the tide of growth of a feudal society and to restore the aristocrats to political power. When once again the warriors reversed the political restoration and broke up unified aristocratic government, the nation entered a period marked by warfare between two imperial courts, one in the north and one in the south—hence the name Nambokucho, or Period of the Northern and the Southern Courts (1336–92). Because of the disorderly state of the country at this time, each local political power began to work solely for the sake of its own aggrandizement, and the destruction of government based on models of the ancient society proceeded at an increasing rate.

At the basis of the conversion of the nation from an ancient social order to a newer feudal order was the steadily increasing progress in production power that took place throughout the thirteenth, fourteenth, and fifteenth centuries. Growing use of iron agricultural implements, the horse and ox for

cultivation purposes, and the water wheel for irrigation resulted in more abundant harvests. When it became possible to raise two crops yearly, the way of life of the peasants became relatively more comfortable. Merchants emerged from the peasant class, and with this development a budding commercial economy necessitated periodic markets and consequently broke down the old self-sufficiency of the enclosed world of the landed manor. The sphere of economic activities expanded. Imports of minted coins from China of the Sung, Yuan, and Ming periods—most notably of the Ming—stimulated the development of a commercial economy.

Supported by these historical trends, the upward movement of popular power grew stronger. The metabolic process by which the inferior gradually takes the place of the heretofore superior—the process is called *gekokujo* in Japanese and means the conquest of the upper by the lower—increased in intensity. The power of the warriors after the overthrow of the so-called Kemmu Restoration of imperial power was immense, and the Ashikaga shogunate (1336–1568) skillfully employed the dissatisfaction of the military class to destroy the unified government created by a coalition of warriors and aristocrats. Nonetheless, the Ashikaga shogunate was never able to become a powerful central authority. Although it held a position of great superiority over the already powerless aristocracy, it never succeeded in becoming even *primus inter pares* with the regional constables, who gradually developed into what is known as constable daimyo (*shugo daimyo*), or feudal lords ruling over one or more entire provinces. The best the Ashikaga shogunate was able to do was to calm the insurrections instigated, one after the other, by these constable daimyo.

With the Onin War (1467–77) Japan entered the century of civil strife known as the Sengoku Jidai, or Age of Warring Provinces, a time when it became impossible to put the orders of the Ashikaga shogunate into effect because of the confusion that reigned in the capital and many other parts of the country. Each of the powerful daimyo made use of the expanded economic sphere to increase his own holdings. In doing this, they all returned to something like the ancient manor system and, by putting both the land and the people tilling it under their direct control, established a truly feudal society. It is important to remember that many of the men who made themselves feudal lords under this system of land control were parvenus from the lower ranks who, in the long period of social disorder, formed a new ruling class that crushed the proud old families who had long ruled the land as constables. In terms of system, the last remnants of the old way were abolished. In terms of social composition, many people who had been in high places fell, while many of those who had been of low rank rose to lofty positions. Because of the workings of a force from below, what had been a two-dimensional opposition resolved itself into a one-dimensional structure amounting to a completed feudal order.

This process did not take place as the result of the intrusion of a few members of an upstart group into the ranks of the ruling class. In the background was the social growth of the masses, a phenomenon that must not be overlooked. One manifestation of the rise of the people is to be seen in the tendency to collect in groups. People who formerly lived scattered among the lands of manorial holdings came together in villages. They elected representatives to councils and bound themselves by social contracts, thereby achieving the ability to conduct local affairs in an autonomous way. No longer did they limit themselves to passive resistance against burdens imposed from above. Instead, they frequently resorted to agrarian uprisings (*do-ikki*). Developments of this type not only hastened the downfall of the already gravely weakened aristocratic class but also enabled the new ruling class to form huge feudal holdings and in this way to abolish the remains of the older social order. Although, once consolidated in power, the new ruling class soon confronted the common people and forced them into a life of strict servility, development among the lower orders was the enabling condition in the transition from an ancient social order to a feudal one.

At last, when feudal society was firmly en-

trenched, the ancient custom of separate domiciles for husband and wife, which had persisted from primitive times, was abolished. Nothing definite is known about the process whereby the Japanese gave up the older system and adopted the new *yome-iri* system, according to which the bride (*yome*) went to live in the husband's home, but the innovation seems to have occurred first among the members of the warrior class. In earlier times, even in warrior families, a system of split inheritance was practiced. Women could be allotted lands, and there were even examples of women appointed stewards. As time went on, warriors came to consider it unfair to grant domains to women, who were incapable of performing on the field of battle. Gradually the system of split inheritance gave way to one in which a single male offspring inherited all the lands and wealth of the father. Women were then forced into a totally subservient position.

Even under the new system, at first, the wife merely lived in the husband's home. In time, however, she began to develop a sense of domestic and matrimonial virtue and an awareness of her role as the guardian of the home. This marked a psychological refinement and improvement, for women of the aristocratic society of the past had not felt such emotions. On the other hand, before long, men began to demand forcibly that their wives abide by double-standard rules of chastity and virtue. In other words, relations between the sexes became one-sided and unjust.

Although it might have been supposed that the establishment of the feudal system would be, in a sense, a triumph for the classes that had formerly occupied the lower rungs of the social ladder, women were forced to become inferior to men, and the common people were subjected to severe exploitation at the hands of new masters. This is one of the contradictions that arise in the course of historical development.

THE CULTURAL REVERSAL The social turn of the tables that put the lowly in power and brought the mighty low was the deciding factor in raising the culture of the common people to preeminence. Although the culture of the aristocrats was still revered as classic, and although it provided material for the growth of a newer culture, it lost its creative powers and its ability for self-generation.

The social fall of the aristocrats meant the loss of cultural vitality for the entire class. Classical romances on the model of the *Genji Monogatari* ceased to be written, and no new developments took place in *waka* poetry. The imperial poetry anthologies were no longer produced, and only foolish esoteric games transmitted some of the ancient poetic traditions of the great anthologies. The art of *yamato-e* declined so seriously that it was forced to cede its dominant position to the newer schools of ink painting and to the Japanese-style painting exemplified by the work of the Kano group. Tosa Mitsunobu (1434–1525) was the last notable artist in the *yamato-e* tradition. Virtually no Buddhist sculpture worthy of consideration was produced, although this trend is linked with the secularization of religion that took place at this time. All of these changes illustrate the large-scale process of cultural change inevitable during major shufflings of social power.

The poetic form known as the *renga* (linked verse) arose as a variation of the *waka* at about this time. The *waka* is a thirty-one syllable poem divided into two hemistichs. In *renga,* one person is responsible for the composition of the first hemistich, to which another person must link a second hemistich of his own composition. *Renga* were first popular at meetings held largely among aristocrats. Gradually, this form of poetry came to attract regional warriors, Shinto and Buddhist priests, and ultimately the common people. Study of the classics and a refined aesthetic sense acquired from the aristocrats enabled *renga* poets among the commoners to make great artistic progress. In the fifteenth century, the poet Sogi (1421–1502) brought the *renga* form to perfection, and the collection called the *Shinsen Tsukubashu,* compiled by him and completed in 1495, gives a good idea of the *renga* in the age of its maturity. The characteristic nature of the genre results from several factors. Although the *renga* poets inherited and developed the spirit of

48. *Dengaku scene from* Daisen-ji Engi (Legends of the Daisen-ji) *picture scroll, by an unknown artist. Late four-teenth century; destroyed by fire in 1928 and extant in photographs only.*

the mysterious, born of the ideals of artificial and fanciful beauty represented in the poems of the *Shin Kokinshu* anthology, they eliminated sentimentality to a greater extent than did the poets of the older collections. They interpreted nature with thoroughly objective resignation, but their works, since they were composed in an impromptu fashion at poetry gatherings, are marked by spontaneous, individual responses to the subject of the moment. Today, at a time when maximum value is attached to individuality, the very idea of jointly composed poems like the *renga* may seem difficult to comprehend. Nonetheless, they vividly reveal the mood of the age in which they were produced. The *renga* and its great popularity may be interpreted as indications of the rise of popular culture. This aspect of their development is especially apparent when one recalls that Sogi traveled all over the

country. His wanderings suggest that *renga* were being composed and accepted by devotees throughout Japan.

Another outstanding art form that derived from popular sources is the Noh drama, of which the forerunner was Sarugaku Noh. From ancient times, music and dancing were performed at Japanese palaces and shrines. Such theatrical forms were either directly imported from the Asian continent or were Japanese variations of imported materials. Although they are called Gagaku, a name meaning "elegant music," these songs and dances derived from generally popular continental sources (Fig. 53). The term Gagaku was used to distinguish imported court music from the native music and dance of the Japanese people. The popular songs and dances known as Sarugaku contrasted sharply with the performances held at

49. *Kanze-school performance of Old Noh. Detail from one of a pair of sixfold screens known as* Rakuchu Rakugai Zu *(Scenes In and Around Kyoto), by an unknown artist. First half of sixteenth century. Colors on paper; each screen: height, 138 cm.; width, 348.5 cm. Agency for Cultural Affairs, Tokyo. Formerly in the Machida Collection.*

palaces and shrines in that they were presented by lower-class performers (*sarugaku hoshi*) on religious occasions such as shrine festivals and Buddhist temple ceremonies. The primitive forms of Noh performed today at rural popular festivals and other ceremonials give an idea of what Sarugaku was probably like. In the thirteenth century, such songs and dances were given organized form as entertainments that came to be known as Sarugaku Noh. The artistic form of this kind of entertainment was perfected by the actors Kan'ami and Zeami, father and son, who were active in the fourteenth century, during the time of the third Ashikaga shogun, Yoshimitsu (1358–1408). The achievements of these two men are truly impressive. In addition to being actors, they wrote plays and composed the words and music for them. Moreover, they wrote treatises revealing their theories of Noh

performances. Enjoying the patronage of the shogun and the ruling class, these men of genius were able to combine elements from such popular performing arts as Sarugaku Noh and Dengaku Noh—the latter a somewhat dramatized version of the ancient rustic dances called Dengaku (Figs. 48, 49)—to produce an art loved and respected by everyone from the rulers of the land down to the common people.

There were, of course, several very popular characteristics in the Sarugaku Noh, just as there are in the Noh as it is performed today. For instance, the play *Okina* (Old Man), which occupies a special place in the Noh canon, is derived from a magical ceremony for bountiful harvest, and the famous Noh masks (Figs. 50, 51) bear traces of the demon masks worn in rituals of sorcery and incantation. Particularly in Kan'ami's time (1334–

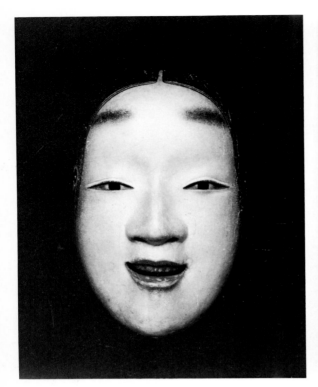 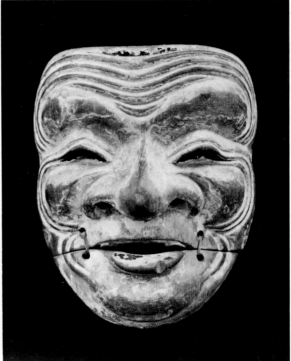

85) the popular influence was still abundantly in evidence, and the plays that he wrote and enjoyed performing were rich in dramatic effect. It should be noted that among them are works like *Jinen Koji* in which he modeled his characters on real-life figures with whom the ordinary people had a feeling of deep intimacy. Many of the plays embody stories of contemporary interest. *Sumida-gawa,* for example, tells the tragic story of a grief-stricken mother whose child has been taken away by a slave trader.

By the time of Zeami (1363–1443), however, the use of material from the classics as subjects for Noh treatment increased, and the extravagant style that had characterized Kan'ami's work underwent polishing and refinement. Among the dramas that were born of this refinement and hold the Noh stage even today are such supreme masterpieces as

Zeami's *Izutsu,* with its haunting expression of a woman's yearning for her lover, and his *Kinuta,* which presents in touching poetry the tragedy of a woman doomed to die of both love and hatred for the husband who is separated from her. The intensified elegance of the performances can probably be attributed to the need to put the dramas of Sarugaku Noh on a level where they were suitable for enjoyment by the highest-ranking warrior classes and by other members of the ruling social group who had inherited the cultural tradition of the older aristocracy. There can be no doubt, however, that this step brought about the maturity of Sarugaku Noh.

Modern Noh, developed from ceremonials of the Edo-period warrior class, has become formalized and rigid. It may seem an error to use it as a basis on which to analyze the Sarugaku Noh of the

50. *(opposite page, left). Noh mask: Magojiro, used for young female roles. Late Muromachi period. Wood; height, 21.2 cm. Collection of Hachiroemon Mitsui, Tokyo.*

51. *(opposite page, right). Noh mask: Okina, used for title role of old man in the play* Okina. *Late Muromachi period. Wood; height, 18.3 cm. Hakusan Shrine, Gifu Prefecture.*

52. *Performance of the Kyogen play* Tachi Ubai *(Sword Stealing) as pictured in the book* Kyogen Ki *(Annals of Kyogen), dated 1662.*

fourteenth and fifteenth centuries. Still, the Noh today (Fig. 54) retains many of the highly effective stage conventions of the early period. For instance, raising the hand to the face is a simple gesture that, in the Noh context, produces more profound emotional impact than actual weeping. Slightly raising or lowering the masked face expresses complicated and subtle emotions. All of the conventions of this kind were developed in the fourteenth and fifteenth centuries during the rise of the popular culture.

The farcical interlude plays called Kyogen (Fig. 52), performed between the Noh dramas themselves, do not deal with elegant classical subjects. Instead, they present unvarnished pictures of their times. Probably patterned on the Sarugaku of more ancient times, they are written in the vernacular language of the day and do not hesitate to deal frankly with the seamy side of the lives of warriors, priests, and other members of the upper classes. In contrast with the Noh itself, which tends to concentrate on dance and music, the Kyogen are filled with dramatic incidents. The most popular of all of the arts to develop up to their time, they take their subject matter from the lives of both the ordinary people and the upper classes and strive to make the members of all classes laugh. But the exposés and satires of the Kyogen lack depth, and the structures of the plays are stereotyped and deficient in creativity.

A cultural development of a similar type is seen in the story collections called *otogi-zoshi* (fairytale books) compiled in the Muromachi period. *Otogi-zoshi* attained prominence in prose when classical romances ceased to be written and military sagas lost their vitality. They were, how-

ever, stilted compositions, artistically simple and childish. It is hardly surprising that in the succeeding age they became mere pastimes for women and children. They deal with the lives of people of low social standing—for instance, the saltmaker of the story "Bunsho-zoshi" and the humble sardine seller of "Sarugenji-zoshi"—and include an abundance of folk-tale elements. It is important to point out the variety of myths and popular legends contained in these stories but lacking in such works as the *Kojiki* and *Nihon Shoki*, where myths are presented in a systematized way to substantiate the claim of the imperial house to political authority. It was necessary that the art of Japanese fiction pass through a stage like the *otogi-zoshi* on the way from the aristocratic classical art to the bourgeois fiction of the Edo period.

The tea ceremony, which does not fit into ordinary artistic genres, is another example of the upward rise of the cultural strength of the common people. Tea was introduced into Japan as a medicine by the Rinzai Zen priest Eisai (1141–1215) when he returned from Sung China. It became an item of luxury, and around the time of the Northern and Southern courts (1336–92) high-ranking warriors began to hold opulent tea parties involving the identification of tea for wagers. In Kyoto, in the sixteenth century, however, a new kind of tea ceremony began to emerge. These tea meetings were held in buildings called *sukiya*, which, though located in the city, were in quiet, wooded places where people could sit calmly in small rooms, prepare tea, and drink it slowly and thoughtfully. Since this practice was diametrically opposed to the luxurious tea-and-gambling parties of earlier times, there are many people who feel that the two cannot have sprung from the same origin. Although there is insufficient historical evidence on the subject, it seems that the *sukiya*-style tea ceremony may have risen not from the luxury of the ruling class but from the common people, who began by holding simple tea parties, which they gradually refined. With the passing of time, the simple, refined tea ceremony gained popularity with the higher classes as well.

During this age, cultural activities began to spread on an increasing scale throughout the entire country. As the warriors gained power in the outlying provinces and as lords came to rule one or more provinces, castle towns became cultural centers as well as seats of political authority. Because the collapse of the aristocratic class made it impossible for Kyoto to serve as the sole heart of all cultural affairs, many noteworthy achievements resulted from accumulations of cultural materials and from new creative forces in regions remote from the capital. Even a few examples should serve to illustrate the force of this tendency. The warrior Uesugi Norizane (?–1466) restored and expanded the curriculum of the Ashikaga College, in Shimotsuke Province (modern Tochigi Prefecture), which had originally been founded as a military school. The powerful Ouchi clan established what is sometimes called the Yamaguchi culture in the city of Yamaguchi, their stronghold. They caused many old books to be copied and published classics on Buddhism and Confucianism. The great painters Sesshu (1420–1506) and Sesson (1504–89?) worked in provincial areas. In short, whereas in the past all artistic and intellectual effort had tended to center in the city of Kyoto and its environs, from this time forward the entire nation became the stage for cultural activities.

THE SECULARIZATION OF RELIGION AND THE NEW ADVANCE IN CULTURAL DEVELOPMENTS

The intense religious spirit of the Kamakura period produced a wealth of new Buddhist sects. Rising on the changing currents of the times, these new groups expanded and took root in the lives of the common people during the fourteenth and fifteenth centuries. Particularly notable developments resulted from the efforts of the priest Nisshin (1407–88), of the Nichiren sect, and the priest Rennyo (1415–99), of the Pure Land sect. Nisshin spread his teachings among the merchant class of the cities, and Rennyo worked largely among the peasants. The Kyoto temple Honganji, of which Rennyo was once chief priest, grew so powerful that it was able to threaten the position

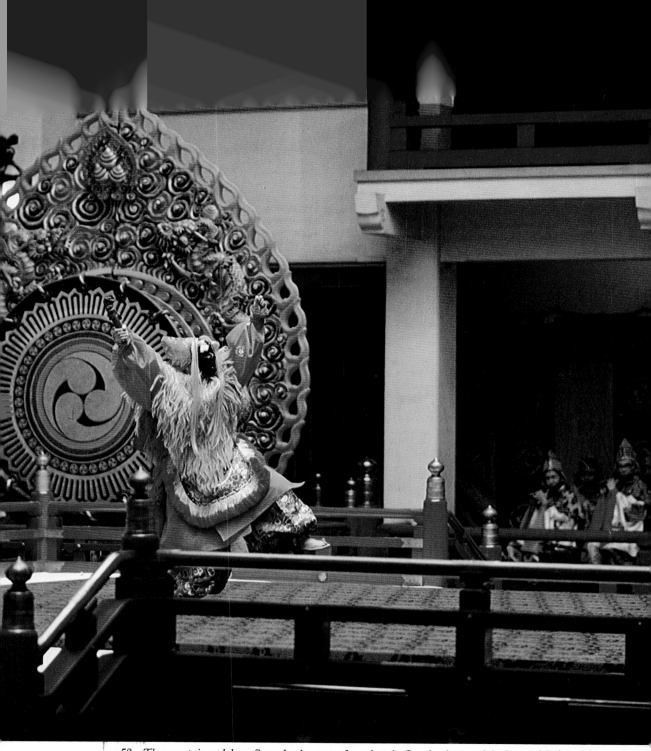

53. *The mountain-god dance* Somakusha *as performed at the Gagaku theater of the Imperial Palace, Tokyo.*

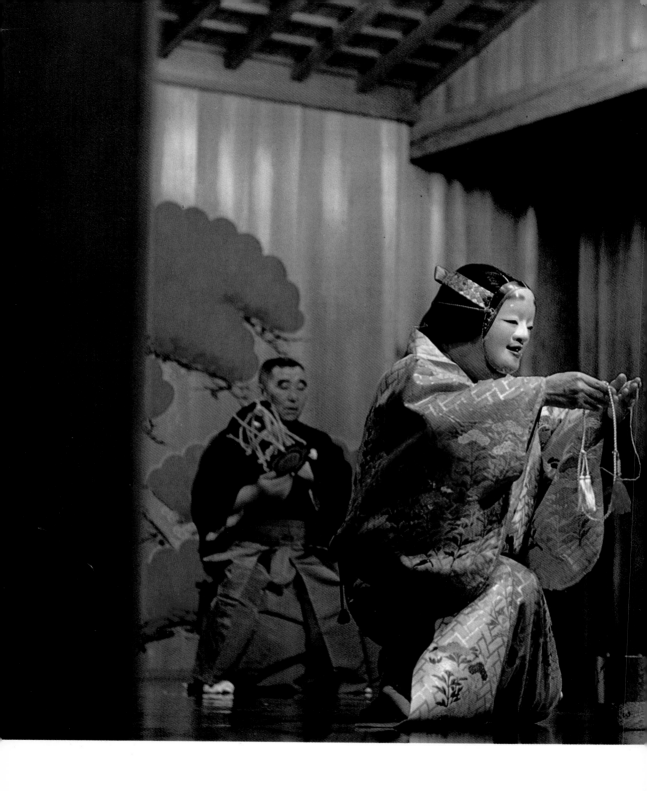

54. *Scene from the Noh play* Izutsu.

55. *Scene from the Bunraku play* Sonezaki Shinju *(The Double Suicide at Sonezaki), by Chikamatsu Monzaemon.*

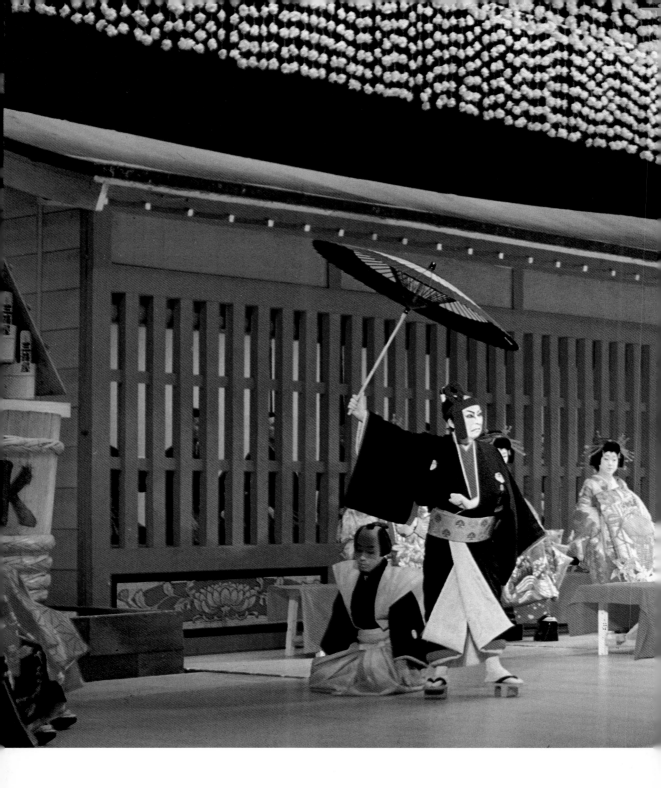

56. *Scene from the Kabuki play* Sukeroku *with Kanzaburo (left) in the title role.*

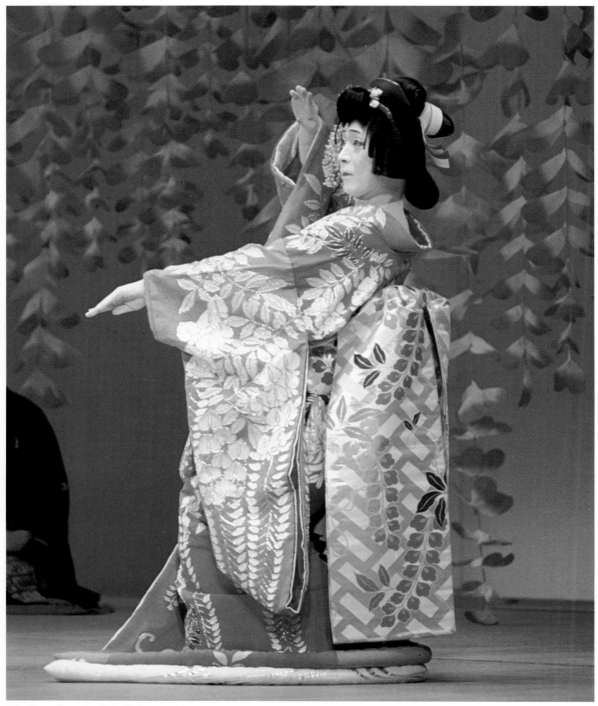

57. Scene from the Kabuki dance Fuji Musume *as performed by Kikugoro.*

of the ruling warriors by inspiring uprisings (the so-called Ikko uprisings) in many parts of the nation.

An easy way to gauge the strength of the development of the new religious groups during this time is to glance at a list of the Buddhist temples still operative in Japan today. The overwhelming majority of such temples belong to religious sects that were new and growing at the time under discussion. Whereas the older Buddhist sects, supported by the aristocracy, relied on their manor lands for income, the new sects were able to achieve tremendous growth because they appealed directly to the common people. In other words, these new sects made skillful use of the historical condition that was elevating the position of the commoners.

But external growth of Buddhist sects did not entail advances in Buddhist spiritual culture and thought. For the sake of expanding their fields of action, religious sects did not scruple to dilute the strict precepts propounded by their founders and to compromise with social realities. From the fifteenth century, Japanese Buddhism underwent no philosophical development worth considering, and in general, at about this time, it ceased to be the leading force in the world of Japanese philosophy. Because the new religious sects placed little value on outward ways of winning merit through virtue, they built few new temples. The technical level of Buddhist art dropped drastically. Furthermore, the new religious groups had lost the profound spiritual strength of the sects of ancient times, and for this reason they no longer had the energy to produce great art. For a long time after this period, Buddhism continued to occupy a prominent position in society, but it undeniably moved in the direction of secularization. The inner condition of Zen culture vividly illustrates my meaning.

The daily life and religious practices in Zen temples attempted to re-create exactly the rules that prevailed in Chinese Zen temples. These rules extended to such matters as sleeping, rising, and eating. Zen priests who had visited China in the Ming dynasty enthusiastically studied the culture of that age. Since Japanese Zen priests of the time were closely related to high society, this social level too became imbued with Ming culture. The social phenomenon is an interesting one. The old Japanese aristocracy had lost its power, and the upper levels of the warrior class rose to take its place. In their turn, seeking a culture that would suit their new position of preeminence in the nation, the warriors selected Zen, with its strong Chinese coloration, as preferable to the rising culture of the common people of Japan. The historical reason for the emphasis on Zen culture in the Muromachi period—an age otherwise known for remarkable gains in popular culture—can probably be found in the needs of the military upper class.

One of the most outstanding features of this Zen culture is the literature of the Five Monasteries, or *Gozan bungaku*, as it is called in Japanese. But since Zen rejects written scriptures as an aid to enlightenment, the very existence of such a literature is in itself odd. Indeed, it was little more than an intellectual game for pedantic Zen priests who had risen in the world. It departed from the true spirit of Zen, since it involved word manipulation, which Zen traditionally distrusts. Evidence of the secularization of Zen is to be found in abundance in the Five Monasteries literature. Nonetheless, the study of Chinese learning and Neo-Confucianism by Japanese Zen priests had one important byproduct. It produced a few written works that were to help lay the groundwork for the rise of Confucianism in the following historical period.

In the fields of graphic and plastic arts, Zen influence was strong. I have already mentioned the *chinzo*, or portraits of priests, which were popular in earlier times and remained popular in this period. Ink painting also became fashionable and was closely related to Zen. Japanese painting in the *yamato-e* style had depended on sentiment and color, but ink painting marked a dramatic change and the creation of a new painting tradition in that, limited mainly to one color, it employed asymmetry and sometimes abstraction and attempted to express its subjects in terms of spiritual or psychological interpretations.

58. Painting of Hotei (Pu-tai), by Mokuan. Fourteenth century. Ink on paper; height, 114.5 cm.; width, 48.5 cm. Private collection, Japan.

Ink painting became an element of Zen culture largely because of such early painters as the priests Mokuan and Kao, both of whom were active around the middle of the fourteenth century. Mokuan traveled to China in 1333 and died there some ten years later. He is famous for painting the fat, jolly priest Hotei (in Chinese, Pu-tai), the symbol of the man who has intuitively surpassed the sorrows of life (Fig. 58). In spite of the Zen backgrounds of such leading artists as Josetsu and Shubun, ink painting itself gradually became an art intended for aesthetic appreciation alone and lost most of its contact with religion.

I have already noted the close connection between *waka* poetry and screen and *fusuma* painting in the *yamato-e* tradition. In the case of Zen painting

also, there were literary connections. The observations of nature found in the Five Monasteries literary tradition were often combined with ink paintings in poetry-and-picture scrolls that emulated those of Sung and Yuan (or Mongol; 1280–1368) China.

Ink painting in Japan represents a rupture with the indigenous painting tradition. Painters in the ink style learned their techniques from the Chinese, and in many cases Japanese paintings were little more than imitations of Chinese originals in terms of subject matter and composition, as well as of techniques.

Sesshu (1420–1506), who returned to Japan in 1469 after a sojourn in China, produced the first truly Japanese ink-painting masterpieces. Although he studied the works of such Chinese masters as Hsia Kuei, like his forerunners in Japan he was an ardent student of the natural appearance of things, and this set him apart from the idealist Chinese mainstream. Furthermore, he did not reside in the center of artistic activities in Japan but went to various out-of-the-way places where he met and talked with people of all social classes. Sesshu created a style of ink painting that is not a copy of Chinese art and that truly expresses the inner emotions of the people of Japan (Fig. 59).

Works of the earlier *yamato-e* tradition had relied heavily on literary allusion and consequently never developed characteristic ways of treating aesthetic forms. Sesshu was the first Japanese painter to compose pictures in which space is given realistic treatment and in which formal beauty characteristic of the pictorial art is evolved. For this reason he deserves to be called the first individualistic artist in the history of Japan.

Sesson (1504–89?) was another artist who made great strides forward in the creation of a truly Japanese style of ink painting. He lived and worked largely in the cold northeastern region of the main Japanese island, Honshu, and left vivid depictions of the severity of nature in that part of the country. His *Wind and Waves* (Fig. 60), although far less grand in scale than Sesshu's celebrated *Long Landscape Scroll*, is a powerful and representative work of this distinctive artist.

59. Section from Sansui Chokan *(Long Landscape Scroll)*, *by Sesshu. Dated 1486. Ink and colors on paper; dimensions of entire scroll: height, 40 cm.; length, 1,807.5 cm. Mori Foundation, Bofu, Yamaguchi Prefecture.*

60. Wind and Waves, *by Sesson. About mid-sixteenth century. Ink on paper; height, 22.2 cm.; width 31.4 cm. Private collection, Japan.*

61. Golden Pavilion (Kinkaku) and garden pond, Rokuon-ji (Kinkaku-ji), Kyoto. Modern reconstruction of original fourteenth-century building, which was destroyed by fire in 1950.

Japanese ink painting evolved from Zen Buddhism but, with the passage of time, gradually abandoned religious topics and turned to the field of natural observation, where it was able to make creative and individual progress. The new kinds of formal aesthetics opened up by ink painting were further developed by the painters of the Kano school, who strove to combine Chinese and Japanese techniques. In doing this, they harmonized the ink painting tradition with the colorful tradition of the *yamato-e* and thereby furnished the starting point for future developments in Japanese painting.

Ink painting aimed at eliminating everything but the essentials of its subjects and at giving the essentials symbolic representation. It was around the fifteenth century that this same aesthetic approach came to be applied to the forms of

landscape gardening. The aristocrats of the past had enjoyed gardens, and their *shinden*-style residences included ponds with islands. The Amida halls built by these noblemen often fronted on ponds as well, and the surrounding gardens were ornamented with arrangements of stones. Such gardens were popular with the upper classes until Muromachi times. The garden of the famous Kinkaku-ji (Temple of the Golden Pavilion; Fig. 61), built in the Kitayama district of Kyoto by Yoshimitsu, the third Ashikaga shogun, is in the ancient Amida and Pure Land tradition. Around the middle of the Muromachi period, however, Zen temple gardens began to employ a new kind of landscaping art in which the vastness of the world of nature was given symbolic representation in highly limited spaces. Two of the finest examples of such gardens are those of

62. Shoin-*style room: tokonoma (left) and* chigaidana *(ornamental shelves) in main room of guest hall of Kojo-in. 1601. Onjo-ji, Otsu, Shiga Prefecture.*

the Ryoan-ji and the Daisen-in, in the compound of the Daitoku-ji. In the former fifteen large and small stones are set in a small plot of raked white sand that represents the sea. In the latter (Fig. 34) stone arrangements are placed to represent the complicated and multifarious views encountered along the course of a mountain river. This garden, like that of the Ryoan-ji, occupies a very small plot of land. Of course, such gardens are not completely divorced from religious associations, since they artistically represent the Buddhist pantheistic philosophy that conceives the possibility of finding the life force of the entire cosmos in a grain of dust. Nevertheless, like other aspects of Zen culture, they display a tendency to move away from religion and to concentrate on purely aesthetic refinements.

An even more striking example of the secularization of religion is to be found in the field of architecture. The traditional Japanese house today is incomplete without certain appurtenances: the tokonoma ornamental alcove and the *shoin,* a windowlike opening occupied by frames covered with translucent white paper and fitted below with a wide shelf. But these important elements were not parts of either the mansions of the rich or the homes of the poor until the middle of the Muromachi period, when they were borrowed from the architecture of temples, in which they had been features of a kind of study for priests. Even the word *genkan,* now used to designate the entranceway of a house, is a borrowed Zen term for the gate to a guest room in a temple or even for entry into the profound way of the Buddha.

With the appearance of the *shoin*-style house (Fig. 62), which included the distinctive elements

63. Flower arrangement in rikka *style by Ikenobo Senko II. From* Ikenobo Senko Rikka Zu *(Pictures of Rikka by Ikenobo Senko). 1624.*

costly painted *fusuma* panels and picture scrolls that had to be unrolled for viewing.

Japanese flower arrangement can only be understood when considered together with *shoin*-style architecture. The evolution of the tokonoma alcove for the first time gave ordinary people a place to display a vase or some other vessel containing flowers (Fig. 63). Originally, arrangement of flowers in a container was done only for the sake of offerings to the Buddha, and it seems that the aristocrats of the Heian period followed this practice. It was not until the Muromachi period, when floral arrangements came to be indispensable to the tokonoma, that the practice grew into a secular art with its own famous artists.

DAILY LIFE IN THE MUROMACHI PERIOD

Up to the end of the Muromachi age, Japan had experienced two great periods of cultural importations from the Asian continent. In the seventh and eighth centuries, borrowings had been made from the Sui and T'ang dynasties. In the thirteenth, fourteenth, and fifteenth centuries, further borrowings were made from Sung, Yuan, and Ming (1368–1644) China. Because, in the Japan of the seventh and eighth centuries, a small ruling class concentrated vast power in its own hands, the cultural importations of that time, though brilliant, had a narrow range of influence. In contrast, the cultural importations made in the thirteenth, fourteenth, and fifteenth centuries—when the common people were able to make themselves more strongly felt—were unimpressive on the surface but exercised substantial influence on the daily lives of the Japanese in a wide range of fields.

One such field is that of currency. The first coins minted in Japan are said to have been made in 708 (the opening year of the Wado reign period). After that time, coins continued to be minted, and the government exerted its authority to encourage their use. But since the economy of the nation was not a circulating one, there was little need for money. After a time its use was abandoned. By the twelfth and thirteenth centuries, however, circulation economy had made great

outlined in the preceding paragraph, there evolved a number of cultural forms that are impossible to understand outside the context of this architectural style. Until this development took place, Buddhist pictures in the home had been something to view when they were unrolled. The only pictures constantly on display for the enjoyment of the viewer were those on the decorated sliding panels known as *fusuma*. Picture scrolls could be enjoyed only when unrolled on the top of a desk or a table. But it was possible to hang pictures in the tokonoma for the sake of appreciation, and this meant that the hanging scroll became an important form in Japanese painting. Furthermore, this form enabled pictures to be more widely appreciated among ordinary people than had been possible in the days of nothing but

forward strides, and an urgent need for money arose. To meet the need, large amounts of coins were imported from China. These importations helped the Japanese establish a circulation economy and proved that cultural borrowings from abroad were no longer limited to luxuries for a small ruling class.

Another far-reaching cultural importation took place during the Kamakura period with the introduction of cotton cloth and glazed ceramic dishes (Fig. 64). Until this time, the people who could not afford the luxury of silk were forced to wear coarse linen or cloth made from the paper mulberry (*kozo*). Cotton plants were first introduced into Japan from Ming China and Korea, and in the late Muromachi period the cultivation of cotton began in the Mikawa area (the present Aichi Prefecture). This development opened the way for vast and extensive changes in the apparel of the ordinary Japanese.

A man named Kato Kagemasa traveled to Sung China, where he studied the techniques of ceramic art. Upon his return to Japan, he opened a kiln on the shore of the Seto Inland Sea and began to produce glazed ceramics, which soon became an important element in the daily lives of the people. (Still today, the name of the Seto Inland Sea appears in the word *setomono*, a generic term for chinaware.)

64. *Ash-glazed jar with three ears. Old Seto. Kamakura period. Height, 22.7 cm. Tokugawa Art Museum, Nagoya.*

The effects of glazed ceramics and cotton cloth on the Japanese way of living and thinking are difficult to overestimate. In his book on the subject, the noted ethnologist Kunio Yanagida has pointed out the fact that cotton cloth had a much greater influence than the different fabrics imported in the twentieth century. He explains that the poor people of the past found silk not only far beyond their means but also uncomfortably slick and cool. They much preferred the tactile qualities of cotton. The reds, greens, and purples of dyed cotton cloth enriched the daily lives of the people. Yanagida goes on to discuss the improvement in living and eating habits brought about by the replacement of easily soiled, unfinished wooden bowls with chinaware. He also remarks on the pleasure the ordinary man was able to take in using glazed ceramics, which had once been reserved for temples. One of those pleasures was the simple one of feeling his teeth strike against the surface of glazed dishes. Yanagida compares this to the pleasure rich people had once taken in hearing the sound made by two pieces of jade striking together. Certainly the designs painted on the glazed ceramic wares added great charm and interest to the everyday act of eating.

Not only the containers but also the food itself was seriously affected by continental influence at this time. Oils began to be used for cooking. Sugar and tea became more common than they had been. Bean curd (*tofu*) and stuffed dumplings, foods still deeply loved by the Japanese, were introduced at about this time.

CHAPTER SIX

The Culture of Established
Feudal Society

THE AESTHETICS OF
MILITARY COMMANDERS
AND RICH MERCHANTS

As feudal lords came to exercise unchallenged control over one or more entire provinces, they naturally developed their own bases of power and influence. In time, however, the so-called three great heroes Oda Nobunaga (1534–82), Toyotomi Hideyoshi (1536–98), and Tokugawa Ieyasu (1542–1616), each in his turn, imposed unified control on these provincial rulers. By conducting an extensive land survey throughout the nation, Hideyoshi effectively did away with the last vestiges of the old manor system and firmly established the feudal system of land control. In 1591 he divided the population of the country into warriors, citizens of the towns, and farmers, forbidding any movement from one class to another. He conducted what is called a great sword hunt and confiscated all weapons in the possession of the farmer class. In this way he made clear and lasting the distinction between the sword-wearing warriors and all other members of society. In short, he called a halt to the upward movement from the lower ranks of society that had been taking place until his time.

Still, during the age of these three great leaders, a mood of extravagance pervaded the country. On the international scene, trade and other exchanges between Japan and outside nations were conducted on a wide scale, and a general attitude of enterprise and daring was abroad. The cultural field was rich with lively and stirring events of kinds not to be experienced for long years after the isolation of Japan in the seventeenth century. In terms of political events, it is customary and acceptable to divide this age into the Momoyama period (1568–1603), when Nobunaga and Hideyoshi were in power, and the Edo period (1603–1868), which began when Ieyasu assumed power and lasted until the final downfall of the shogunate he established. In terms of culture, however, it is better to think of the Momoyama period as lasting for eighty years, well into the middle of the seventeenth century.

The rulers who held power before the isolation of Japan—virtually complete by 1640—forbade the guilds that had formerly held a monopoly interest in trade. The government minted money, attempted to stimulate a circulation economy, and encouraged international trade. Rich merchants of such cities as Sakai, near Osaka, and Hakata, in Kyushu, eagerly cooperated with the rulers in these matters. At this time the distinctive culture of the townspeople had not yet come into being. The major leaders in matters of culture were the military commanders, who had newly

65. *Juraku-dai castle-palace. Detail of late-sixteenth-century folding screen by an unknown artist. Colors on gold ground; dimensions of entire screen: height, 156 cm.; width, 302 cm. Mitsui Collection, Tokyo.*

risen to power and prominence, and the wealthy merchants, who were in tune with the tastes of the military. Both groups favored splendor and grandeur of scale (Fig. 76). The men of these classes allowed their magnanimous spirits to find untrammeled expression. In its power and vigor, their culture differed sharply from the elegant, but feeble, culture of the aristocrats of the past and from the full, but sometimes corrupt and petty, culture of the townspeople of the seventeenth, eighteenth, and nineteenth centuries.

The great symbol of the culture of this time is the castle. In earlier days, warriors took no more military precautions in building their homes than those of erecting a simple tower on the roof and excavating shallow moats. When long sieges had to be withstood, these men retired to strongholds built on the tops of hills. As feudal lords came to control large stretches of land, however, they moved their castles to more convenient open plains, where they became centers of the lords' holdings. With this change in location, the castle became a much more permanent thing than it had been when it served as a mere stronghold in time of siege. Feudal lords raised great stone ramparts around their castles. They dug wide, deep moats and built imposing towers and great gates. In the inner compound (*hommaru*) was the donjon, usually of three or five stories, symbolizing the lord's authority. Retainers and merchants built their homes and places of business in the vicinity, and settlements of this kind grew into castle towns, or *jokamachi*.

It is true that older Japanese architecture offers

66. Japanese Cypress, *attributed to Kano Eitoku. Second half of sixteenth century. Four panels of* fusuma *painting remounted as eightfold screen; colors and gold on paper; dimensions of entire screen: height, 170 cm.; width, 462.5 cm. Tokyo National Museum.*

the pagodas and two-story gates of temples as examples of imposing, large-scale building, but the architectural styles used in such buildings were borrowed from the Asian continent. The castle donjon, on the other hand, is an example of a multistory building produced solely by the creative imagination of the Japanese people. Furthermore, it is a unique example of a Japanese architectural form evolving from domestic architecture without relation to religion. The rulers of the aristocratic society of the past, in spite of their lofty social position, were compelled to look up to temple buildings with a profound awareness of the insignificance of mundane things and the immensity of the infinite, as symbolized by religious architecture. The generals of the feudal society entertained no such feelings of humility.

They unhesitatingly burned temples to the ground. Nobunaga, for example, destroyed the Enryaku-ji monastery on Mount Hiei in 1571, and in 1585 Hideyoshi burned the Negoro-dera. Instead of humbling themselves before religious buildings, as some of their predecessors had done, these men erected towering donjons to serve as proud symbols of their authority. Castles replaced temples as the predominant element in the world of Japanese architecture while the religious spirit faded still more noticeably.

The most grandiose castles of the time were those of Azuchi, built by Nobunaga, and Fushimi and Osaka, built by Hideyoshi, who also built the castle-palace Juraku-dai (Fig. 65). Fushimi Castle later became known as Momoyama (Peach Hill) Castle and gave its name to the historical period.

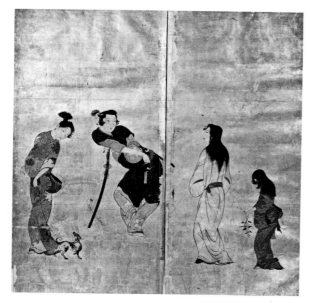

67. Detail from Hikone screen (screen handed down in the Ii family of Hikone), by an unknown artist of the Kano school. First half of seventeenth century. Six panels originally in the form of a folding screen; colors and gold on paper; each panel: height, 94 cm.; width 48 cm. Ii Collection, Shiga Prefecture.

68. Writing box called Boat Bridge (Funabashi), by Hon'ami Koetsu. Early seventeenth century. Lead and mother-of-pearl on gold lacquer; length, 24.2 cm.; width, 22.7 cm.; height, 11.8 cm. Tokyo National Museum.

(There was no place named Momoyama during Hideyoshi's lifetime.) Of the early castle buildings, hardly any have survived in original form. Even the Nagoya Castle donjon was destroyed in World War II, and only the splendid Himeji Castle (also known as the White Heron Castle, or Shirasagi-jo), near Kobe, is intact (Fig. 77).

Within castle compounds, the lords built great *shoin*-style mansions for their own residences. The sliding *fusuma* panels partitioning many of the rooms in these houses were often decorated with magnificent paintings in the rich colors and dynamic lines of the Kano school, whose style was well suited to the splendor of such buildings. Two of the most famous artists of this school are Kano Eitoku (1543–90) and Kano Sanraku (1559–1635). Even Hasegawa Tohaku (1539–1610), who is said

to partake of the tradition of Sesshu, turned his hand to gorgeous works in the Kano style.

The Kano painters attempted to fuse the colorist tendencies of the *yamato-e* tradition with the compositionalist tendencies of the ink painters (Fig. 33). Only in the Momoyama period did they break away from mere eclecticism and manifest a vital style of their own. Two of the greatest pictures of this genre are the immense Japanese cypress tree painted in rich colors by Kano Eitoku (Fig. 66) and the maple trees with bush clover and cockscomb by Hasegawa Tohaku at the Chishaku-in. Attempts of this kind to apply new perceptions to capture the beauty of plants and flowers helped artists discover a zest not found in the *yamato-e* or the ink-painting tradition. The Momoyama period introduced size and com-

positional boldness into Japanese painting, which had been remarkable mostly for elegance and delicacy. Thus Momoyama paintings must be regarded as highly unusual in Japanese art history.

In the Edo period the Kano school was to become the specially protected province of the shogunate, and, as feudal society itself rigidified, the extravagance of Momoyama-period art was to weaken and give way to trite, uninteresting stylizations. By late Momoyama times, in fact, formalization had already begun (Fig. 67). The glory of this age was not to come from the painters of the shogunate. It was to be the cometlike phenomenon of Tawaraya Sotatsu (?–1643?).

Sotatsu, who was stimulated by the aristocratic art of people in Kyoto like Karasumaru Mitsuhiro and who studied the decorative arts with such craftsmen as Hon'ami Koetsu (1558–1637; Fig. 68), revitalized the elegance of the *yamato-e* tradition with the perceptions of a new age. He has left a number of masterpieces, including the *God of Wind and God of Thunder* screens (Fig. 79) and the *Genji Monogatari* screens, that employ elements taken from artistocratic art. The style of Sotatsu's painting is replete with an entirely new decorative quality. So little is known of his biography that it is impossible to make any definite statements about it. But from the fact that there existed in Kyoto a dealer in Chinese textiles named Tawaraya, some people argue that his establishment may have been the place where Sotatsu was born. If this is true, his birthplace gives a strong hint for tracking down the source of his decorative tastes. Since his work is more in harmony with the aristocracy than with the warrior class, it is different from that of the Kano school. On the other hand, his art smacks strongly of the way of life of the wealthy merchant class that accounted in part for the spiritual vigor of the Momoyama period. An artist of distinct personality, he ranks with Sesshu as a giant of Japanese painting, though in many other respects they are diametric opposites.

People of the Momoyama period were fond of ostentation and splendor, but, in contrast, they sometimes sought calm and subtlety. The reason for this may have been that the warriors and rich merchants who felt compelled to concentrate their mental forces for the sake of secular activity needed spiritual relaxation. The painter Hasegawa Tohaku illustrates this contrast. Although he was, as I have mentioned, the painter of the picture of maples on the *fusuma* panels at the Chishaku-in, he was also an ink painter who reflected a strong desire for calm in such pictures as the screen of a grove of pine trees in fog (Fig. 69).

Still another illustration of the same contrast is the tea ceremony. Warriors and merchants held tea parties for the sake of discussing politics and business, but they also enjoyed a quiet excursion into the different world of the tea ceremony, where the only sound to break the stillness was that of the water boiling for the beverage. Sen no Rikyu (1521–91), a townsman from Sakai working under the patronage of Hideyoshi, organized the ritual of the tea ceremony into what is now called *chado*, or the way of tea. Demands for the quiet and repose of the tea ceremony made possible Rikyu's great achievements. Hideyoshi built an ostentatious golden tearoom, but he preferred the calm of the tea ceremony performed in a small room set in a grove of trees in an environment reminiscent of villages deep in the mountains.

In the Edo period, Kano-style painting and the Sarugaku Noh were to lose vitality and become conventionalized and fixed. The same thing happened to the tea ceremony, which became a formalized affair controlled completely by the heads (*iemoto*) of the several schools of tea that evolved after Rikyu's time. Today the tea ceremony is little more than a pastime for people of the leisured classes. What makes it difficult for us to reconstruct the nature of the tea ceremony in its early forms is the predominance today of suspicious documentary materials concocted by the various *iemoto*. Fortunately, the comparatively permanent evidence of teahouses and tea gardens remains to give some idea of the tea ceremony of the past.

In architecture, the tea ceremony inspired unprecedented departures. Some of the characteristic features of early teahouse architecture are still to be seen in the Tai-an teahouse of the Myoki-an in Yamazaki (Kyoto Prefecture), which

69. Pine Trees in Fog, *by Hasegawa Tohaku. Late sixteenth century. Pair of sixfold screens, of which the right-hand screen is shown here; ink on paper; dimensions of each screen: height, 155.5 cm.; width, 347 cm. Tokyo National Museum.*

70. *Interior of Tai-an teahouse. Design attributed to Sen no Rikyu. About 1582. Myoki-an, Kyoto Prefecture.*

is said to represent the tastes generally attributed to Sen no Rikyu (Fig. 70). It is thatched in a way that recalls traditional farmhouses. This and its small size (two tatami mats in area) give an immediate impression of crudeness and cramped space. But the elaborate ceiling composition, the care devoted to the smallest details, and the great skill shown in the planning of the total structure demonstrate high-level architectural mastery and create a feeling of infinity within a limited space.

The few remaining buildings that are said to have been transported to their present locations when Hideyoshi's Fushimi and Juraku-dai castle-palaces were dismantled give ample evidence of the way in which Momoyama extravagance and love of splendor led artists and artisans to cover structures with decorative carving and to use elaborate painting on *fusuma* panels and screens. In the two shrine-mausoleums of the Nikko Tosho-gu—the first completed in 1617 in accordance with the will of the first Tokugawa shogun, Ieyasu, and the second in 1636 by the third shogun, Iemitsu—

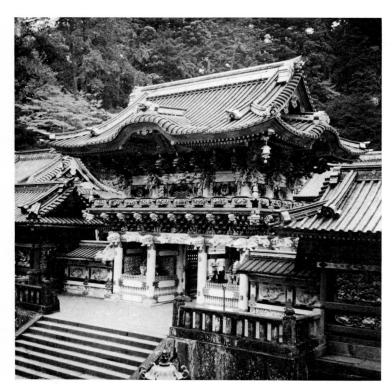

71. *Yomei-mon (Gate of Sunlight), Toshogu. Early seventeenth century. Nikko, Tochigi Prefecture.*

72. *View of Upper Garden, Shugaku-in ▷ Imperial Villa, Kyoto, showing Pond of the Bathing Dragon and "borrowed scenery."*

the tendency toward excess decoration overrides all considerations of structural integrity (Fig. 71). In general, however, the spirit that gave birth to the functional and architecturally direct style of the teahouse has held passion for ornament in check. Usually, the avoidance of extremes has saved Japanese architecture from gross errors in taste.

Although it belongs more properly to the tradition of *shoin* architecture, the Katsura Imperial Villa (or Katsura Detached Palace, as it is officially known) represents another kind of effort to avoid excess and to emphasize both dynamic beauty of structure and the functions of a place for living (Fig. 78). The buildings of the villa, placed at intervals in an exquisite garden designed for strolling, have long since become famous as one of the most noteworthy properties of Japanese

culture. Together with the garden, they were planned and constructed under the supervision of the two imperial princes Hachijo Toshihito and his son Noritada (or Toshitada) during the early years of the seventeenth century. The design of both the architecture and the landscape recalls the work of Sotatsu in that it represents an application of aristocratic cultural education.

Another example of imperial construction in the seventeenth century is the Shugaku-in Imperial Villa, built in the hills to the north of Kyoto for the emperor Gomizuno-o (1596–1680). The site commands a panoramic view that is unusual in Japanese gardens (Fig. 72).

Katsura and Shugaku-in were the final contributions to Japanese culture of an aristocracy that had lost its ancient powers and creative strength. Neither these achievements nor the aristocratic

productions of the artist Sotatsu had progeny. They were unable to provide starting points for newer, higher growth because the aristocrats themselves had lost the ability to respond to new stimuli.

INITIAL CONTACTS WITH THE WEST Up to this point I have spoken of the Momoyama cultural traits that resulted from the Japanization of elements imported from Sung, Yuan, and Ming China. But much of the sixteenth century in Japan was pervaded by an international and open mood that this limited view fails to suggest. Cultural importations from Europe, with which Japan had previously had no contacts, are too important to be overlooked.

In 1543, Portuguese sailors landed on the island of Tanegashima off the coast of Kyushu. Then, in 1549, the Jesuit missionary Francis Xavier arrived to teach Christianity. For roughly the following century, trade and missionary work on the part of the Portuguese and between the Portuguese and the Japanese advanced, only to cease with the isolation of the nation in the second decade of the seventeenth century. Cultural imports from the *nambanjin,* or southern barbarians, as the Portuguese were called, included material things like rifles and spiritual things like the Kirishitan (Catholic Christian) faith itself. Somewhat later than the Portuguese, the Spanish reached Japanese shores. Still later, the Dutch and the English arrived. All of these newcomers instigated trade relations. Toyotomi Hideyoshi's invasion of Korea in 1592, his plans to conquer Luzon, his employment of licensed ships (*shuin-*

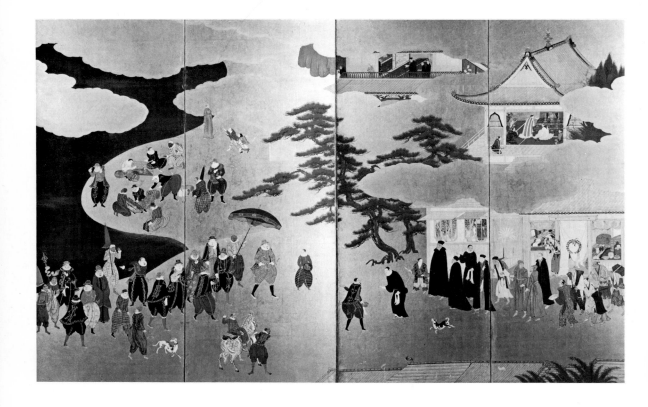

sen, or red-seal ships, so named because their licenses to engage in overseas trade bore red seals), and the expanding expeditions by Japanese vessels into the South Pacific exemplify the relatively free spirit of the times. Relations with the Portuguese and the Spanish and with other European nations were all part of the general pattern.

Before this time the Japanese had considered foreign countries to consist more or less entirely of China and India. But increasing contacts with Europeans took place in the sixteenth and early seventeenth centuries, and for the first time in their history the Japanese became aware of the existence of Western culture and thus acquired a knowledge of the wider world (Fig. 73). Nobunaga, Hideyoshi, and Ieyasu had the opportunity to study terrestrial globes and world maps and were thus able to form some idea of the relation of Japan to the whole. Knowledge of this kind brought about a complete alteration in the world view of some of the Japanese people.

Contacts with peoples of the West introduced many new things into the daily lives of the Japanese: hats, trousers, raincoats, beds, chairs, eyeglasses, clocks, tobacco, and so on. Although some of these things were to disappear from the scene in the succeeding historical period, many of them persisted in popularity. Indeed, the use of words derived from Portuguese for a number of articles of common use has continued to the present. For instance, the Japanese word for bread is still *pan,* derived from Portuguese *pão.*

In the immaterial aspects of culture, too, European ideas introduced startling things. For instance, the Japanese, who had formerly known

73. Greeting the arriving Portuguese: detail from a pair of sixfold namban screens attributed to Kano Naizen. Sixteenth century. Colors on paper; dimensions of each screen: height, 155.6 cm.; width, 364.6 cm. Kobe Municipal Museum of Namban Art.

NIPPON NO IESVS
no Coinpanhia no Superior
yori Chriſtan ni ſǒt̃ǒ no cotouari uo tagaino
mondǒ no gotoqu xidai uo vacachi tamǒ
DOCTRINA.

IESVS NO COMPANHIA NO COLLE-
gio Amacuſa ni voite Superiores no von yuru
xi uo cǒmuri, core uo fan to naſu mono na
ri. Toqinigo xuxxe no NENQI. 1592.

74. Title page of Doctrina Christan (Christian Doctrine), published in Romanized Japanese in 1592 at Amakusa, Kyushu. Copperplate print. Toyo Bunko, Tokyo.

only polytheistic or pantheistic religions, were amazed at the Christian idea of one absolute god. The concept of monogamy must have seemed astounding. The very method by which Christianity was introduced was unusual from the Japanese viewpoint. No Chinese missionary groups had ever tried proselytizing in Japan. On the contrary, the ruling Japanese class had sent representatives to China to learn Buddhism. What the upper classes learned as an outcome of such expeditions gradually filtered down to the common people. Missionaries from the European Catholic countries, on the other hand, made deliberate attempts to win converts from the masses of the Japanese people and had considerable success in a short time. The activities of the missionaries and their followers provided an opportunity for a part of the Japanese population to come into contact with several facets of Western civilization and thought.

In connection with religious ceremonies, Christians find the seven-day-week calendar indispensable. The Catholic missionaries were the first to introduce it into Japan. They also instituted such schools as the *seminario* and the *collegio* for the sake of spreading Christian teachings. They printed romanized translations of Christian texts and Japanese classics as well as dictionaries of Japanese (Fig. 74). Oil paintings and copperplate etchings revealed to the Japanese something of the nature of Western graphic art. Performances conducted in conjunction with Christian meetings showed some aspects of the music and drama of Europe.

But the Japanese were less assiduous in adopting the spiritual elements of Christian culture than they were in adopting guns, clocks, and eyeglasses.

The religious success of missionary efforts seems to have been fairly limited. Warriors wore crosses into battle as charms against injury, and commoners drank holy water in the hope of curing illnesses. In most cases it was probably magical benefits that the Japanese hoped for in taking over some of the outward trappings of the Christian faith. It is highly doubtful that Christianity was ever very effective in bringing about dramatic alterations in the spiritual constitution of the Japanese people.

Nonetheless, the ruling classes saw a threat to the newly established feudal order in the bonds of faith forming among missionaries and their converts. Oda Nobunaga had permitted the Christian faith to grow because he hoped in this way to restrain the power of the Buddhists. Toyotomi Hideyoshi, on the other hand, forbade Christianity after first having appeared to tolerate it. And in 1639 the third Tokugawa shogun, Iemitsu, refused to allow Portuguese ships to visit Japan and cruelly oppressed the Christians, many of whom suffered martyrdom. The faithful who chose death instead of renouncing their beliefs were paragons of spiritual courage, but, in the long run, oppression from above was so strong and so thorough that the Christians were all but entirely wiped out. Moreover, the Western culture that had been associated with Christianity vanished from Japan like a fleeting dream, leaving behind only a few such hardy favorites as tobacco and eyeglasses.

It is necessary here to inject a brief word about the nature of the culture brought from the West in the sixteenth and seventeenth centuries, for this importation and its failure to work a lasting change in Japanese life and thought must not be overestimated. The *namban* culture of the Portuguese and Spanish was a religious complex directly linked with the Middle Ages and was not—like the later cultural influences exerted by the Dutch—based on modern science. People who have been attracted by the exoticism of the *namban* culture and by its failure to survive sometimes overemphasize its importance and in this way gravely misunderstand its relations with the history of Japanese culture in general. Contacts with this culture were important largely because, even though only temporarily, they caused the people of Japan to expand their field of vision to include the rest of the world.

Before leaving the topic, I should like to comment on the delegation of young men sent to Europe by three Kyushu daimyo—Omura, Arima, and Otomo—and received in audience by the king of Spain and by Pope Gregory XIII in 1585. These young men were the first Japanese ever to set foot on European soil. They took with them as a gift to the pope a screen by artists of the Kano school depicting scenery at Azuchi. Certainly the screen had no lasting effect on Western art of the time, but I find the incident interesting because it shows that cultural exchanges of the Momoyama age were not absolutely limited to Japanese imports and because the screen itself is a kind of forerunner of the woodblock prints that were to exert a powerful influence on the impressionist painters of the late nineteenth century.

THE ENTRENCHMENT OF THE FEUDAL SYSTEM AND THE SUPREMACY OF CONFUCIANISM

Although a genuine feudal order had come to firm establishment in the early Edo period, there were two reasons why society was not yet entirely stabilized: the daimyo retained formidable powers of their own, and a measure of the general ebullience of the Momoyama period persisted. Nevertheless, by the time of Tokugawa Iemitsu (shogun from 1623 to 1651) the central authority of the government was rigidly fixed, and the daimyo once associated in power with the Tokugawa were compelled to accept the subordinate positions of retainers. Mobility among the classes became a thing of the past as the categories of warrior, farmer, craftsman, and merchant came to be the unshakable basis of the social order.

Such social gradation insured that the warrior class could economically coerce the farmers—the direct producers—to pay them a tax in the form of produce (*nengu*). This in turn raised an insuperable barrier between the ruling warrior

class and the ruled farmers and townspeople and further created classes below the ordinary ones. These classes were the *eta* and the *hinin*, groups considered in some respects less than fully human. Hierarchical distinctions not only separated the classes themselves but also resulted in splits within each class. Everyone was part of a system in which he was either superior or inferior to everyone else. Obviously this set of relationships held true between lords and warriors. In addition it extended with equal strength into relations between the main shop and its branches, the employer and the employee, and the landowner and the sharecropper. Further, it pervaded the family to set up clear rankings among father, wife, and elder and younger children.

As I have shown, the social position of women began to decline in the Muromachi period. It reached a nadir in the Edo period, when the practice for the wife to live in the husband's home became the generally accepted rule. In terms of the basic social structure, this age in the history of Japan is usually considered a classic example of feudalism, but, in family relations only, it might be more apt to compare it with the age of Greek and Roman slave systems. Property—more accurately the right to inherit and bequeath property—conveyed absolute authority. (What I am about to say does not apply strictly to the lower farming and merchant classes, whose lack of anything that might justly be called property forced man and wife to labor side by side in a degree of equality.) In the cases of the warrior with his fief, the rich merchant with his place of business, or the farmer with his arable land, the head of the family had the exclusive right to the property on which the welfare of the entire family depended. He alone had the right to inherit this property, and he exerted absolute authority over it and over other members of the family.

The newlywed wife—less a wife in the full sense than a woman taken into the house of the husband —was often a wretched being, deprived of all right to her husband's property and forced to put up with the pressures exerted on her by her father-in-law and mother-in-law. Whereas sexual

promiscuity was permitted, even sometimes encouraged, in men, strict chastity was demanded of wives. A woman who committed adultery was liable to the death penalty. A man was permitted to have numerous women. For instance, he might have one fully legal wife and a number of mistresses or concubines. The mistresses were compelled to be as chaste as the wives, but their social position was no better than that of servants, and they themselves were despised.

The feudal structure encouraged the spread of rigid social categorizations in positions of superiority and inferiority as a way of insuring the warriors' income from the produce of the farmers. The relations between the lord and the warrior retainer were still based on the idea of the favor of the former and the service of the latter, but when the warrior retainers came to live largely in castle towns and to be consumers living on stipends, they lost the power to resist their lords effectively. Consequently, the lords' power to control grew much greater than it had been when the warriors were firmly based in agricultural villages of their own.

I do not intend to give the impression that rigid categorization of people according to social class explains everything about the Edo period. As I shall mention later, accumulation of wealth among the merchants and impoverishment of the warriors had a relaxing effect on relations between these two classes. In the family, love and affection overcame strict authority and promoted amicable relations. Nonetheless, as long as such a social order remained the basis of the feudal structure, people were compelled to act within its framework. Such was the case in the Edo period, and the ideology that justified the order and occupied the leading position in the thought of the day was Confucianism, especially Neo-Confucianism.

The laboring classes, who had begun to rise socially but who later bowed once again to a ruling class, adhered to their beliefs in the gods and the Buddhas. But the self-made lords of the Age of Warring Provinces and the three great unifying leaders Nobunaga, Hideyoshi, and Ieyasu cared little for the older religions and had no intention

of respecting a paper morality like that of Confucianism. It is true that Ieyasu employed the Confucian scholar Fujiwara Seika, his pupil Hayashi Razan, the Zen priest Sogen, and the Tendai priest Tenkai as advisers, but this does not mean that Ieyasu was willing to submit to the teachings of any of these men. In employing them, he was only following the tradition, established in the Muromachi period, for a leader to surround himself with literati of the Five-Monasteries Zen kind.

Later, when the feudal order was firmly fixed, demands for learning increased. It then became apparent that Confucianism, and especially the brand of Confucianism developed by the Chinese scholar Chu Hsi (in Japanese, Shushi; 1130–1200) and known in Japanese as Shushigaku, could serve as an excellent theoretical foundation for the feudal social order. The fifth Tokugawa shogun, Tsunayoshi (ruled 1680–1709), decided to revise the governmental structure and to base it on a civil administration. The shogunate took definite steps to encourage the study of Confucianism, and Hayashi Nobuatsu, grandson of Hayashi Razan, was made president of the Confucian university. This step reveals the special protection afforded the Hayashi group of Confucian philosophers by the shogunal government. Called the Shoheizaka College, the university did not in fact become an official shogunate institution until 1790, in the time of Matsudaira Sadanobu, on whose advice an ordinance was passed declaring only the Shushigaku branch of Confucianism to be truly orthodox.

It is easy to see why the metaphysical theory of Neo-Confucianism was extremely attractive and useful to the ruling class, since it advocated an order of inferiority and superiority pervading the world of all human relations. Hayashi Razan had condemned the Christians for holding the theory that the world is round. He claimed that this must be an error, for if the world were round, there could be no relation of higher and lower between heaven and earth. The teachings of Neo-Confucianism were precisely what was needed by the shogunate because it too insisted on a rigid order

in which everyone was subordinate to someone else. According to these teachings, whenever two people come together, if any order at all is to be preserved between them, one must be superior to the other. In terms of social ethics, peace and tranquility can be maintained only if the proper relations of superiority are maintained between ruler and minister, parent and child, and husband and wife and if the inferior faithfully obeys the superior.

Though the Hayashi school of Confucian philosophy was not the only one in Japan—others included those of Kinoshita Jun'an and of Yamazaki Ansai—and though not all of the schools agreed on all points of discussion, it is highly doubtful that the scholarly differences among them are of any real significance. It is much more useful, for an understanding of the role of Confucian philosophy in Japanese feudal society, to examine models of everyday ethical behavior proposed by all of these schools of thought. One illustration of ethical standards taught by Neo-Confucian scholars is the book of precepts called *Yamato Zoku-kun,* written by Kaibara Ekiken (1630–1714). Considered a classic example of Neo-Confucian teaching, the book contains the following ideas about ethical living: nothing is more infamous than slandering one's lord; a person whose position does not entitle him to do so must not judge government policy; children must be devoted to their parents; and younger brothers must obey elder brothers because such relations of superior and inferior are the basis of all human morality.

Some of the most interesting moral precepts widely accepted in the Edo period were those laid down for the guidance of women. There were seven conditions that women were expected to meet in married life. A woman who failed in any one of them was—willy-nilly—liable to divorce. Of the seven conditions, two might be regarded as decreed by fate: barrenness and serious illness. A woman cannot justly be held blameworthy for either. Nevertheless, an Edo-period husband was entitled to divorce his wife on these counts if he saw fit. The other five conditions involved the behavior

of the woman. Infringements on them redounded directly on her. She must be careful never to show jealousy and never to talk too much. If she failed in these things, she could be driven from her husband's home. She was enjoined to consider her husband's mother and father more important than her own and to abide by their orders in all things. If her in-laws did not love her, she must not hate them in return. Since women had no other lords, the wife must regard her husband as her lord and serve him well. She was repeatedly and forcefully reminded that, even should her husband pursue a mistaken course, she must not hate him or be jealous of him. In short, she was instructed that she must serve as a veritable slave in the home into which she entered on marriage. There is a famous book called *Onna Daigaku* (The Great Learning for Women), which sets forth all this and more. Probably this book was compiled by several people on the basis of borrowings from the precepts of Kaibara Ekiken. Its interest lies not so much in its role as a guidebook for female behavior as in the light it sheds on the entire structure of feudal morality. It symbolizes a moral code for women that established a servility transcending even social class. Not just the wives of one special class but all women in the Edo period were expected to comply with this code. In other words, the rules set forth in works of people like Kaibara Ekiken extended throughout feudal society and concerned everything from Confucian study itself to the anti-Confucian school of thought known as Kokugaku, or National Learning. The total control of all aspects of society by a single philosophy of this kind clearly sets Edo feudalism apart from systems of more ancient times.

But thought did not always run in lines compatible with the desires of the rulers. Conflicts occurred within feudal society, and philosophy could not remain stagnant in the face of them. The first voice to be raised against the inhuman severity of Confucianism arose from within Confucianism itself. This was the voice of the Kogaku-ha, or school of Ancient Learning, which advocated the abandonment of Buddhist philosophical accretions and a return to the original teachings of Confucius and Mencius. Yamaga Soko (1622–85) was the first to criticize Neo-Confucianism openly. He did so in a book called *Shogyo Yoroku* (Essential Records of the Holy Teachings). Following him, Ito Jinsai (1627–1705), a common citizen of Kyoto, insisted that Neo-Confucianism was a secondary teaching and that the important thing was to return to the primary teachings. He instituted what is called the Horikawa-gaku school. Still a third member of the Ancient Learning group was Ogyu Sorai (1666–1728), who advocated a return to the Chinese classics.

The three schools of thought founded by these men differed, but the important point is not the discrepancies in their scholarly interpretations but the similarities in their general approaches. All of them emphasized practical action instead of empty theorizing, natural human feelings instead of formalistic moral rules, and deliberate activity instead of retrogressive conservatism. Although the social positions of the three men were different, all of them contributed to the early development of a distinctly modern kind of thinking. Soko created an ethic for warrior training. Jinsai enjoyed the pleasures of life among the merchants of Kyoto. Sorai became an adviser to the eighth Tokugawa shogun, Yoshimune (ruled 1716–45), and devoted efforts to restoring strength to a weakening feudal order.

In addition to these men, other independent thinkers assisted in making the seventeenth century a highly varied period for Japanese philosophy. Among them was Nakae Toju (1608–48), who gave up his status as a warrior to become a masterless samurai (*ronin*) and who advocated the teachings of the Ming-period Neo-Confucianist philospher Wang Yang-ming (in Japanese, O Yomei; 1472–1529). One of Nakae's disciples was Kumazawa Banzan (1619–91), whose individual way of thinking led him to claim that a specifically Japanese kind of teaching was needed to conform with the distinctive nature of the land and the people. Tominaga Nakamoto (1715–46) advanced the thought of Banzan still further.

A kind of bourgeois Confucian philosopher, born in Osaka, Nakamoto rejected the idea of a universally applicable philosophical concept. He

75. *Fudo Myo-o, by Enku. Late seventeenth century. Wood; height of entire statue, 88.9 cm. Kiyotaki-dera, Nikko, Tochigi Prefecture.*

insisted that Confucianism had been the way for ancient China, Buddhism the way for ancient India, and Shinto the way for ancient Japan but that none of them was the way for the Japan of his times. He felt that although the school of Ancient Learning and the followers of Wang Yang-ming had been able to break with the orthodox Neo-Confucianism supported by the government, they had failed to break with Confucianism itself. He became convinced that it was necessary to abandon preconceived ideas and to evolve a religion in conformity with historical facts. Nakamoto died very young and never gave his thought full manifestation. Still, his efforts deserve high praise as theoretical preparation for the later National Learning and other theories opposed to orthodox Confucian thought.

The Shinto philosopher Masuho Zanko (1655–1742), who lived the life of the ordinary people of Kyoto and gave popular lectures, sharply criticized Confucian morality for paying too much attention to formality and ceremony and for ignoring human emotions. He pointed to the many men and women who had been made unhappy because they were forced into loveless marriages and insisted that mutual affection ought to be the basis of all marital unions. In his bold insistence that true love, even when adulterous, can overcome everything, even death, and that the superiority of the male over the female is a Chinese idea ill suited to the traditional Japanese Shinto belief in the equality of the sexes, Masuho is sometimes thought to be a forerunner of the twentiety-century Japanese attitude toward the family. Actually, however,

because his thought is based on the idea of a return to primitive and ancient ways and is thus a criticism of feudal morality, this interesting philosopher belongs more properly with the advocates of National Learning and the members of the Shinto revival movement.

Buddhism, while gaining tremendous social power, underwent a grave decline in the field of philosophy during the Edo period. During the early part of the period, as a method of stamping out Christianity, a system was forcibly imposed whereby each person in the nation was required to become a lay member of a temple. As an outcome of this purely political move, Buddhism became the national religion. But the special protection that this system afforded the priesthood spelled ideological lethargy and dullness. Consequently, though possessed of strength and power and deeply rooted in the society of the nation, Buddhist religious groups became philosophically flaccid. They were no more than propounders of religious faith to the ignorant.

The last Buddhist sect to be introduced into Japan was the Obaku-shu, brought by a Chinese priest who was later naturalized and is known by his Japanese name Ingen (1592–1673). After this development no Buddhist sects were brought into or founded in premodern Japan. As religion gradually became secularized, Buddhist art ceased to generate new styles. Japanese art in general became almost completely dominated by secularism. The only notable exception to this trend was the itinerant priest Enku (1628–95), who traveled about the country carving Buddhist sculpture in a distinctive style of his own (Fig. 75).

As its fortunes improved, Confucianism assumed the leadership that Buddhism had formerly exerted. In contrast with Buddhism, whose teachings are basically related to the afterlife and to ways of escaping from the transient world of phenomena, Confucianism is totally practical, earthly, and unrelated to supernatural powers. Although Confucianism demands unquestioning obedience by the governed people, it also demands that the governors be concerned for the welfare of their charges. During the Edo period this aspect of

Confucian thought inspired extensive study in what today is called politics and economics.

Ogyu Sorai and his followers were especially notable for writings on political and economic subjects. The *Seidan* (Political Discussions) of Sorai himself and the *Keizairoku* (Economic Record) of his disciple Dazai Shundai (1680–1747) are famous examples of work in this field. These men were not satisfied with abstract philosophical discussions and attempted to define the social actualities of their time. But they did not find a way out of the contradictions that were becoming increasingly manifest in feudal society. Their works now seem impractical in comparison with the writings of later political and economic theoreticians. In the time of the eighth Tokugawa shogun, Yoshimune, reforms known as the Kyoho no Kaikaku (Reforms of the Kyoho Era) were carried out with the general aim of returning to an older and stronger feudal system and of countering the weakening of feudal control that had resulted from increasing reliance on commerce and a money economy. In his political writings Ogyu Sorai advocated improvement of the social conditions of the farmers and warriors. But he felt a need for concern about the crushing effect that such reforms would have on the merchant class and even advocated that the warriors themselves return to the land. His theories were not out of line with the trend of the Kyoho Reforms, but they were impractical because they attempted to run against the current of the times. His philosophy emphasized the importance of farmers and agriculture, but it did so for the sake of preserving agriculture as the source of income of the warrior class. It took no consideration of the humanity or welfare of the farmers themselves. Theoretically, in the Edo-period four-class hierarchy, the farmers ranked higher than the artisans and merchants of the towns, but in fact they bore the most arduous labor and tax burdens in the nation. Their position is well illustrated by the motto attributed to the tax collectors of the times: "The peasant is like a wet towel: the more you squeeze him, the more comes out."

This approach to the farmer was considered only common sense. The way of life of the entire peas-

ant class was fixed at a level that barely enabled them to continue producing as was demanded of them. The governing classes constantly meddled in the daily lives of the farmers by such acts as forbidding them luxuries like silk and forcing them to separate from wives who drank too much tea. Exploitation and the spread of a commodity economy, under which they must somehow survive or go completely bankrupt, forced farmers to live as modestly as possible and to work like draft animals.

Although the Edo period is famous for its popular culture, this culture was the affair of the townspeople and not of the farmers, who produced very little in the way of cultural innovations. During the growth phase of feudal society, the energy for historical and cultural progress had risen largely from rural villages. But in the Edo period, when the feudal system was firmly entrenched, the town far outstripped the country in such matters.

THE FLOURISHING OF SCHOLARSHIP AND THE SPREAD OF EDUCATION

Confucian studies were not the only field to flourish in the Edo period. History, too, was enthusiastically pursued by many scholars, as the large-scale historical writings undertaken by the Hayashi family and by the Mito branch of the house of Tokugawa indicate. Hayashi Razan (1583–1657) initiated work on the history compiled by his family and their school of Neo-Confucianist scholars. The full three hundred chapters of the work, called the *Honcho Tsugan* (General History of Our State), were finished in the time of Razan's son Shunsai (1618–80). Tokugawa Mitsukuni of Mito (1628–1700) planned a rewriting of Japanese history on a grand scale and called for the assistance of a number of historians in the project. Part of the work was finished in 1699, but writing and research continued until 1906, when the *Dai Nihon Shi* (History of Great Japan), in 397 chapters, was finished. In terms of scale and amount of time expended, this history is unparalleled. But it has other values. In spite of the thoroughgoing Confucian tone—which is only to be expected, since Confucian scholars wrote it—the history is every-

where penetrated by respect for the searching out and recording of corroborated historical facts. The spirit of scientific study is revealed in the exclusion from the *Dai Nihon Shi* of accounts of the so-called Age of the Gods, which are insusceptible to historical verification, and in the scrupulous notation of materials used as sources. In addition to the Hayashi and Mito schools of historical writing, Arai Hakuseki (1657–1725), a great scholar and administrator under two Tokugawa shoguns (the sixth, Ienobu, and the seventh, Ietsugu), is noted for distinguished achievements in the field of historical writing. For example, his *Dokushi Yoron* (Essays on Political History) is the first instance of a rational set of period divisions applied to Japanese history. In his *Koshitsu* (The Understanding of Ancient History), he attempted a rationalistic explanation of the tales of the Age of the Gods as parables of human history, and his *Hankampu* (History of the Feudal Domains) is the first history of the more important clans of Japan.

Another field in which scholarship was on the increase was that of agriculture. Not only political measures but also scientific studies were needed to support and strengthen the all-important base of agricultural production. One of the fruits of attempts to meet this social and economical need was the *Nogyo Zensho* (Complete Agriculture) of Miyazaki Yasusada (1623–97).

The distinctive Japanese system of mathematics (*wasan*) reached a high level of development at this time. It is said that the mathematical studies of Seki Takakazu (1642–1708) reached the realm of differential and integral calculus. In this case, Japanese mathematics was somewhat ahead of Newton and Leibniz. But whereas European mathematics made rational progress on the basis of natural science and applied technology, Japanese mathematics remained a scholar's amusement for the solution of interesting difficult problems and never attained systematic organization. The tragedy of Japanese mathematics was that it was forced to develop abnormally as a professional man's performing art in total isolation in a nation where the spirit of rational scientific inquiry remained underdeveloped.

76. Armor of yoroi *type with red lacing and with helmet and shoulder pieces. Kamakura period, thirteenth century. Height of* trunk section, 33.3 cm. Kushibiki Hachiman-gu, Aomori Prefecture.

78. *Middle Shoin and garden as viewed from New Shoin, Katsura Imperial Villa, Kyoto.*

◁ 77. *Main donjon of Himeji Castle. Completed in 1609. Himeji, Hyogo Prefecture.*

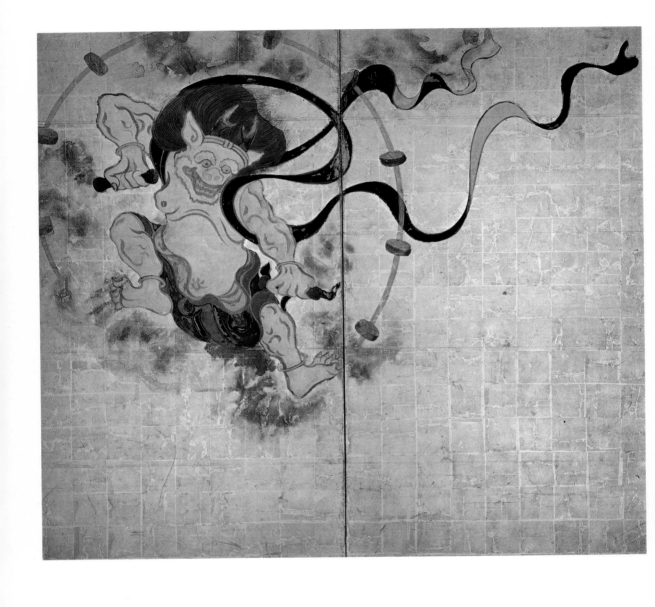

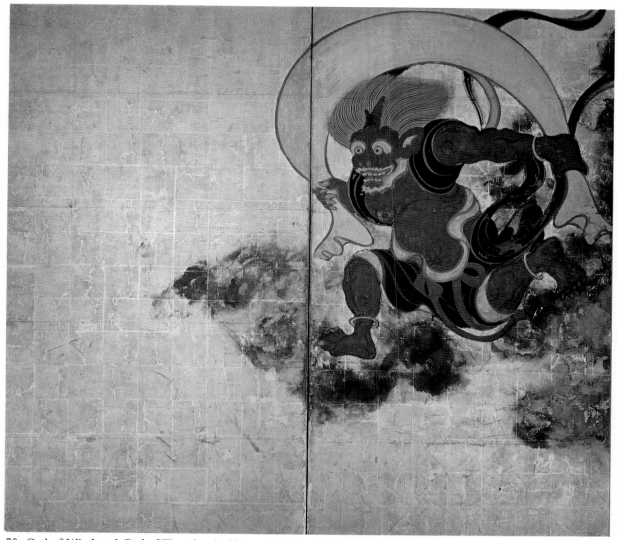

79. God of Wind and God of Thunder, *by Tawaraya Sotatsu. Mid-seventeenth century. Pair of twofold screens; colors on gold foil over paper; each screen: height, 154.5 cm.; width, 169.8 cm. Kennin-ji, Kyoto.*

日本橋

小網町

81. Miyanokoshi *from* The Fifty-three Stations on the Tokaido, *by Ando Hiroshige. Dated 1833. Woodblock print of* oban nishiki-e *type: a polychrome print averaging 26.3 by 39.3 cm. in size.*

◁ *80. Detail from* Scenes in Edo *screen, showing Nihombashi. Anonymous. First half of seventeenth century. Pair of sixfold screens; colors and gold on paper; each screen: height, 162.5 cm.; width, 363.4 cm. Hayashi Collection, Tokyo.*

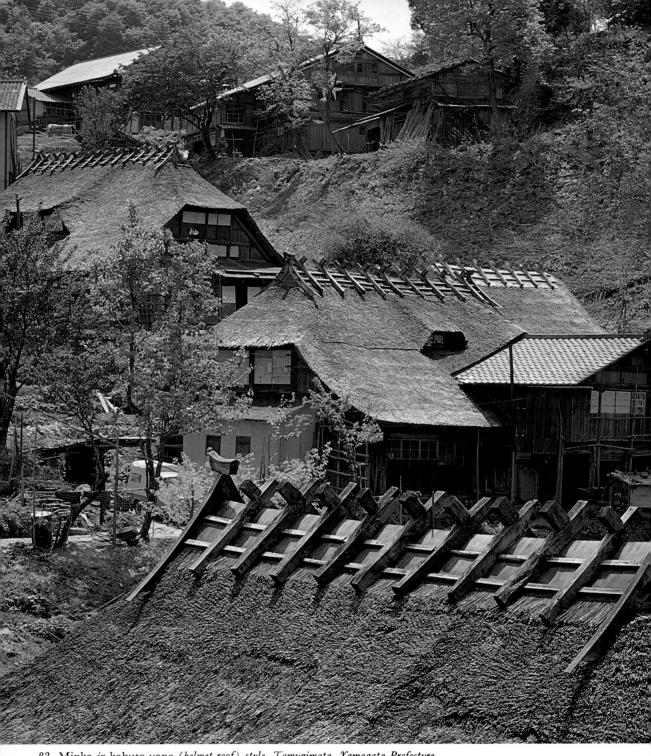

82. Minka *in* kabuto-yane *(helmet-roof) style, Tamugimata, Yamagata Prefecture.*

In general, this was a time when the prevailing peace and the need for cultural growth inspired astounding progress in the fields already discussed and in pharmacology and medicine as well. Education, of course, played a role in the stimulation of demand for cultural activities. In the middle ages, the temple served as the sole institution of learning open to children. In the Edo period, however, schools called *terakoya* (temple schools), conducted by priests or sometimes by masterless samurai, offered children of the common classes instruction in reading and writing.

The growth of printing and publishing contributed to learning by providing more books for people to read. Even in the earlier periods, Buddhist classics were sometimes printed and published in Nara and Kyoto, but, in general, books were laboriously copied by hand. In the Edo period, however, in large cities, publishing became a profitable business as more and more people printed and sold books to satisfy the rising demand for reading materials. Reliance on printed books commercially produced and sold is one of the characteristics that distinguish Edo town culture from the cultures of preceding ages. The ruling classes may not have approved of burgeoning knowledge among the common people, but the process had already begun, and there was no way to stop it.

THE DEVELOPMENT OF POPULAR ARTS The development of a strong commodity economy and the elevation of the ordinary townsman's social position are basic trends that must be considered in examining the historical causes of the budding intellectual activities in Edo times. The feudal society necessarily rested on a foundation of maximum agricultural production, and the commodity economy tended to act to the detriment, even to the destruction, of that foundation. Ironically, however, from its very inception the feudal society required the expansion of economic spheres made possible by the commodity economy. As Japan entered a long era of peace following the internal conflict of the sixteenth century, this contradiction grew more

serious. The outcome of the situation was impoverishment for warriors and farmers, who depended absolutely on agricultural production, and enrichment for the merchants, who controlled the commodity economy and who gradually rose in social position.

Population concentration in the cities is a remarkable phenomenon of the period. In the preceding age, Kyoto had a population of something over 100,000; the important trading town of Sakai, something over 30,000; and Kamakura, something over 10,000. By the middle of the Edo period, the townspeople of Edo (Tokyo) numbered 500,000 and those of Osaka 300,000. It is not surprising to find the demands and tastes of the town being reflected strongly everywhere and to observe the gradual flourishing of a bourgeois culture in the cities (Fig. 80). Even in the realm of scholarship, where the authority of the military classes was generally most in evidence, outstanding men from the common people, like the aforementioned Ito Jinsai and Tominaga Nakamoto, played important roles.

In the arts, Sarugaku Noh and the painting style of the Kano school, both of which enjoyed the protection and patronage of the military class, lost vitality and merely repeated and preserved old traditions. Furthermore, given the restrictions imposed on them by Confucianism, the samurai code, the formalities and ceremonies of feudal morality, and demands for suppression of emotions, it is scarcely to be wondered that the warriors lost the ability to contribute to the development of the arts.

Although formerly followers in such matters, the people of the towns assumed the position of leadership in culture and ushered in the age of brilliance that probably reached its pinnacle in the Genroku era (1688–1704). One of the things that must be cited first as outstanding in the art of this age is the *haikai* poetic form, which evolved from *renga,* or linked verse. Originally used for humorous purposes, *haikai* verse reached its finest flowering in the work of the samurai-turned-commoner Matsuo Basho (1644–94), who began to write a new, more profound kind of *haikai* in 1681. Characterized by

a preoccupation with the stillness of nature, his poems, in their elegance and lack of worldliness, recall the religious attitudes of the preceding age; In contrast with *renga,* which had become trite in form and vocabulary and limited in subject matter, the *haikai* of Basho find artistic material in the lowly objects of daily life. Especially in this respect, his work is in keeping with the general trend of Edo-period art to be the art of the ordinary people.

The *haikai* (now generally called haiku), which was originally the seventeen-syllable opening verse to a *renga* series, came to be enjoyed and written as an independent form, not merely by a few specialist poets but also by a wide range of ordinary people. Because of its far-reaching popularity, it was an important phenomenon in the spread of interest in literature and art. Only seventeen syllables long, the haiku is probably one of the most compact verse forms in the world, but its very shortness and the ease with which it can be composed invited the danger of its becoming shallow and coarse in the hands of eager, but inept, amateurs. The subtle balance that Basho maintains between a lofty artistic spirit and popular appeal deserves special praise.

Another important kind of writing of the Edo period is genre literature (*ukiyo-zoshi*), which grew out of the fairy tales and stories (*otogi-zoshi* and *kana-zoshi*) of the preceding age but which, when written by an author as talented as Ihara Saikaku (1642–93), became a tool for realistic depictions of all aspects of town life. Saikaku was a composer of *haikai* poems as well as a realistic novelist. Perhaps the method of the *haikai* poet, when applied to long prose works like his famous *Koshoku Ichidai Otoko* (The Man Who Spent His Life Making Love) and *Koshoku Ichidai Onna* (The Woman Who Spent Her Life Making Love), accounts for a structural weakness that these books share with the *Genji Monogatari,* which served as a model for their creation. Still, in all of his works, from these two early ones, in which he describes the love of pleasure and wealth of the townspeople, to his later *Seken Mune San'yo* (This Scheming World) and *Saikaku Okimiyage* (Souvenir of Saikaku), in which

83. Bunshichi head, used in Bunraku for middle-aged-male roles.

he describes the struggles and resignation of the wretchedly poor, Saikaku achieved a realism that remains a high point in Japanese literary art.

The puppet drama (*ningyo joruri*) is a third characteristic art form of this age (Figs. 55, 83, 84). From ancient times, puppeteers, called *kugutsushi,* had manipulated doll figures in performances largely connected with magical religious ceremonies. Gradually, however, puppet performances came to be admired and enjoyed in their own right. During the Age of the Warring Provinces the stringed instrument known as the *jabisen* was imported into Japan from Okinawa. It was somewhat modified and became the three-stringed *shamisen* still popularly played today. The *shamisen* was used to accompany recitations of narratives called *joruri.* When these narratives were combined with puppet performances, the *ningyo joruri,* or puppet

84. Scene from Bunraku play Oshu Adachigahara, *with the famous blind puppeteer Bungoro at left.*

plays, came into being. In the early Edo period the derring-do of superhuman characters like the famous Kimpira drew the greatest audiences for *joruri* performances. But by the end of the seventeenth century the puppet theater at last reached a high level of artistic sophistication with the emergence of Takemoto Gidayu (1651–1714), who produced ballad dramas in a form named for him (*gidayu-bushi*), and his collaborator, the famous dramatist Chikamatsu Monzaemon (1653–1724). Chikamatsu wrote the kind of period pieces that show off the rapid movements of the puppets, but he is best admired today for the quiet plays in which he gave subtle and realistic expression to human emotions. In these dramas, which are intended first and foremost for performance and not for reading, Chikamatsu lacked the freedom to vary his characters to the extent that was possible

for Ihara Saikaku in his novels. Chikamatsu never presented life with the detached objectivity of Saikaku, but he revealed warm sympathy for the people in his plays, which often deal with the conflict between love and duty and which succeed in giving expression to the pathos that marked the lives of many people under the feudal regime. Arousing sympathy by means of puppets without the assistance of living actors is one of the highest achievements of the Japanese performing arts.

The Kabuki drama (Figs. 56, 57), another of the characteristic forms of this era, originated with simple dance performances called Okuni Kabuki, first given by Okuni, a girl in the service of the great Shinto shrine Izumo Taisha, and Nagoya Sanzaburo in the early seventeenth century (Fig. 85). By the latter part of that century, however, performance techniques had greatly advanced.

浄瑠璃歌舞伎芝居之図　歌川豊春画　板元　松村彌兵衛

87. Beauty Looking over Her Shoulder, *by Hishikawa Moronobu. Late seventeenth century. Hanging scroll; colors on silk; height, 63 cm.; width, 31.2 cm. Tokyo National Museum.*

85. *Okuni Kabuki as illustrated in the narrative picture scroll* Okuni Kabuki Ekotoba, *by an unknown artist. Early seventeenth century. Colors on paper; height, 18 cm.; width, 27 cm. Kyoto University Library.*

86. *Interior of late-eighteenth-century Kabuki theater as pictured in a woodblock print by Utagawa Toyoharu.*

They were to be still further improved and sophisticated by such outstanding actors as the first Ichikawa Danjuro and Sakata Tojuro.

The theater in which the plays were performed underwent drastic changes as the contents of the drama altered. At first, Kabuki performances took place on a stage that was only a replica of the stage used for the Noh drama. The audience sat on the ground around the front. Later, roofed theaters with first and second floors for the audience and with a draw curtain and the distinctive *hanamichi* runway leading from the back of the auditorium to the stage came into common use (Fig. 86). Large-scale public buildings of the kind required for Kabuki performances were entirely new in Japan, and their emergence tells something about the rising need of cultural facilities for the ordinary people.

The now world-famous ukiyo-e paintings and woodblock prints are another manifestation of the popular culture of the time. One of the meanings of the term ukiyo-e (usually defined as "pictures of the floating world") is "pictures of popular manners and mores." The ukiyo-e style was originated in 1681 by Hishikawa Moronobu (1618?–94; Fig. 87). In earlier times, *yamato-e* painters and artists of the Kano school had pictured the ways of life among the people, and ordinary painters of the town had produced many pictures of such things as the coquettish behavior of the prostitutes of the hot-springs resorts. The fondness of the ukiyo-e artists for painting beautiful women of the pleasure quarters indicates a continuation of this tradition. But the important characteristics that defined the ukiyo-e as it was perfected in the form of woodblock prints were cheap prices, mass production, and ready accessibility. These pictures dealt with prostitutes, actors, sumo wrestlers, and other popular personages, but subject matter alone did not account for the fondness the people felt for them. The methods by which they were produced and distributed were of great importance. The printing and sale of the pictures took place in a way that parallels the printing and sale of the current popular literature. True products of popular art, the ukiyo-e prints were at first made in

88. Irises *(Kakitsubata)*, by Ogata Korin. Early eight-eenth century. Pair of sixfold screens, screens, of which the left-hand screen is shown here; colors on gold foil over paper; dimensions of each screen: height, 151.2 cm.; 360.7 cm. Nezu Art Museum, Tokyo.

89. Four-eared jar with design of wisteria, by Nonomura Ninsei. Late seventeenth century. Height, 28.8 cm. Ha-kone Art Museum, Gora, Kanagawa Prefecture.

90. Square dish with basket-weave-bamboo pattern, by Ogata Kenzan. Early eighteenth century. 14.7 cm. square. Private collection, Japan.

monochrome with black ink, but later the polychrome print was developed.

Finally, improvements in the way of life of the ordinary people and an increase in the amount of money they could afford to spend on consumer items stimulated craft production. Nor were the purchasers of craft works limited to the ruling class. They included representatives of the wealthy townsmen as well. Since there were no factories and no mass-production systems, most of the craft articles produced and sold in Edo times were the works of skilled artisans who made lacquerware, ceramics, and textiles. Among the finest of these craft products are the gilded lacquerware of the painter Ogata Korin (1658–1716) and the ceramics of his brother Ogata Kenzan (1663–1743; Fig. 90) and Nonomura Ninsei (c. 1574–1660/6; Fig. 89). Korin occupies an unusual and a high place in the

history of Japanese painting because of the stylization to which he brought the manner of painting that he inherited from Sotatsu (Fig. 88). Korin's painting style is related to the work he did as a craftsman.

URBAN CULTURE IN THE GENROKU ERA

Improvements in urban living were reflected in architecture and clothing as well as in the arts and crafts. During the Momoyama period it had been unusual to find two-storied shops in the cities, but in the Edo period merchant establishments became most impressive. For the sake of protection from fire, an ever present danger in the almost entirely wooden cities of Japan, merchants began to build shops with clay and plaster walls and massive tile roofs (Fig. 105). The business districts of Edo were

91. *Summer kimono with design of pine grove, waves, and calligraphy on white ground. About Genroku era (1688–1704). Private collection, Japan.*

filled with these large buildings lined up side by side along narrow streets.

During the Genroku era the clothing of both the upper and the lower classes was colorful and gay, but, though luxurious, the costumes of the towns-people were rarely convenient or appropriate for labor. As it became more and more customary for the Japanese to sit on tatami flooring and as the people of the towns spent more and more of their time in this position, the clothes they wore lost all connection with physical work and other actions that must be performed in the standing position. In the Genroku age, the kimono reached the form still seen today: a long, one-piece garment tied with a sash and topped with a short outer coat

(Fig. 91). This costume clearly reflects the largely sedentary way of life of the cities of those times. Farmers and people who must do physical labor have never found the kimono convenient and therefore have always preferred close-fitting sleeves and trousers or bloomers (*momohiki*) to the flowing skirts and sleeves of the kimono.

The artificiality and inconvenience of the Japanese costume reached a pinnacle in the clothing of leisure-class women, who wore long trailing garments and large cumbersome sashes tied in great bows at the back. This apparel was related to the lowered social position of the female. The women of the warrior class and of the wealthy segment of the merchant class, deprived of opportunities for

productive activity and freedom of action and restricted to the role of an outlet for the sexual appetites of the males, sacrificed efficiency and adopted elaborate clothes and coiffures for the sake of preserving doll-like femininity. It is a great mistake to assume that the costumes of this period reflected the true and ancient Japanese tradition in sartorial matters.

Part of the ability of the popular culture to play a creative and progressive role at this time is explained by a general human desire for equality and freedom and a reaction against the hypocrisy and inhumanity of the morality prevalent among the ruling classes. Nonetheless, this same popular culture reveals its own kind of unpleasant aspects, especially in a powerful hedonistic current directed toward the satisfaction of instinctive desires. Extramarital relations on the part of men were regarded as harmless mischief. Ihara Saikaku opposes the orthodox moral viewpoint that such sex is criminal and extols freedom in the love affairs of the characters in his books. But these romances usually end as no more than an affirmation of the satisfaction of physical desire. In this, Saikaku illustrates the moral dichotomy of his times.

Earlier I said that the term ukiyo-e refers to the customs of the people. It can also be said to concern matters of sex. In this connection it is interesting to note that roughly one-third of the prints by Moronobu depict sexual intercourse. Pictures of the same kind were produced by all the other ukiyo-e artists. But the fondness for what would today be called pornography is best interpreted as a traditional Japanese lack of taboos on sexual matters. Nonetheless, such pictures underscore the fundamentally worldly nature of the townsmen of the Genroku era. For them, religion was directed only toward success in business. If their attitude reflects an absence of fear about the other world, it also reveals their failure to come to grips with the basic issues of the human condition.

In the final analysis the merits and faults of the urban culture derived largely from the historical position in which the townsmen found themselves. Whatever improvements occurred in the social position of the commoners necessarily took place within the framework of feudal society. The warrior class, which headed the system, provided the best customers of the merchant townsmen, who were therefore in no position to oppose feudal power or to try to establish a modern kind of capitalism, as the bourgeoisie of Europe did. It would be difficult to expect a culture of the kind created by the Japanese townsmen to do any more than attempt to mitigate some of the abuses of the feudal system. Their class included no revolutionary elements.

As is explained by some of the characters in the plays of Chikamatsu, the awareness of the equality of warrior and townsman in basic humanity was beginning to dawn at this time. The man of the town was both conscious and proud of his own way of life, which was as vital to him as the way of the samurai was to the warrior class, though it involved mostly profit and the amassing of wealth. But no one would have dreamed of attempting to alter the social system. The merchant class knew that its economic power, to a certain extent, protected it from the warriors, who needed it. But a common man with no productive and no progressive world in which to interest himself could do nothing but concentrate on making and spending money. It is not surprising that some of the merchant townsmen felt impelled to squander their gold in amusements in the famous gay quarters of the large cities. Indeed, it is for this reason that much of the urban culture of this age is related to those very quarters.

CHAPTER SEVEN

The Culture of Feudal Decline

THE DECLINE OF THE FEUDAL SYSTEM AND THE OVERRIPENESS OF URBAN CULTURE

As time passed and the new commodity economy developed, the situation of the warrior and farmer classes grew more distressing. The eighth Tokugawa shogun, Yoshimune, who assumed authority in 1716, attempted to stem this tide and to bolster the feudal order by means of a series of conservative reforms. Under the rule of the tenth shogun, Ieharu, which lasted from 1760 to 1786, Tanuma Okitsugu (1719–88) was in virtually complete control of governmental affairs. He attempted to regulate the development of the commodity economy by colluding with the merchants, but when the extent of his complicity in commercial matters became publicly known, he fell from power in a barrage of concentrated criticism. Then, in 1787, during the rule of the eleventh shogun, Ienari (1787–1837), the leading government elder, Matsudaira Sadanobu (1758–1829), instituted what is known as the Kansei Reform. This program was an attempt to return to old ways. It regulated the administration and revamped financial policies by encouraging thrift, controlling extravagance, offering financial assistance to the warrior class, and preventing the depopulation of rural villages. But with the retirement of Sadanobu in 1793, the shogun Ienari assumed control himself, and the regulative policies were abandoned, while upper and lower classes indulged in a splurge of sensational pleasure seeking. The period in which this took place is referred to as the "overmature period of Edo culture" and was a time of hedonism and extravagance throughout the nation.

Under the leadership of Mizuno Tadakuni (1794–1851), who served as an elder from 1841 to 1843, during the rule of the twelfth shogun, Ieyoshi (1837–53), still another—and the last—attempt was made to restore the stability of the old feudal order by encouraging thriftiness, regulating the manners and behavior of the people, and putting the financial affairs of the nation in good order. These attempts, part of a program that is called the Tempo Reform, caused extensive parts of the city of Edo to be conceded to the shogunate, put newly prosperous merchants in rural villages under the direct control of the government, and attempted to centralize authority in an absolutist fashion that aroused opposition from all sides, with the effect that Tadakuni lost power in 1843. From this time onward, the Tokugawa shogunate declined steadily.

As this brief sketch shows, time passed in recurring cycles of interventionist conservative attempts to employ controls for shoring up the increasing rift in the feudal society followed by cycles of laissez-faire, practical policies geared to conform with prevailing currents. No matter what the intention of the reformers, the only result of their efforts was to stimulate the growth of the

commodity economy and subsequent alterations in the basic nature of the social system. Ordinarily, each bout of conservative reforms imposed strict controls on the culture of the townsmen. But since oppressive laws demanding total obedience cannot engender wholesome cultural growth, the overripeness and degeneracy of the urban culture remained uncorrected. Although the people adopted poses of compliance with regulations imposed by authority, they nonetheless persisted in seeking the satisfaction of their desires. In other words, governmental attempts to stem them did nothing but intensify the unwholesome aspects of society.

The peaceful balmy way of life of the townsmen of the late eighteenth and early nineteenth centuries supported an overripe consumer culture. It could not blaze new trails, however, because it did not stimulate accumulation of revolutionary energy. There are instances in which this very culture supported later philosophical and scholarly movements for a break with feudal ideology. This deserves praise. In terms of basic nature and of relations with historical actuality, however, this culture is less praiseworthy. As I have already mentioned, the culture of the aristocrats of the late Heian period was isolated from historical reality. Something similar can be said about the culture of the townspeople in the time when the feudal system had entered its period of decline. Although the art of this time is more subtle and refined than that of the vigorous Genroku era, instead of being directly related to the historical current it seems to travel in a kind of dead-end street.

After the works of Ihara Saikaku, the novel became stereotyped and degenerate. Later a number of different kinds of popular reading material developed: didactic storybooks, novelettes about life in the pleasure quarters, so-called comic books, and love stories. Among the didactic storybooks one of the most impressive is the very long *Nanso Satomi Hakkenden* of Takizawa Bakin (1767–1848). This book, which relates historically based material about eight warrior heroes, each of whom had a noble dog for an ancestor, took the author twenty-eight years to complete and runs to 106 volumes. In spite of the enormous length of the work, the characters are hackneyed, and the feudal morality of "admire virtue and chastise vice" is mechanically introduced, with the result that the total effect is extremely unnatural. Aside from its complicated plot, it has little charm. Other similar long storybooks, called *kusa-zoshi* and evolved from children's picture books, are no better.

These *kusa-zoshi* were in fact more picture books than novels with texts intended to be enjoyed for themselves. The independent pictures, including the cover, were done by artists of the ukiyo-e tradition. The illustrations printed with the text were the major attraction, for the stories were often unrealistic and absurd. Indeed, when the illustrations for these books began to draw more and more heavily on the performance styles of the Kabuki for inspiration, the texts lost what little intrinsic interest they had ever had.

In comparison with these books, the *sharebon,* or novelettes about life and love among the patrons and women of pleasure in the gay quarters, are more true to life, even if the monotony of their subject matter is boring. The most noteworthy of the *kokkeibon,* or comic books, of the period are the *Ukiyo-buro* (Bathhouse of the Floating World) and *Ukiyo-doko* (Barbershop of the Floating World) by Shikitei Samba (1776–1822), in which dialogues among the young and old customers of these two kinds of establishments produce a lively and realistic impression of the mood of contemporary life. With a considerable amount of such artificial material as devices copied from the Kyogen farces, *Tokaido-chu Hizakurige* (Shank's Mare Along the Tokaido), by Jippensha Ikku (1765–1831), is less realistic than the books of Shikitei Samba. Nonetheless, it is interesting because of the way in which it reveals the carefree attitudes of the Edo townsmen.

Among the love stories (called *ninjobon*), the most outstanding is the *Shunshoku Umegoyomi* of Tamenaga Shunsui (1790–1843), which uses illustrations to create the atmosphere and to tell the story of the ins and outs of love affairs in the

pleasure quarters. Because books of this type succeed in picturing one aspect of the overripeness of the urban culture, they are artistically superior to the didactic novels and the other kinds of illustrated books. Still, they are small in scale, philosophically shallow, and lacking in dignity.

One aspect of the popular culture of the times not related to printed matter was the growth of the *yose,* or variety hall, where people gathered to hear lectures and to laugh with raconteurs of humorous stories known as *rakugo.* This was a new cultural development and one that has persisted to the present, for *rakugo* entertainment, which calls upon the everyday lives of ordinary people for its material, is a kind of art of laughter that, refined and improved over many years, is still very much alive.

After the time of Chikamatsu Monzaemon, excessively eager search for variety led writers of scripts for the puppet theater to abandon the unified story and to prefer series of isolated scenes that attracted audiences because of the chance they provided for lively movement on the part of the puppets. Performances that gave precedence to music over story gained in popularity. In the Kabuki, on the other hand, play structures made considerable progress as, during the declining age of the shogunate, such writers as Tsuruya Namboku (1755–1829) and Kawatake Mokuami (1816–93) produced plays that realistically represented the world as they saw it. Indeed, the style of the Kabuki, which still draws large crowds, reached perfection in the time of these men. But, from its inception to the present, Kabuki has been a performing art that places more importance on the attractions of the individual actor than on the content or form of the play itself. It has relied on the popularity of its stars, and for this reason it tends to present programs of isolated scenes and dances that show off the actors' talents to best advantage. In this, Kabuki followed a trend that I have pointed out in connection with the puppet theater.

In recent times the art of the Edo townsmen has become the object of great praise, but the people of that period regarded their arts as no more than pleasant diversions and pastimes. Writers called themselves creators of literature for amusement and were unashamed to cater to the tastes of their readers. In this, they were deficient in the traits that characterize the more ancient romantic tales and the best work of the Genroku era: inner creative passion and sincere concern with the truth of human nature. In portraying sexual affairs and romance the writers of the late Edo period avoided becoming mired down in hypocritical morality and remained more realistic than the Confucian writers, but this by no means indicates opposition to the orthodox feudal morality. It must be remembered that these writers remained at least superficially in step with that morality and acclaimed virtue and chastised vice in order to escape suppression by the authorities. Nor is it surprising that they should have done this, since they lacked courage and lofty ideas. Such a lack explains why the didactic storybooks and other literary forms, as well as the Kabuki, sought to titillate and excite by depicting cruel murders, evil plots, grotesque ghosts and monsters, and blatant sexual scenes. The creators of outstandingly realistic Kabuki plays were by no means free of degenerate tendencies. For instance, Namboku is famous for his tale of murder and vengeful ghosts entitled *Tokaido Yotsuya Kaidan,* and Mokuami wrote a play called *Benizara Kakezara,* in which a scene of cruel torture is a central feature. From another viewpoint, however, it is possible to interpret these apparently degenerate elements as expressions of ironic popular resistance against the feudal system, as ways of dissipating ambitious popular energies, and as reactions against the fixed social order and the feudal morality. The Kabuki pictures of the Tosa-school painter Ekin, which have only recently been brought to light, are a case in favor of such an interpretation (Fig. 92).

In poetry, the *haikai* tended to become stale, although the poet-painter Yosa Buson (1716–83) brought it into a new phase and the rural poet Kobayashi Issa (1763–1827) used it in a praiseworthy way to give poetic, faithful expression to the everyday lives of the peasants. Though later

92. Scene from Kabuki drama Sendai Hagi, *by Ekin. Eighteenth century.* Fusuma *painting; colors on paper; height, 171 cm.; width, 183 cm. Akaoka Hachiman Shrine, Kochi Prefecture.*

it was to become stereotyped and lifeless, at this time the *senryu*—a seventeen-syllable form evolved from an old game of writing first parts for already composed last parts of poems (*maekuzuke*)—produced a number of skillfully perceptive witty poems on ordinary daily life. One of the best judges and a collector of these poems at their finest was Karai Senryu (1718–90), for whom the form is named. Satirical verses in the thirty-one-character style called *kyoka* revealed the humor of the people of this age of peace, but they never amounted to truly biting satire. The form later degenerated into a game of wit.

Technical improvements in the production of ukiyo-e prints made possible the richly colored *nishiki-e* (literally, "brocade pictures"—that is, polychrome prints). Representations of beautiful women continued to be popular, especially in the works of such artists as Suzuki Harunobu (1725–70) and Kitagawa Utamaro (1753–1806). Outstanding portraits of actors were produced by Toshusai Sharaku, whose works appeared in 1794 and 1795, but about whom virtually no biographical information is available. The women painted by Harunobu (Fig. 93) and Utamaro (Fig. 94) are already famous the world over as a

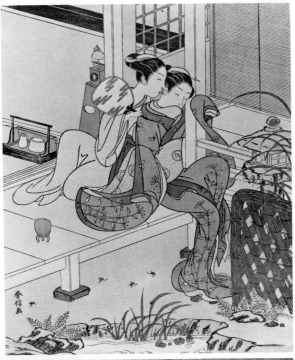

93. Whispering, *by Suzuki Harunobu. Between 1764 and 1770. Woodblock print of* chuban nishiki-e *type: a polychrome print averaging 19 by 29.3 cm. in size.*

94. Three Beauties of the Kansei Era, *by Kitagawa Utamaro. Between 1789 and 1801. Woodblock print of* oban nishiki-e *type: a polychrome print averaging 26.3 by 39.3 cm. in size.*

95. The Actor Ichikawa Komazo II as Shiga Daishichi, *by Toshusai Sharaku. Dated 1794. Woodblock mica print of* oban nishiki-e *type: a polychrome print averaging 26.3 by 39.3 cm. in size. Riccar Art Museum, Tokyo.*

96. Mishima Pass in Kai Province *from* Thirty-six Views of Mount Fuji, *by Katsushika Hoku-sai. Between 1823 and 1833. Woodblock print of* oban nishiki-e *type; height, 25.5 cm.; width, 37.7 cm.*

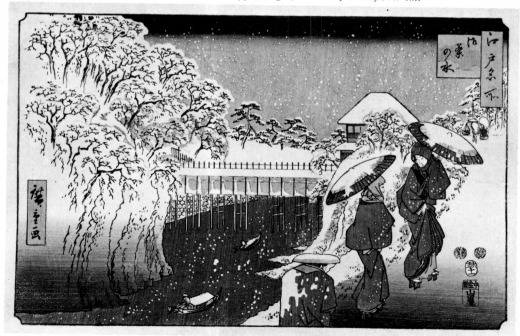

97. Ochanomizu *from* Edo Meisho (Celebrated Places in Edo), *by Ando (Ichiryusai) Hiroshige. Mid-nineteenth century. Woodblock print of* oban nishiki-e *type: a polychrome print averaging 26.3 by 39.3 cm. in size.*

98. *Detail from* Hozu River *by Maruyama Okyo. 1795. Sixfold screen; colors on paper; height, 155 cm.; width 497 cm. Nishimura Collection, Kyoto.*

type of elegant Japanese femininity, but they lack individuality to such an extent that it is difficult to tell one from the other. In this, they contrast with the more individualized pictures of beautiful women painted in the Genroku age. Perhaps it can be said that the lassitude one senses in these pictures symbolizes woman in a degenerate society. Sharaku employed perception and understanding to make his actor prints (Fig. 95) a successful exception to the general anonymity of subjects, but his work failed to find favor with his contemporaries, and after a brief career he put down his brush forever.

The woodblock print had reached an impasse in representations of human beings and the manners and mores of the people when the late period of the Tokugawa shogunate gave birth to two geniuses who pioneered a new way by developing the field of woodblock-print landscapes: Katsushika Hokusai (1760–1849) and Ando Hiroshige (1797–

1858). Hokusai is most famous today for his series *Thirty-six Views of Mount Fuji* (Fig. 96) and Hiroshige for his two series *The Fifty-three Stations on the Tokaido* and *One Hundred Views of Famous Places in Edo.* Although Hiroshige may be accused of a lack of artistic depth and sharpness in his work, this gentle, modest artist had greater success than the eccentric Hokusai in capturing the spirit of the Japanese land and people in all seasons of the year and in rain, wind, and snow (Figs. 81, 97).

The wealthy merchants of this time welcomed paintings by the Maruyama school, originated by Maruyama Okyo (1733–95), who placed emphasis on drawing from nature (Fig. 98), and the Shijo school, founded by Matsumura Goshun (1752–1811), who also painted realistic scenes of Kyoto. Artistically, however, the work of these groups seems mediocre and undistinguished.

Another school of painting that has earned much praise is that of the literati. It is based on the

99. The Pleasure of Summer, *by Yosa Buson (from* The Ten Conveniences and the Ten Pleasures*). Dated 1771. Album leaf; ink and colors on paper; height, 18.1 cm.; width, 17.7 cm. Collection of the late Yasunari Kawabata, Kanagawa Prefecture.*

100. The Convenience of Fishing, *by Ikeno Taiga (from* The Ten Conveniences and the Ten Pleasures*). Dated 1771. Album leaf; ink and colors on paper; height, 17.9 cm.; width, 17.9 cm. Collection of the late Yasunari Kawabata, Kanagawa Prefecture.*

southern painting styles of Ming and Ch'ing China and on the teachings of the Chinese treatise known in English as *The Mustard-Seed Garden Painting Manual,* which made its appearance in Japan in the late seventeenth century. This kind of art was compatible with the attitude of the intellectuals who prized Chinese learning, and the artists who painted pictures in the literati style have been highly regarded as differing from professional painters. Among the most noted of the literati painters were the previously mentioned *haikai* poet Yosa Buson (Fig. 99) and Ikeno Taiga (1723–76; Fig. 100). There is no denying the poetry and unworldliness of paintings in the literati style, but it cannot be denied, either, that they tend to lapse into pedantry and aloofness.

What I have said about the graphic arts should show that the late Edo period, just as it failed to produce literature worthy of being ranked with the *Genji Monogatari,* the poetry of Basho, the plays of Chikamatsu, or the novels of Saikaku, also failed to produce art of the category of the *Shigisan Engi* or the paintings of Sesshu or Sotatsu.

A subject that must be mentioned and emphasized before I leave the discussion of graphic arts in the late eighteenth and early nineteenth centuries is the introduction of Western painting principles and techniques. Although the Japanese came into contact with Western painting in the days of intercourse with the Spanish and Portuguese during the sixteenth and seventeenth centuries, in those times they did no more than copy imported pictures in, to them, strange styles. In the eighteenth and nineteenth centuries, on the other hand, truly serious study of Western art—together with the study of Western science—had its real beginnings. This development not only made possible the emergence of a Western-style painter like Shiba Kokan (1747–1818; Fig. 101) but also stimulated the artists of the ukiyo-e tradi-

101. Willow and Waterfowl in Winter, *by Shiba Kokan. Late eighteenth century. Oil on silk; height, 138.5 cm.; width, 84.4 cm. Collection of Kimiko and John Powers, New York.*

102. Portrait of the Confucianist Sato Issai, *by Watanabe Kazan. Early nineteenth century.*

tion to employ perspective and other Western principles in their work. Traces of Western drawing techniques can be seen in such things as the rendition of clouds in the landscapes of Hokusai and Hiroshige. The portraits painted by Watanabe Kazan (1793–1841) would lack the power they have if the artist had not employed Western-style realism (Fig. 102).

But more important than the effect of imported Western methods on the Japanese was the influence that pictures made in Japan had on Western artists when, after Japan resumed contacts with the rest of the world in the late nineteenth century, they were exported abroad. There may be many historical and cultural reasons for the bright compositions and fresh colors that the late impressionists introduced into a Western art that had become hidebound by classical realism, but there can be no doubt that one important factor was the stimulus supplied by the woodblock prints of such artists as Hokusai and Hiroshige. The case of Édouard Manet, whose juxtaposition of primary colors without intermediary tones shocked the people of his time, may have resulted

103. Olympia, *by Édouard Manet. 1863; Salon of 1865. Height, 130 cm.; width, 190 cm. Louvre, Paris.*

104. The Sower *(sketch), by Vincent van Gogh. 1888.*

in part from the development of a color sense derived from Spanish painting. But art historians point out the Japanese woodblock print, a topic of great interest among Parisian painters around 1855, as the more important, even the definitive, influence in the development of Manet's style (Fig. 103). The impressionists broke with the tradition, honored by artists since the Renaissance, that physical objects must be represented in pictures by means of light and shade and insisted that nature is a world of color. In this, too, they were influenced by the Japanese artists of the colored woodblock print. Both van Gogh (Fig. 104) and Gauguin learned from Japanese prints to use bold, unrealistic colors.

I have already pointed out the esteem in which the Chinese of the Sung dynasty held examples of *yamato-e* pictures exported to their country. I have also mentioned the sending of a Kano-school painted screen to the court of Pope Gregory XIII in the sixteenth century. In neither of these cases did Japanese art have any influence on the art of the country into which it was sent. But the woodblock print had a revolutionary effect on the art

of the West. For the Japanese, who throughout their history have been on the receiving end of cultural exchanges, the chance to contribute to the cultural growth of other countries was a revolutionary experience. At our present stage of knowledge, basic research on the nature of the Japanese contribution to Western culture has not been satisfactorily carried out. It is wise, then, to refrain from making overly bold statements. Still, I feel reasonably sure that the influence of the ukiyo-e print on Western art is virtually unparalleled in Japanese history (with such exceptions as the influence of haiku poems on the imagists of the free-verse movement in England and the United States around 1910).

THE BIRTH OF THE SCIENTIFIC SPIRIT

No footfall of progress toward the new era was heard in the hedonistic world of Japanese art at this time, but learning and thought strove to point out the path of future historical development. In the preceding chapter I have shown how there evolved from within orthodox Confucianism itself a rejection of the all-powerful authority of Confucianism and a desire to find a new way compatible with actual conditions. This tendency finally produced two separately organized systems of learning that opened up vistas impossible to people who persisted in adhering to classical Chinese Confucianism as the paramount authority. One of these new systems was the previously mentioned Kokugaku, or National Learning. The other was the so-called Rangaku, or Dutch Learning.

In the late seventeenth century the Buddhist monk Keichu (1640–1701) compiled an annotated version of the ancient poetry anthology *Man'yoshu* and attempted to stimulate research in the Japanese language. Kada Azumamaro (1669–1736), a Shinto priest at a shrine in Kyoto, advanced the idea that research in the Japanese classics would reveal the way of thinking among people of the ancient past. This approach to history and philosophy was further expanded by Kamo Mabuchi (1697–1769), another Shinto priest, and his disciple Motoori Norinaga (1730–1801). These

men all insisted on the importance of studying pure Japanese doctrines of the past instead of devoting total attention to the study of the Chinese classics. Motoori produced one of the great works of the National Learning movement in his immense *Kojiki-den* (Commentary on the *Kojiki*). After working on the book for thirty years, he completed and published it in 1798. It remains today a work of such careful and authoritative scholarship that no one doing serious work on the *Kojiki* can afford not to have a copy near at hand. The scholar Hanawa Hokinoichi (1746–1821), who was blind, produced the most amazing work of the movement in his *Gunsho Ruiju* (An Assortment of Writings), which is a collection of annotated and edited literary and historical texts in 530 volumes.

Though examining old Japanese texts in the hope of shedding light on the thought of the people in earlier times resembled the methods of Ogyu Sorai, who advocated the study of the Chinese classics in the hope of penetrating to the true thought of Confucius and Mencius, there is an important difference in the aims of the two approaches. The scholars of the National Learning movement were unconcerned about Chinese sages; they were combing the Japanese classics in order to arrive at pure Japanese thought as they believed it had existed before it was adulterated with Buddhist and Confucian importations. Ironically, this insistence on the primary importance of Japanese literature is only a kind of inversion of the philosophy of Ogyu Sorai. And as long as scholars of the National Learning movement remained devoted to this way of thinking, they were unable to break free completely from Confucian interpretations of the world. In their vigorous insistence that study of the Japanese classics was vitally important and in their attacks against Japanese Confucians who spent all of their time studying Chinese and knew nothing about their own country, the men of the National Learning group represented a step forward. But, like the Confucians, they limited themselves to researching old documents and refused to turn their eyes to the actualities of Japanese history. Although the National Learning movement was

unable to break out of the feudal mold in matters of this kind, in other connections it made great forward strides. For instance, one of the abuses of learning in Japan since earlier ages had been the doctrine that students must not question their teachers. But the scholars of the National Learning movement insisted that truth was greater than the pronouncements of any teacher. They encouraged the spirit of free debate, and they opposed the Confucian tendency to judge all things from a moral viewpoint, since they held that facts were more significant than moral codes.

Into the field of literary criticism they brought considerable freshness of view. Motoori Norinaga, the son of a merchant from Ise, showed that the *Genji Monogatari* was not an expression of Confucian or Buddhist thought, as had previously been assumed. Indeed, some Buddhists had gone so far as to claim that the famous romance was a version of the *Lotus Sutra,* but Motoori taught that it expressed the Japanese sense of pathos and sorrow at the transience of life (*mono no aware*). In this way he made it clear that the book was not merely a means for advancing religious or moral precepts but had its own individual artistic existence. Motoori argued that passionate love was one of the most poignant of human emotions, and in doing so he delivered a direct attack against the feudal condemnation of much traditional Japanese literature as immorally erotic. Viewed from this standpoint, Motoori seems very modern indeed. Nonetheless, it remains a great failing in the men of the National Learning movement that they found it impossible to turn from the study of ancient writings to the study of the living facts of their time.

Still, it is possible to cite exceptions to this general rule. For instance, Sugae Masumi (1754–1829) traveled far and wide through the northern reaches of Honshu, where he studied the way of life among the common people in fishing and farming communities. He compiled the results of his studies to produce a book illustrated with his own delightful drawings. But even he did not adopt a forward-looking attitude. Instead, he was interested in discovering ancient customs, which

he hoped to reconstruct from popular legends. Furthermore, since he is so exceptional a case as to make it doubtful whether he ought to be included among the National Learning scholars at all, he cannot be used as an example to suggest that these men could escape from the dead end in which they found themselves. Isolating themselves from reality in classical studies, they betrayed the objectivity required of such study by adopting a mystical and irrational view of the world. In comparison with the scholars of the National Learning movement, the men who made Dutch Learning their principal interest were far more scientific.

The isolationist policies adopted by the Tokugawa shogunate may have had the objective of blinding the people to what was happening in the rest of the world, but the government was unable to suppress interest in Western culture and the desire to study it. The previously noted early-Edo-period government adviser and scholar Arai Hakuseki showed interest in affairs in the world outside Japan. He learned much about these things from an Italian named Giovanni Battista Sidotti (1668–1714), who surreptitiously entered Japan. Later Hakuseki compiled his knowledge into a geographical work called *Seiyo Kibun* (A Report on the Occident). At about the same time, the small settlement of Dutch traders on the island of Deshima in Nagasaki harbor served as the only source of information about Western culture. Trips to Nagasaki to study and the yearly journey of the Dutch merchants to Edo were considered excellent opportunities to make even limited contacts with Western learning. So important was Nagasaki in this connection that the person in charge of the Dutch factories there was often expected to answer questions that, as a mere member of a trading firm, he could not justly be expected to understand.

The ruling class, too, felt the need to acquire a certain amount of Western scientific knowledge and technological skill for the sake of strengthening feudal society. For example, the eighth shogun, Yoshimune, encouraged the study of Western matters, especially astronomy and the calendar,

but because of the prohibition imposed on the Christian faith, the reading of Western books was severely restricted. The only people who were allowed to know even a small amount of the Dutch language were the interpreters who worked in Nagasaki. Such circumstances made the acquisition of knowledge about the West and its learning extremely difficult.

The way was opened to easier research in these matters by two courageous doctors, Maeno Ryotaku (1723–1803) and Sugita Gempaku (1733–1817), who, after performing experimental autopsies, proved the accuracy of Dutch medical books and the unreliability of Japanese anatomical works based on Chinese models. After bitter suffering and great effort, a Japanese translation of a Dutch medical book was completed and published in 1774. It was the first translation of an original Dutch book to become available to Japanese scholars, and Sugita Gempaku, in his *Rangaku Kotohajime* (The Beginning of Dutch Learning), relates the conditions under which the work was done. The book was followed by others that helped to ease the way for further scholarship: *Rangaku Kaitei* (Introduction to Dutch Learning) by Otsuki Gentaku (1757–1827) and a Dutch-Japanese dictionary compiled by Inamura Sampaku (1758–1811). Then, in 1823, the German doctor Philipp Franz von Siebold (1796–1866) arrived at the Dutch settlement in Nagasaki and soon began to give organized lectures on Western learning and scholarship at a place called the Narutaki Private School, on the outskirts of the city. Interested scholars from all over the nation attended these lectures.

Toward the middle of the nineteenth century, study of this kind ceased to be limited to Dutch matters and included scientific knowledge from many European countries. Consequently, in its later phase, the movement is more accurately described by the name Yogaku, or Western Learning. The ordinary people tended to look askance at this kind of study as something odd and even repugnant, but because its value was undeniable, the shogunate and many of the clans vied with one another in its pursuit.

In spite of their achievements in art and religion—achievements worthy to stand beside those of any other people—the Japanese produced no organized rational system that might be called science. Contacts had been made with the West in the sixteenth and seventeenth centuries, when the Portuguese and the Spanish introduced the culture of the "southern barbarians," but this culture was closely related to Christianity, and later prohibitions of this religion effectively ended such contacts. It was not until the Western Learning movement of the eighteenth and nineteenth centuries that the Japanese succeeded in acquiring some of the knowledge and methods of modern European science. It must be borne in mind, however, that ground was being prepared for this importation even among scholars who adhered to Chinese traditions. Such preparations were stimulated by a loss of interest in supernatural religious interpretations of the world and increasing interest in the realities of daily life. For example, experimental autopsy was performed as early as 1754 by Yamawaki Toyo, who published his work under the title *Zoshi* (Internal Organs). Yamawaki's work predates that of Maeno Ryotaku and is part of the trend that was to prepare conditions conducive to scientific learning at a slightly later date.

As Maeno Ryotaku, Otsuki Gempaku, and Philipp Franz von Siebold were opening doors to scientific and experimental study of physiology, Shizuki Tadao (1760–1806) was studying astronomy and physics. In his book *Rekisho Shinsho* (A New Work on the Calendar) he introduced the theory of the movement of the earth. Hiraga Gennai (1728?–79) made thermometers and electrical generators, and Ino Tadataka (1745–1818) engaged in surveying and made careful maps of Japan. All of these achievements were stimulated by the study of Western science.

It is important to note, however, that the achievements I have been discussing were confined to the fields of natural and applied science. Feudal society exercised rigid control over ideas and permitted no study of the kind of sociology and social philosophy that was being pursued in Eu-

rope. The shogunate actively promoted Western studies with the express purpose of strengthening feudalism. Obviously, the government forbade the study of anything that might inspire criticism of the established system or doubt concerning it, although later, as relations with other countries assumed great importance, the abandonment of isolationist policies became unavoidable. The government and the clans continued enthusiastically to encourage Western studies but solely for the aim of learning how to strengthen their own martial power. For instance, in 1850 the Nabeshima clan of Kyushu built a refractory furnace for the founding of cannons. Somewhat later, Shimazu Nariakira of the Satsuma clan had a refinery built for the production of military equipment. This trend reveals the nature of the historical conditions under which technological importations were made. After the ports of Japan were in part opened to trade with other nations, the Satsuma clan took advantage of assistance from England to open its own mechanized textile mill, and the shogunate called on the assistance of France in establishing shipbuilding yards at Yokosuka.

In 1857 the shogunate opened what was first called the Bansho Shirabesho (Office for the Study of Barbarian Writings) and later the Kaiseijo, which, as one forerunner of the present Tokyo University, was of immense importance to the growth of Japanese education. But in its earliest days it taught only subjects that were directly or indirectly related to military science. Drafting, for example, was taught because of the need to train cartographers, who are of obvious value in warfare. Viewed in this light, the theory that Western studies did no more than serve to reinforce the feudal system does not entirely lack substantiation.

Nonetheless, it must be recalled that Western studies played a large part in broadening the world view of the Japanese and in opening their eyes to the folly of the prolonged isolation policy. Certain writers and thinkers of the time emphasized this foolishness and had some effect on national policy. For instance, Kudo Heisuke (1734–1800), in his book *Aka Ezo Fusetsu-ko* (Re-

port on Kamchatka), insisted on the opening of trade with the Russians. As a result of the publication of his book, a program of developing the northern island of Hokkaido, located fairly near the Russian mainland, got under way. In his *Saiiki Monogatari* (Tale of the Western Region) Honda Toshiaki (1744–1821) argued that the only way to enrich Japan was to build ships, open the nation to foreign contacts, and engage actively in trade with other nations.

In spite of such forward-looking people, the ruling classes did their utmost to prolong the slumber of isolation. Finally, however, pressure was exerted by powerful Western nations. In 1791 Hayashi Shihei (1738–93) published his *Kaikoku Heidan* (A Discussion of the Military Problems of a Maritime Country), a book in which he foresaw the advances of the Western nations and warned the government about them. For his pains, he was imprisoned as a subversive thinker determined to pervert the people.

The government persisted in trying to blind the people to true conditions in the world. Other Western-study scholars, like Watanabe Kazan (1793–1841) and Takano Choei (1804–50), formed an association called the Shoshi-kai, which engaged in exchanges of knowledge and remained reasonably well abreast of affairs in the West. The government had issued orders that all foreign ships appearing in Japanese waters should be fired on, and the members of the Shoshi-kai argued that this order was an error. Watanabe and Takano both expressed criticism of the government in their writings and, in doing so, invited punishment. Oppression of thinkers averse to the government position successfully stifled Western-style philosophy critical of the shogunate.

Immediately before the fall of the shogunate and the political restoration of authority to the imperial throne in 1868, a number of Japanese gained further experience with Western political and social ideas. Nishi Amane (1829–97) traveled to Germany, where he studied the philosophy of Immanuel Kant. Kato Hiroyuki (1836–1916) discovered books on Western politics and economy in the library of the Bansho Shirabesho and learned

from them the good points of the parliamentary system of government. Upon his return from Europe, Fukuzawa Yukichi (1835–1901) described the lack of social restrictions and the equality of the people he had observed there and expressed his envy. But all of this study and discussion took place very late in the day for any reform in the shogunate. It can be said that so far as social phenomena and the interpretation of the human condition were concerned, the Western studies of the Edo period did nothing to introduce a modern spirit of reform.

THE RISING SPIRIT OF SOCIAL REFORM

Although Japanese students of Western learning in the Edo period abandoned the fields of philosophy and speculation and concentrated solely on practical matters, this was entirely as the government wished, for its only desire was to reinforce the feudal system. The distinction between the kinds of knowledge that were thought suitable to the loyal subject is well expressed in the words of the scholar Sakuma Zozan (1811–64), who spoke in terms of the morality of the Orient and the art (by which he meant the technology) of the Occident.

Nonetheless, the times were clearly marked by the process of dissolution in feudal society, and experience had taught the Japanese people to be critical of the shogunate and the clans. In spite of the lack of organized education in social philosophy, it was impossible not to entertain serious thoughts about reform. Political leaders of the latter half of the nineteenth century insisted that a united national body was the traditional Japanese way and that modern social and political philosophies were merely foreign importations. But this is not entirely true, for the modern social awareness of the Japanese people was born of their own experiences during the time when feudal society was collapsing. Philosophies of reform were a plague for the feudal authorities of the late Edo period. It is true that these philosophies were immature and that they were marred by inherent contradictions, but their very existence made possible the later grafting of modern Western political thought. Consequently, from the standpoint of the early history of modern Japanese thought, the developments of this particular period are of great significance. A high point in the early growth of egalitarian thought in Japan was the work of Ando Shoeki (1703–62), who wrote books on naturalist philosophy around 1752. He argued that all human beings ought to cultivate their own foodstuffs and support themselves by their own work. Further, he maintained that taking grain raised by farmers without proper compensation constituted theft, and he presented a severe criticism of history and social phenomena on the basis of this fundamental thought. He claimed that in the ancient past people lived in a natural stage in which everyone raised his own food. Then the sages appeared and taught a false morality that ushered in a legalistic stage in which emperors, generals, feudal lords, merchants, and other nonproducers committed robbery by taking the grain grown by other people. This was, according to him, the source from which crime, wickedness, war, and all other evil sprang. Furthermore, he insisted that until the source of thievery was removed, the world would not be free of wickedness. Finally, he claimed that all social distinctions of the kind that existed between ruler and ruled and among the four feudal classes —warrior, farmer, craftsman, and merchant— must be abolished and that man must return to the natural state in which one eats and lives by the fruit of one's own labor. Not only did Ando flatly reject class oppositions, controlling powers, and the class system, but he also bitterly attacked the family system in which the female was relegated to an inferior position. He said that it was animalistic for one man to be able to amuse himself with several women and that a monogamous union ought to be formed so that the man and the woman would work on an equal footing by day and sleep together at night in order to produce the materials needed for life and to insure the procreation of the human race.

One can only conjecture about the historical conditions that caused a man living in feudal

society to reject the prevailing system and to produce this creative philosophy. Since Ando's thinking was too advanced for his times, it is unlikely that it was widely known. Indeed, his very existence remained little known until his work was discovered in the late nineteenth century. Consequently, biographical information about him is limited, aside from the fact that he began medical practice in the city of Hachinohe and that he died in what is now Akita Prefecture. Possibly he developed his original philosophy of society and morality as a result of observations of the dire conditions under which the farmer labored to make a living in the retarded northeastern part of Honshu, where Hachinohe is located. Considering the general philosophical acceptance of the inevitability of ruled and ruling classes, Ando Shoeki has earned a very high place in the history of Japanese creative thought for the bold way in which he attempted to refute this class system and to come to grips with absolutely basic issues. But, as an outcome of the highly radical nature of his thought, Ando had no disciples to carry on and develop his work. Even during his lifetime, he was hampered by his own attitudes. Conducting his research against the background of a retarded rural society, he cherished the ideal of returning to a primitive system free of both exploitation by the warrior class and incursions by the merchant-capitalist class. Since his philosophy was a revivalistic one advocating a return to self-sufficient agricultural society, he failed to evolve an accurate understanding of the process of actual historical progress.

Though less revolutionary than the philosophy of Ando Shoeki, other trends of thought in this period attempted to understand history accurately and to demolish the accepted views of feudal ideology. Efforts were being made to develop productive power in various fields, but the feudal social order and the government policy of isolation made it impossible to hope for rapid improvements in these fields and difficult to evolve a positive idea of the expansion of productive power as a goal. In the popular morality of the time, thrift and limitations on consumption were important virtues. It was even thought that a person could not become wealthy if he did not suffer hunger and if he was not swift in everything, even in paying condolence calls after a fire. But gradually a new way of thinking came into being. According to this new philosophy, the highest mission of man was to take deliberate steps to obtain wealth and to increase the productive capacity of society.

The aforementioned Hiraga Gennai is an interesting illustration of the new trend. Possessed of outstanding ability in both art and science, he found no place to exercise his talents to the full in the rigid social conditions of his times, and he died mad. Nonetheless, he made many attempts to aggrandize society in general. He said that most people thought of nothing but getting rich quick when they thought of cotton or sheep. His intention, however, was to stimulate the growth of a textile industry that would make the importing of cloth unnecessary. He devoted the best of his knowledge to the development of tools that he thought would be of use to the nation.

Another thinker who emphasized the contradictions of feudal society was Kaibo Seiryo (1755–1817), who found it meaningless to give prizes to children for filial devotion and insisted that praise ought to go to people who cultivated new plants imported from abroad or who built large ships and increased the national wealth by exporting Japanese products. He criticized the military class for living on rice stipends taken from farmers' harvests and for despising and ridiculing the merchants. He said that the times would not permit a proud and superior attitude toward agriculture and commerce, for without these two fields of endeavor life would be impossible. He accused the warriors of laughing at commerce while actually engaging in it. He said that the bond between the warrior and the lord was in a real sense commercial. In poking fun at people engaged in commerce, then, the warrior was in effect poking fun at himself. Kaibo insisted that a fluid economy based on exchange was historically inevitable. It is true that the philosophies of both Hiraga Gennai and Kaibo Seiryo were less profound than the philosophy of

Ando Shoeki in that both of them remained within the framework of feudal thought and recognized the superiority of the military class, although they did advocate recognition of the importance of the mercantile class as well. On the other hand, Hiraga and Kaibo were truly revolutionary in that they went beyond the orthodox feudal position that agriculture was of paramount importance and pointed the way to the evolution of a new and different kind of society.

During the final years of the Tokugawa shogunate, the agricultural scholar Okura Nagatsune (1768–?) studied ways to enable farmers to improve their lot. He urged them to plant commodity crops as a means of escaping from hardships imposed on them by the money economy of the merchants. His attitude was diametrically opposed to the old-fashioned emphasis on the importance of the farmer. The older view was actually no more than an effort to beautify an inhuman system designed' to overwork farmers and prevent them from bettering their standard of living. Whereas an earlier book called *Nogyo Zenshu* (Complete Agriculture) had dealt with nothing but cereal cultivation, Okura's *Koeki Kokusan-ko* (Treatise on Profitable National Production) studied such matters as the cultivation of crops that would provide raw materials for cottage industries in rural villages. To enlighten conservative farmers who had remained content with primitive techniques for centuries and who had made no effort to introduce new ways, Okura studied agricultural tools with an eye to reducing the burden of labor and increasing production. He paid little attention to the position of the farming class within the feudal society and was much more progressive than Ninomiya Sontoku (1787–1856), who approved primitive farming methods, emphasized the importance of physical labor, and trusted in the good graces of the ruling class.

In one way or another the revolutionary philosophies that I have just discussed were included in the theories of reverence for the emperor (*sonno-ron*) and the exclusion of foreigners (*joi-ron*). The popularity of this attitude gained impetus in the late Edo period. Its advocates were not eager for

fundamental changes in the feudal order. Reverence for the emperor and fidelity to the Tokugawa shogunate were thought to be entirely compatible. Nonetheless, the shogunate cannot have been pleased by people who stressed the dignity of the imperial house, which had for centuries been virtually ignored. Perhaps the shogunal authorities acted in haste in 1759, when they exiled Takenouchi Shikibu from the city of Kyoto for advocating loyalty to the emperor in his teaching sessions, and again in 1767, when they condemned to death Yamagata Daini, who was in the habit of lamenting the sad condition of the imperial family and who was accused of having given lessons in the strategies suitable to attacking Edo and Kofu castles. Still, all of the repressive efforts of the authorities far from promoted the shogunate's cause, for, with increasing pressure, the theory of reverence for the emperor became a tool in political tactics aimed at the overthrow of the established government. Until the time of Motoori Norinaga, thinkers and teachers of the National Learning school had been conservative and loyal. Among them were people like Ban Nobutomo (1773–1846), who carried on Motoori's tradition of corroborative study. Hirata Atsutane (1776–1843), however, developed only revivalist Shinto aspects of National Learning and from them evolved a fanatic, though practical, teaching that exerted a profound influence on warriors and peasants in provincial districts in the already shaky society of the last days of the shogunate.

In 1853 Commodore Matthew C. Perry of the United States sailed into the bay at Uraga and demanded that the Japanese open their nation to trade and navigation. The overwhelming military power of the Western nations forced Japan to abandon its policy of isolation. Under the irresistible force of capitalistic production, trade was opened with other countries. Conflict with the more conservative elements in Japanese society generated a simple nationalistic reaction under the banner of the *joi-ron,* or theory of the expulsion of foreigners.

Japanese contacts with foreigners—with the possible exception of long-forgotten incidents in the

very ancient past, the Mongol invasions of the thirteenth century, and Hideyoshi's campaigns in Korea—were cultural instead of political. The Japanese had usually been eager to adopt foreign culture. The forbidding of Christianity in the seventeenth century was the only instance of rejection of foreigners that had occurred in the history of the nation. But Perry and his famous Black Ships set into action a course of events that, by inspiring fear in the minds of some of the people and by causing other evils, such as sudden rises in prices brought on by foreign trade, fanned the flames of a xenophobic movement and planted in the minds of the Japanese an awareness of Japan as a national state in relation with other similar states. In fact, however, there was no truly united Japanese national state at the time, for the country was split up among a number of clans that were virtually independent. Furthermore, society was compartmentalized by the rigid status system. This meant that there was no true unity of people or nation. The antiforeign movement was directed— if perhaps only vaguely—toward the solution of this problem by means of the fostering of a sense of national unity. When the theory of revering the emperor was channeled in the same direction, an absolutist national awareness of one people united under an imperial sovereign came into being. By 1858, Ii Naosuke (1815–60), chief minister of the shogun, imprisoned supporters of the movement and had some of the leaders, including Yoshida Shoin (1830–59), executed. At the time, the antiforeign and imperial-loyalist elements were pursuing a circuitous course. Still, Ii's action reflected the alarm with which the shogunate regarded them.

Although the loyalists were strong enough to function in a revolutionary way and to attain considerable historical significance, their philosophy cannot be said to have been always progressive. Their movement was supported largely by low-ranking members of the warrior class who were dissatisfied with the oppressive social-status system of the feudal order. It would be difficult to expect a movement with such a backing to produce a clear, accurate image of modern society. The

Tokugawa shogunate had turned its back on the energy of the people. For a few public-spirited men to try to revive the ancient authority of the emperor was in itself an attempt to run counter to the flow of history. The advocates of the antiforeign policy were striving to curb the development of the influence of the Western powers. Their attempts were both futile and anachronistic. Ironically, the drive behind these absurd ideas did manage to play a large part in the later development of Japanese history. But it is mistaken to think that the imperial-loyalist and antiforeign elements alone were the sole leading force in the agitation to reform the shogunate. Below the surface, a deeper philosophical current was at work to bring about change. This current was embodied in the growing political awareness of the peasantry.

The townspeople of the feudal age lived under relatively fortunate circumstances. The peasants, on the other hand, while supposedly collateral with the townsmen in the feudal scale of statuses, were forced to bear immense burdens. Unlike the people of the towns, rural farmers could find little to eulogize in the status quo. The development of a commercial commodity economy impoverished the warriors, who, in their turn, demanded larger rice stipends from the farmers. The farmers naturally found it increasingly hard to make ends meet. In time of such natural disasters as typhoons or earthquakes, still greater hardship became their lot. Dispersed throughout the nation in isolated communities, the peasants lacked class awareness. Because they were overworked, forced to live on a low standard, and deprived of knowledge and self-awareness, they were unable to generate a revolutionary philosophy that could enable them to break out of their wretched circumstances. They did have one weapon that they could use for the achievement of immediate goals: the agrarian uprising, involving violence, destruction, and direct forced appeals to the authorities for the correction of given abuses. Although, in isolation, uprisings solved only immediate, individual problems, when they occurred in waves, they became a force that stimulated the dissolution of the feudal social order. Names of men who gave their lives in sacrifice as

leaders of agrarian uprisings have survived among the people to serve as encouragement and inspiration. Some of them, like the famous Sakura Sogoro, found their way into popular literature and plays for the Kabuki stage.

But peasant reactions did not always take the form of violence, for the class was slowly becoming aware of itself and its social position. Reforms were being effected in the ordinary daily management of village politics. Officials were closely supervised, and those who failed to act in complete justice were removed from their positions. Village expenses were beginning to be publicly shared, and when the peasants realized that the confused financial policies of the warrior class brought poverty on their heads, they requested reforms, as many examples of petitions testify. Against this background, one revolutionary surge for human rights developed in the 1870s and 1880s. Although this movement was only temporary, it was based on the rural village and manifested considerable energy.

It is true that the peasants of Japan never developed a splendid culture of the kind created by the townspeople of the Edo period. They were in no political or financial position to do so. But their cultural contribution must not be despised, for in the late nineteenth century they showed an aggressive spirit in a movement for human rights that was virtually the only democratic movement in all of Japanese cultural history.

CULTURAL EXPANSION During the late fifteenth and the early sixteenth centuries, powerful daimyo spread cultural activities far and wide. Until then, Kyoto had been the unrivaled center of art and letters. For a while, owing to the activities of these daimyo, it lost its position of preeminence. But with the rise of Hideyoshi to power and the unification he helped to effect, Kyoto once again assumed the lead, and as time passed, the whole region around Kyoto, including Osaka—even then a great commercial city—became the heart of Japanese cultural life. When Tokugawa Ieyasu moved the seat of his shogunate to Edo, that community was culturally far behind the Kyoto and Osaka area, as were the

ancient city of Kamakura and the entire Kanto region surrounding Edo and Kamakura. A list of the great men of art and literature of the first half of the Edo period (seventeenth and early eighteenth centuries) shows that all of them were from Kyoto, Osaka, or neighboring vicinities and that, with the exception of Matsuo Basho, who moved to Edo, all of them worked in that same part of the country.

In the second half of the Edo period, however, all of this changed as the cultural center shifted to the shogunal capital. Ogyu Sorai started a new branch of the Kogaku (Ancient Learning) school of Confucianism in Edo. The National Learning school of philosophy began to flourish in Edo after 1738, when Kamo Mabuchi moved there. These two trends symbolize the general move of art and literature to the capital, where, from that time on, leading painters, writers, poets, and ukiyo-e artists lived and worked.

It is not surprising that in the course of this shift of importance the dialect of Edo should have assumed the leading position long held by the dialect of the Kyoto-Osaka area. In the *Heike Monogatari*, Kyoto noblemen ridicule one character as a country bumpkin because he speaks the language of the Kanto district. In a much later novel, Shikitei Samba's *Ukiyo-buro* (Bathhouse of the Floating World), however, the tables have been turned, and an Edoite lady is able to praise the way she talks as being superior to the language of people from Kyoto.

In saying that the cultural center of the nation shifted to Edo, I do not imply that cultural activities came to a standstill in the Kyoto-Osaka area. The true nature of the process can probably be best described in the following way. Cultural activities were no longer confined to Kyoto and Osaka but were spread throughout the entire country. The political center of the nation, Edo, became a huge city with an immense population and a flourishing culture.

A number of political and other factors inspired an increased amount of traveling in Japan at this time and thus contributed to cultural dispersion. For instance, the Tokugawa government's policy

of forcing daimyo to spend part of their time in the capital and part in their own domains meant that there were always great processions of lords and retainers passing to and fro over the nation's highways. Obviously, the lords and their underlings carried back to their homes the latest cultural and social trends that they encountered in Edo. The *haikai* poets were fond of making excursions throughout the countryside, writing about their impressions and sharing their thoughts with others. Aside from these somewhat special groups, the population in general took a lively interest in traveling, especially to visit famous Shinto shrines and Buddhist temples.

Although many people connected with learning and art came to Edo—if they did not already live there—not everyone followed this example. For instance, an undisputed giant of philosophy of the time, Ando Shoeki, as we have seen, spent his life in the region of Akita and Hachinohe in the relatively isolated northeastern part of the main island of Honshu. The great scholar Motoori Norinaga perfected his version of National Learning and taught people from all over Japan at Ise. Many other prominent people in learning and the arts lived in remote areas. Among them were the great natural philosopher Miura Baien, who lived in Kizuki, in the northern province of Kyushu called Bungo (now Oita Prefecture), and the master of *nanga,* or Southern-style painting, Tanomura Chikuden, who lived in the village of Takeda in the same province.

Education was more widely dispersed because of influences from Edo. The shogunate established its two famous schools the Shoheiko, a Confucian college and one of the forerunners of the modern Tokyo University, and the Bansho Shirabesho, a school for Western learning and another of the forerunners of Tokyo University. In imitation of these institutions, each of the feudal clans set up its own schools in the towns surrounding the lord's castle. The schools of the Yonezawa, Mito, and Nagoya clans were especially noted for their excellence, though all the clan schools employed scholars trained in the capital as instructors. It is true that these institutions were devoted to the education of children of the ruling warrior class. But the common people also had village schools for the formal education of their children, and many of these schools were run on private funds with some assistance from the feudal lord. It is said that even the small and relatively poor Isezaki clan had twenty-four village schools within its domains. One of them, called the Kyogido, is still in existence today. The number of temple schools for primary learning grew quite large in this period. It is said that in 1722 there were about 800 instructors for such schools in Edo alone, and surveys have shown that by the end of the Edo period there were about 15,000 private schools and temple schools in Japan. So far, there are only one or two of the old provinces where it has been impossible to establish definitely the former existence of temple schools.

In addition to this more formal education, a moral-education movement teaching what was called *shingaku* (practical ethics) was initiated in the eighteenth century by Ishida Baigan (1685–1744) and was carried on by others, notably Tejima Toan (1718–86). This kind of teaching consisted mainly of lectures on moral and Confucian matters, the content of which was couched in simple language that the ordinary people could understand. Buildings for this type of education were erected in more than thirty provinces.

It is not surprising that the townspeople of the time should demand education in art and culture and that, as a consequence of the fulfillment of this demand, the culture of the cities should flourish. But as I pointed out in the preceding chapter, this created a cultural gap between the people of the towns and the peasants.

Certain advances were made in farming methods in these years, but they were limited to such achievements as the invention of iron tools for harvesting. As far as planting seedlings in the paddies and weeding the fields were concerned, primitive methods that had been in use for centuries went unaltered. The labor of the farmer was cruel and crushing. This and the exploitation to which they were subjected robbed the peasants of any chance to improve their way of life and, in turn, made it impossible for the average rural

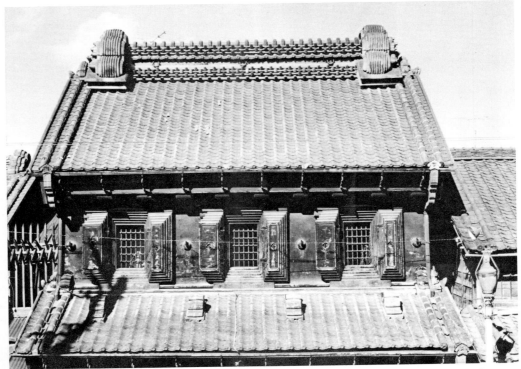

105. Upper floor of shop-storehouse (misegura). *Late nineteenth century. Kawagoe, Saitama Prefecture.*

dweller to enjoy the high-level cultural developments that characterized urban regions.

Still another reason for the failure of the rural population to develop its own culture can be found in the very nature of farm life in those times. In rural villages the sense of communality was very strong. Planting, harvesting, thatching, weddings, funerals, and virtually all things auspicious and inauspicious were done together by everyone. Work and leisure were shared. The outcome was an almost total lack of freedom. Because high-level culture demands the creative thought and cultivation of individuals as a basis on which to grow, it could not take root in soil like that of the closely knit community life of the old-time Japanese village. Nor is this set of circumstances surprising in the light of the way in which cruelly repetitious labor under primitive working con-

ditions and the narrow scope of village life robbed the farmers of a chance to take a wide view of the world in which they lived. But these conditions had another effect. The historical role of the peasant class has not been organized production of learning, art, and philosophy but the creation of a material basis on which high-level culture must rest. From the desperate and repeated attacks they suffered from all sides, Japanese peasants evolved their own kind of simple democratic spirit.

Though the majority of the Japanese peasant class in the Edo period lived the kind of life I have been describing, there were such people as rich farmers who enjoyed conditions that enabled them to participate in cultural activities and to serve as cultural leaders. Because their affluence freed them from the need to work, rich farmers could import art and learning from the urban centers. Motoori

Norinaga once made an analysis of his students on the basis of social class and learned that among them there were 166 townsmen, 114 farmers, 69 Shinto priests, 68 samurai, 23 doctors, 22 women, and 2 others. This is forceful indication that the National Learning philosophy appealed most strongly to the common people. In Motoori's case, emotionalism and conservatism may have accounted for this distribution because of the attraction such traits had for the townsman class in general. In the case of National Learning as interpreted by Hirata Atsutane, village priests and farmer-landowners accounted for the overwhelming majority of students. Among Hirata's group were such leaders of the Somo (Grass Roots) National Learning as Miyaoi Sadao, who expounded the duties of village officials, criticized the standards of living in the rural village, and studied agricultural technology. As is often pointed out by scholars, the work of the leaders of the Grass Roots National Learning must not be overlooked in serious study of the cultural history of the late Edo period.

But it would be wrong to leap to the conclusion that dispersal of culture and education among various areas and classes of the nation amounted to qualitative cultural progress. The *shingaku* moral lectures and the Grass Roots National Learning that were introduced into the lives of the rich peasant class were in fact attempts to devise a philosophical guidance system that would deal with the increasing conflicts within feudal society and would bring the common people into line with the ruling system. It is doubtful that these two movements were historically more important than direct activities of the poor peasant class in their attempts to move instinctively from cultural darkness along a path of progress.

No culture is unchanging. Even though it might seem that a culture dispersed over a wide area has little intrinsic value, undeniably the adoption by the Japanese people in general of art and learning, which had formerly been the possession of a small, specially privileged class, must be regarded as an important historical development. It was because of the emergence of a popular national basis during the late Edo period that Japan, after the Meiji Restoration of 1868, was able to pursue an intricate but relentless course of modernization.

Though it was different and less sophisticated than the culture of the cities, rural areas had their own culture, which was marked by a wholesomeness often wanting in the cities, whose civilized life was sometimes marred by degenerate characteristics. The strength of the rural culture is to be seen in the surviving handsome farmhouses (Fig. 82), which are very different in most respects from the combination shop-and-residence structures and shop-storehouses (Fig. 105) that were common in the cities. In addition, much attention was devoted by the peasant class to the creation of articles of everyday use that, though simpler than the elegant craft items of the city, have distinctively warm, human qualities. In our own time the merits of both farmhouse architecture and folk-craft articles of daily use have been recognized. All of these things were born from the needs of ordinary living. They vividly illustrate the Japanese tradition that beauty is to be found not necessarily in the lofty and remote but in the near at hand.

CHAPTER EIGHT

Traditional Characteristics of Japanese Culture

IN THE PRECEDING chapters I have traced the main features of development in the various aspects of Japanese culture during what might be called the premodernization period—that is, the period before the Meiji Restoration of 1868 and the resultant introduction of wide-scale borrowings from Western science and technology as well as the Industrial Revolution, which, in its turn, led to the development of a capitalistic society. I have conducted my discussion in constant relation to the changes that took place in the social structure. Furthermore, I have touched on those things that can be considered typical of Japanese culture. In this final chapter I should like to make one more mention of the things that I believe characterize Japanese culture throughout its history until the conclusion of what I call the premodernization period.

The first characteristic is a lack of interest in the question of conflict. In the literature of the Edo period, mention is sometimes made of a Good King and an Evil King, and these references might lead one to assume that the Japanese mind thinks in terms of such duality. I believe that a closer approximation to the truth is to be found in the explanation offered in the writings of the philosophical historian Sokichi Tsuda (1873–1961). Tsuda says that good for the Japanese means conformity to the social order and to the social authorities,

whereas opposing the social order and the authorities is evil. The distinction between good and evil is clearly drawn in this definition. But "good" does not pertain to a person of high ideals and devotion to the betterment of all mankind. Instead, it means the kind of person who is always devoted to the maintenance of the status quo and who obeys the laws of what is called *giri* (a word that is sometimes imperfectly translated as "social justice" but that carries connotations of all kinds of obligations and responsibilities). Conversely, an evil person is only one who tries to give full rein to his own personal desires, not the profoundly wicked person of a diabolical nature who considers evil a source of rejoicing and who attempts to wreak havoc on human life itself. Tsuda made this analysis in relation to Edo-period literature, but I believe it can be regarded as commentary on a characteristic that persists throughout Japanese culture.

This characteristic arises from an ambiguous attitude concerning aspirations toward high ideals, a lack of thoroughness in opposing evil, and a basic unawareness of dual oppositions in human life and the world at large. Although in the references to the good and evil kings a clear conflict has been established, it is a conflict between those who do and those who do not abide by the dictates of social order. It is difficult to accept this shallow

difference as awareness of the profound duality between good and evil in the world. The true duality rises from conflicts in the deepest layers of human life and is not concerned solely with maintaining the status quo and abiding by the dictates of a social justice called *giri*.

The characteristic Japanese lack of awareness of conflict and oppositions extends to such things as gods and humanity, crime and punishment, spirit and flesh, nature and man, society and the individual, the lord and his people, and many other examples of deep conflict. Japanese culture is poor in philosophies, religion, and art based on treatments of the complications associated with these conflicts. It seems that behind Japanese civilization there is always a force at work to resolve conflicts and to harmonize all things. One of the classic representations of the Japanese belief in the oneness of nature and humanity is the *yamato-e* painting of the Heian period.

As I have already mentioned in the section on this subject, in the *shinden*-style houses of the Heian-period aristocrats many paintings were required to decorate the screens and sliding panels that were indispensable features of interior design. The subject matter for these pictures was usually taken from the world of nature or from the world of human events. The passing of the seasons, the natural characteristics of each time of the year, and seasonal celebrations and human activities were depicted in paintings that were called four-seasonal pictures. A series of twelve such pictures could be combined for a panorama of the entire year. In the category of natural characteristics of the seasons could be found such things as plum trees, mist, bush warblers, pheasants, wild geese, peach blossoms, cherry blossoms, Japanese yellow roses (*yamabuki*), a kind of iris called *kakitsubata*, wisteria, another kind of iris called *ayame*, lotus flowers, deutzia flowers, wild pinks, cuckoos, early summer rain, waterfalls, the moon, dew, deer, chrysanthemums, fog, autumn foliage (especially the scarlet maple), autumn showers, desolate fields, animals and plants in the snow, heavenly bodies, meteorological phenomena, and so on. The following are some of the human events and activities

that might be shown: cutting spring grass; a game with small pines called *komatsuhiki;* votive visits to Shinto shrines; the Kamo Festival; the great purification performed on the last day of June, called the Minazuki-barae; summertime *kagura* (ritual dance); enjoying the fresh air in summer; the August ceremony to receive the horses sent to the imperial capital as tribute; pounding cloth to make it soft; the autumn hunt for small wildfowl; the Rinji Festival, which took place in November at the Kamo Shrine; trips to the fields; the hunt for large wildfowl; and the December Buddhist ceremony known as the Butsumyo-e.

Although these lists might suggest that the pictures dealt with the natural and the human in separated, isolated categories, such was not the case. The two are usually shown together in harmony—not in conflict. For instance, if the topic is blossoming plum trees, the picture will show something like young women going into a garden to view the trees. If the subject is wild geese, the birds will probably appear in association with travelers. Again, when the themes are human events, man and the natural world are invariably shown together. In portraying the Butsumyo-e, for example, a typical *yamato-e* version pictures snow falling while priests stand in the garden on the morning of the ceremony. In a word, although the picture deals with a human activity, the artist of the *yamato-e* tradition does not forget to introduce the natural element—in this instance, snow. When they are ostensibly devoted to depictions of natural things, the pictures include the human because their painters regarded man and his natural environment as closely bound to each other. Even in the genre paintings known as *meisho-e*, or pictures of famous places, objective representations of popular scenes were often mere copies of the four-season pictures with snatches of poems added to them. Pictures dealing with the love of man and woman, a subject of purely human interest, treated in the manner of novels, connect the affairs of lovers with the changes of the seasons. These and other similar examples make it clear that *yamato-e* pictures interpreted and expressed man and nature in a relationship of inseparable unity.

No matter what their origins, the pictorial arts of other peoples, once they have achieved technical sophistication, always treat things in such distinct categories as landscapes, animals or flowers, still life, and individual or group portraits. In paintings of people, nature is usually nothing but background, and whatever human beings appear in landscapes are no more than accents. Though these categories are applicable to the pictorial arts of both China and the West, they are inappropriate in relation to Japanese art of the *yamato-e* tradition. On the other hand, in the arts of China and the West there is nothing like the Japanese four-season paintings.

But the approach found in these paintings is not necessarily peculiar to them, for the romantic tales of the Heian period and the *renga* and *haikai* poetic styles of later times all treat man and nature as an inseparable unity. The noted Japanese art historian Tsuneyoshi Tsuzumi, in his book *Nihon Geijutsu Yoshiki no Kenkyu* (Study of Japanese Art Styles), has said that Japanese art is boundaryless in the sense that it is difficult to make clear compartmental divisions in relations between nature and humanity and in relations among various art genres. The scroll pictures of the Heian and Kamakura periods illustrate this meaning. They are examples of literature and painting intimately bound together. The pictures do not have the autonomous independence that Lessing mentions in his discussion of the *Laocoön.* Still another example of the fusion of genres—one without peer in the rest of the world—is the *Heike Nokyo,* the set of sutra scrolls produced at the request of the Taira clan in the twelfth century (Fig. 39). These handsome scrolls are an amalgamation of craft work, represented by the beautiful colored and decorated papers; the calligraphy in the texts of the sutras themselves; the graphics in the decorative calligraphy; the metalwork in the rollers and mountings; and the painting in the illustrations for the texts. Examples of the lack of boundary between architecture and natural setting are numerous. Two that come to mind at once are the Phoenix Hall of the Byodo-in, at Uji, and the Tosho-gu shrine at Nikko. In the former the architectural impression of the building against its landscape setting is strong. In the latter the dazzlingly decorated buildings are virtually wrapped by the magnificent forests in which they stand. It seems probable that the lack of dividing boundaries in Japanese art originated in the mentality that makes a one-dimensional interpretation of man and the world and pays little attention to conflicts and contradictions. In other words, this is the mentality that has only a superficial understanding of good and evil and that strives for agreement.

This characteristic of Japanese culture may be described in many ways. It can be called lack of awareness of conflict, lack of dividing lines, all-inclusiveness, and lack of thoroughness. But the interesting thing—the point to which I want to devote my final remarks—is the historical source of this characteristic. Before touching on this, however, I should like to mention other major cultural characteristics.

Japanese culture has achieved great things in fields related to human emotions. Although it has not been completely devoid of achievements in the fields of rationalism, intellect, and technology, it has done much less in these areas. The result has been an imbalance that is, I believe, the second great characteristic of Japanese culture. In art—especially the plastic arts and literature—Japanese achievements are worthy to be placed on the highest levels: the poetry anthology called the *Man'yoshu;* the *Genji Monogatari;* the novels of Ihara Saikaku; the plays of Chikamatsu Monzaemon; the poetry of Matsuo Basho; the Buddhist sculpture of the Hakuho and Tempyo periods; the masterpieces of scroll painting; the paintings of Sesshu, Tohaku, Sotatsu, and others; the Noh drama; and the *ningyo joruri* puppet plays. In the fields of philosophy, science, and scientific technology the Japanese have not failed entirely to make progress in keeping with the needs of the times, but they have not produced anything on a level comparable with that of their artistic and literary work. In the field of music, too, they have remained at a low level of development, and in terms of musical instruments they

are far behind the West. It seems to me that this imbalance is related to a tendency to regard mankind and the world not in an analytical way but intuitively as an all-inclusive entity.

The characteristics of Japanese culture originate in the distinctive nature of Japanese society. On the other hand, to posit a fixed character permeating all of Japanese society or to say that the Japanese are a race incapable of extricating themselves from established patterns is to adopt the same kind of unscientific, fatalistic approach shown in the theory that anthropological and geographical environments determine human history. In spite of temporary stagnations and reversals, human history in general is one of unbroken development. There is no reason why the Japanese alone should be regarded as an exception to this rule. The major issue is the way in which Japanese society has developed. Although it would be rash of me to attempt a simple explanation of such an important question here, I should like to suggest one general perspective of the matter.

By this stage the reader has understood the classic path that Japanese social development has followed from primitive to ancient society, from ancient to feudal society, and from feudal to capitalistic society. But it is vitally important to bear in mind the total lack in Japanese history of the kind of break in the flow represented by the decisive social revolutions that have occurred in the West. If, for the sake of argument, I define the word ''revolution'' as a transition from one stage of social development to another, undeniably the Japanese underwent a feudal revolution and a bourgeois revolution. But at no time has Japan experienced the kind of slave uprisings represented by the revolt of Spartacus in the Roman Empire in the first century B.C. Furthermore, Japan has never undergone anything like the French Revolution or the revolution led by Oliver Cromwell in seventeenth-century England. The relatively steady flow of Japanese history, unbroken by clearly recognizable social revolutions, may account for the disagreement and confusion among historians about the beginning and ter-

minating dates of the various periods adopted for convenience in historical study. For instance, some historians insist that Japanese feudalism dates from the founding of the Kamakura shogunate, others argue that it did not begin until the disturbances of the age called the Period of the Northern and Southern Courts, and still others maintain that it did not start until the land survey conducted by Toyotomi Hideyoshi. The situation is equally complicated in connection with the beginning of Japanese capitalistic society, which some date at the Meiji Restoration of 1868, others in the 1880s, others not until the time of World War I, and still others not until the Potsdam Declaration of 1945. This confusion and the historical continuity it represents mean that Japan has developed but that the revolutionary process has been extended into a kind of installment plan. There have been no opportunities to sum up the historical and social conditions of ancient society; consequently, many of these conditions have persisted.

It seems to me that at the bottom of this continuity in Japanese history is the absence of far-reaching revolutions in the way of life of the agricultural villages that have always formed the basis of Japanese society. Until the period following World War II—and especially in the last two decades, which have dramatically transformed Japanese agriculture—throughout the roughly two thousand years that had passed since agriculture was introduced into Japan in the Yayoi period, nothing had happened to replace the old ways of raising crops, at least as far as the wet-field system of rice cultivation was concerned. This made it extremely difficult to achieve any kind of reformation in the human relations of the people living in farm villages. Communal celebrations of agricultural festivals handed down from the Yayoi period, together with a strong communal system, persisted in rural Japan. As long as the merchants, workers, and intellectuals of the cities continued to be of rural origins, no matter how greatly cities developed, the village system was repeated even in urban centers.

I have already mentioned the multilayer nature

of Japanese culture. The bottom layer, which supported the rest, was the life style of the rural village. This life style had been preserved while the cities evolved a new, high-level culture. Society in general progressed toward new stages, but ancient forms persisted at the deepest level. In other words, the ancient and the new layers of Japanese culture coexisted.

The strong sense of communality in the rural villages that formed the basis of Japanese society had two important effects. It gave birth to the multilayer structure that I have been discussing, and, at the same time, it helped to prevent the formation of divisions in content, the absence of which I have already mentioned as characteristic.

Historically, in the rural village, where the community body is all-powerful, the individual has few opportunities to oppose the group or to be aware of his own independence in relation to it. Water for irrigation is common property, firewood and grass come from communal fields, planting and production rely on the united efforts of the entire community. Even such things as weddings, funerals, and festivals are conducted in common. This means that the path to discovery of the bifurcation of the universe into the human and the nonhuman—a bifurcation based on an awareness of the distinction between the self and the other—is closed. Everything transcends opposition between parties and blends into a single unity—sometimes into great confusion.

The view of the world as lacking conflicts forms the ideological background for the folk religion as manifested in communal ceremonies. In the Japanese folk religion, which I have discussed elsewhere, there is no god who exists as an absolute being in opposition to humanity. Consequently, there is no awareness of guilt arising from the fear that severe judgment from some vastly distant place might be imminent. Good and evil remain relatively low-level matters of preserving or violating the social order. This is the fundamental source of the attitude toward good and evil that I discussed as part of Edo-period thought. Buddhism did introduce a sense of sin (*zaigo*) into Japanese life, but although it may have had

deep meaning for the founders of the new Buddhism in the Kamakura period, Buddhism has always been regarded by the mass of Japanese as a kind of magic, like the indigenous folk faith. Buddhism never had the power to alter the way the Japanese people view the world. Such scholars as Ruth Benedict and Sir George Sansom make an anthropological distinction between cultures based on shame and cultures based on sin and say that Japan must belong to the former category. Their argument is in effect a Christian-culture-oriented endorsement of a proposal made by Japanese scholars some decades before Ruth Benedict.

Although Japanese culture has the characteristics I have enumerated, this does not mean that it has persistently limited human versatility and creativity within a fixed cultural pattern. Nor has it closed off roads to pioneering in different directions. Though it has in general taken a one-dimensional, inclusive approach, sometimes Japanese culture has demonstrated movements that surpass this general tendency. For instance, when Japanese Buddhism had been assimilated into the kind of magical functions fulfilled by the traditional folk religion, Shinran and Dogen developed a religion that came face to face with the profound conflicts and contradictions inherent in the bifurcation between the human and the nonhuman. These men broke with the traditions of worldliness prevalent in Japan since the time when religion was regarded as no more than a magical means to protect the nation. They rejected the actual world and opened up a lofty realm of the spirit. In doing this, they produced a great religious philosophy. The failure of their followers to carry on the purity of their faith suggests that the kind of religion Shinran and Dogen developed is highly exceptional in Japanese history. Still, the very fact that Japan produced a religion of this caliber proves that historical possibilities for variation and versatility were a part of the Japanese tradition. Nonetheless, since Buddhism itself lacks a historical philosophical view, the new Buddhism of the Kamakura period failed to reveal clear theories of social reform.

Another highly exceptional product of Japanese culture is the nature-oriented philosophy of Ando Shoeki, who argued that it was wrong for one class to take away the fruits of the labor of another class without suitable remuneration. He insisted that everyone should work and that mankind ought to live in a classless, governmentless society. This, of course, is completely alien to the Japanese tradition, in which there is no structure for social reform at all and in which reforms have rarely manifested themselves. It is true that the group they founded lost strength and virility in later times, but Shinran and Dogen had a large following nevertheless. Ando, on the other hand, was an isolated instance without significant historical influence. Nonetheless, he is another illustration of my insistence that the Japanese tradition has not closed the door on creative, independent possibilities. Ando was able to work out his philosophy on the basis of his real-life experiences in the retarded northeastern part of Honshu.

In this book I have done no more than present a few examples illustrative of major trends in Japanese cultural history in what I call the premodernization period. I have had nothing at all to say about Japan after the Meiji Restoration of 1868, not only because these trends suddenly broke off at that time but also because, since then, and increasingly in the last two decades, Japan has been losing the agricultural traditions that have long been the basis of its society. Among the things that have happened in recent times to alter the picture, I might mention the following: rapid mechanization of agricultural techniques, reduction of the proportion of the total Japanese industrial structure occupied by agriculture, mass urbanization of the population, and consequent breakdown of the rural communal body. In the past the rural village was the heart from which arose the agrarian uprisings with their revolutionary and reformatory aims. It is sometimes believed that the rural village can once again become the source of forward developments in the lives of the masses. Discussion of such an issue is beyond the scope of this book. I merely raise it as a matter for thought.

In concluding, I should like to repeat my conviction that the characteristic traits that permeate Japanese cultural history in the premodernization period did leave some room for versatility and revolution and that talented people who broke through the tradition managed to create on a level unsurpassed by any other culture. It is my hope that in the future the Japanese will further refine and advance the traditions of the past while at the same time creating a totally new culture that breaks with and even rejects those traditions.

TITLES IN THE SERIES

Although the individual books in the series are designed as self-contained units, so that readers may choose subjects according to their personal interests, the series itself constitutes a full survey of Japanese art and is therefore a reference work of great value. The titles are listed below in the same order, roughly chronological, as those of the original Japanese versions, with the addition of the index volume.

The "weathermark" identifies this book as a production of John Weatherhill, Inc., publishers of fine books on Asia and the Pacific. Supervising editor: Ralph Friedrich. Book design and typography: Meredith Weatherby. Layout of illustrations: Miriam F. Yamaguchi. Production supervision: Yutaka Shimoji. Composition: Samhwa Printing Co., Seoul. Offset platemaking and printing of color plates: Nissha Printing Co., Kyoto. Offset platemaking and printing of monochrome plates and text printing: Kinmei Printing Co., Tokyo. Binding: Makoto Binderies, Tokyo. The typeface used is Monotype Baskerville, with hand-set Optima for display.